MODERN ARTISTS ON ART

second, enlarged edition

Edited by

Robert L. Herbert

DOVER PUBLICATIONS, INC.
Mineola, New York

To George Wittenborn

Copyright

El Lissitzky: "New Russian Art: A Lecture," (1922). From Lissitzky-Küppers, Sophie, ed.: *El Lissitzky, Life, Letters, Texts*. (Copyright © 1968 by Thames and Hudson Ltd.) Reprinted by permission of Thames and Hudson Ltd.

Ernst, Max: "Beyond Painting," (1937). Translated by Dorothea Tanning. Reprinted from Motherwell, Robert, ed.: *Max Ernst: Beyond Painting*. (Copyright © Wittenborn, Schultz, 1948.) Reprinted by permission of Wittenborn Art Books, Inc.

Léger, Fernand: "The Machine Aesthetic: The Manufactured Object, the Artisan, and the Artist" (1924). Reprinted from Fry, Edward F., ed.: *Functions of Painting* by Fernand Léger. (New York: Viking, 1973). Originally published in French as *Fernand Léger, fonctions de la Peinture*. (Copyright © 1965 by Les Editions Gonthier.) Reprinted by permission of Georges Borchardt, Inc.

Schwitters, Kurt: "Merz" (1920). Translated by Ralph Manheim from *Der Ararat 2*. Reprinted from Motherwell, Robert, ed.: *The Dada Painters and Poets*. (Copyright © 1951, 1979 by Wittenborn Art Books, Inc.) Reprinted by permission of Wittenborn Art Books, Inc.

Bibliographical Note

This Dover edition, first published in 2000, is an expanded, slightly corrected republication of the work originally published in 1964 by Prentice-Hall, Inc., Englewood Cliffs, N.J., under the title and subtitle *Modern Artists on Art: Ten Unabridged Essays*. The Dover edition has been expanded by the addition of a new Preface; four essays (by Schwitters, Lissitzky, Léger, and Ernst), each with a new introduction by the editor; and a bibliography. Each of the ten introductions to individual artists' essays that the editor wrote for the first edition has been altered slightly, primarily for the purpose of updating.

Library of Congress Cataloging-in-Publication Data

Modern artists on art / edited by Robert L. Herbert.—2nd, enl. ed.
 p. cm.
 Includes bibliographical references.
 ISBN 0-486-41191-5 (pbk.)
 1. Art, Modern—20th century. 2. Art—Philosophy. 3. Art criticism—History—20th century. I. Herbert, Robert L., 1929–

N6490 .H45 2000
709'.04—dc21

00-043166

Manufactured in the United States of America
Dover Publications, Inc., 31 East 2nd Street, Mineola, N.Y. 11501

Contents

Preface to the Dover Edition

I am grateful to Pearson Education, Inc., acting for Simon & Schuster, for having returned to me the copyright of the 1964 book, and to Dover Publications for publishing this new, expanded edition. Introductions to the ten texts of the first edition have been revised only sufficiently to take account of anachronisms. In adding essays by Schwitters, Lissitzky, Léger, and Ernst, I have extended the range of this anthology so that it now includes salient statements of the "machine esthetic" and of Dada and Surrealism. This furthers my original goal, which was to put entire essays before the reader instead of the fragments that still characterize most compendia of artists' writings. Indeed, as a sign of the times, the most popular anthology nowadays incorporates far more essays by critics and historians than by the artists themselves.

The original dedication to George Wittenborn is now a heartfelt memorial to the man whose bookstore and publications of artists' writings were a delight to young students and professionals alike in the decades following the Second World War.

Robert L. Herbert
South Hadley, 2000

Preface

This book brings together essays by major painters and sculptors of the twentieth century, selected for their intrinsic quality and documentary value. They are not abridged or condensed in any manner, but presented in their entirety to permit the fullest possible expression of their authors' ideas. Another kind of anthology may choose to relinquish such completeness for an extended range of interests, and several excellent gatherings, both in print and in preparation, offer a rewarding sweep across modern art. By their nature, however, they can include only short excerpts and are apt to subordinate the individual artist to thematic or chronological schema. The essays in this collection, since they are left intact, carry the reader into deeper and more prolonged contact with the artists, one at a time. For the same reason, they may have a second and new life among those outside the visual arts, who are apt to be put off by an anthology of short selections.

The choice of essays was determined quite simply. A list was established, based upon several admittedly arbitrary criteria: widely recognized historical significance, classroom use and experience, the quality of thought and expression (which has helped determine the previous two), and a representative expression of the different modern attitudes toward art. Then as many of these were included as the tangled web of copyright permitted.

One essay, Le Corbusier and Ozenfant's "Purism," is here given its first English translation, and four others are revised or retranslated. Matilda Beckmann supplied corrections to "On My Painting" from her late husband's manuscript. My wife, Eugenia W. Herbert, has retranslated Kandinsky's "Reminiscences," and I have revised the 1913 translation of Gleizes and Metzinger's "Cubism"; I have more extensively retranslated Boccioni's "Technical Manifesto of Futurist Sculpture" and his preface to the 1913 exhibition of his sculpture in Paris, neither of which has been adequately served by existing translations.

These five translations have consistently maintained the flavor of the original texts (the other essays were first published in English or else in excellent translations). Coined words have been given English equivalents whenever it is certain that the author was seeking special emphasis: in "Cubism," for example, "intellective effort" for *effort intellectif*. Unusual punctuation and spacing is retained if it is an integral part of the original. In "Purism," the constant use of semicolons

to subordinate a series of statements to one dominant idea, and the
frequent wide spacing between lines to separate one series from the
next, are stylistic mannerisms which suit perfectly the essay's hard and
geometric clarity. Brackets are used to enclose all editorial words or
phrases, in both the texts and the footnotes; parentheses and ellipses
are the authors', never the editor's.

I am very grateful to several of the artists, who authorized the
reprinting of their essays: Naum Gabo, Henry Moore, Amadée
Ozenfant and Le Corbusier; to Mme. Albert Gleizes and Matilda
Beckmann for facilitating the inclusion of their late husbands' writ-
ings; to Mr. Harry Holtzman and attorney Ralph Colin, acting for the
estates of Piet Mondrian and Curt Valentin, and to Faber and Faber
Limited and Paul Theobald and Company, for their authorizations.
My wife postponed her own scholarly work to retranslate
Kandinsky's "Reminiscences," and had the fortitude to help prepare
and proofread the manuscripts.

R. L. H.

Gleizes and Metzinger

Cubism

"Cubism," the collaborative effort of the painters Albert Gleizes (1881–1953) and Jean Metzinger (1883–1956), has been read less than Apollinaire's *Cubist Painters,* due to the poet's reputation, the charm and wit of his essay, and its greater availability. Yet there can be no doubt that "Cubism" is a more certain embodiment of the ideas of one large group of Cubist painters, and a much more reasoned presentation of artistic theory.

Gleizes and Metzinger had met in 1910, when both had already adopted the new visual language whose initial impulse came from Picasso and Braque. By the spring of 1911, Gleizes and Metzinger banded together with Léger, Delaunay, and Le Fauconnier at the *Salon des Indépendants* to form a self-aware artistic movement. Although Picasso and Braque remained aloof, Cubism burgeoned over the next months, with public exhibitions, many articles, and incessant interchange of ideas in the studios of Puteaux and Courbevoie. Unlike the two initiators, whose still lifes, nudes, and interiors of studios and cafés showed no overt social concern, the Puteaux-Courbevoie group (by now including among others, the brothers Jacques Villon, Marcel Duchamp, and Raymond Duchamp-Villon) chose themes which they considered more modern, especially the city and its industrial suburbs. In October 1912, they joined in the *Section d'Or* exhibition, one of the climactic events of prewar painting. Just a few weeks earlier, the essay "Cubism" had been published.

Gleizes and Metzinger had written the essay in the span of months preceding the *Section d'Or,* the most dynamic period in the history of Cubism. In contrast to Picasso and Braque, who, by keeping to themselves, tended to let others speak for them, the Puteaux group was anxious to explain itself. From their many interviews and articles of 1911 to 1913, we are entitled to conclude that "Cubism" embodies some of the ideas of the circle as well as those of its two artist-authors.

Published by Figuière in 1912, "Cubism" was given its first and only English translation in 1913 by the firm of T. Fisher Unwin. Their successors, Ernest Benn Limited, as far as their rights are involved, have kindly authorized me to reprint it. The 1913 translation is an excellent one, but at times a bit insensitive and lacking in nuance. I have revised it accordingly, especially in order to preserve the flavor of its coined words, and its assertive, energetic mood. I am immensely grateful to the late Daniel Robbins for his comments on my revisions and for his contributions to two editions of this essay, *Du "Cubisme"* (Sisteron, 1980) and, with Fritz Metzinger, *Die Entstehung des Kubismus: eine Neubewertung* (Frankfurt, 1990).

1

Cubism

The word *Cubism* is only used here to spare the reader any doubts about the object of this study, and we hasten to state that the idea it implies, volume, could not by itself define a movement which aims at an integral realization of Painting.

However, we do not intend to provide definitions; we only wish to suggest that the joy of taking by surprise an art undefined within the limits of the painting, is worth the effort it demands, and to incite to this effort whoever is worthy of the task.

If we fail, what is the loss! To tell the truth, we are impelled by the pleasure man takes in speaking of the work to which he dedicates his daily life, and we firmly believe that we have said nothing that will fail to confirm real Painters in their personal dilection [*dilection*].

I

To evaluate the importance of Cubism, we must go back to Gustave Courbet.

This master—after David and Ingres had magnificently brought to an end a secular idealism—instead of wasting himself in servile repetitions like Delaroche and the Devérias, inaugurated a yearning for realism which is felt in all modern work. However, he remained a slave to the worst visual conventions. Unaware that in order to discover one true relationship it is necessary to sacrifice a thousand surface appearances, he accepted without the slightest intellectual control everything his retina communicated. He did not suspect that the visible world only becomes the real world by the operation of thought, and that the objects which strike us with the greatest force are not always those whose existence is richest in plastic truths.

Reality is deeper than academic recipes, and more complex also. Courbet was like one who contemplates the Ocean for the first time and who, diverted by the play of the waves, does not think of the depths; we can hardly blame him, because it is to him that we owe our present joys, so subtle and so powerful.

Edouard Manet marks a higher stage. All the same, his realism is still below Ingres' idealism, and his *Olympia* is heavy next to the *Odalisque*. We love him for having transgressed the decayed rules of composition and for having diminished the value of anecdote to the extent of painting "no matter what." In that we recognize a precursor,

we for whom the beauty of a work resides expressly in the work, and not in what is only its pretext. Despite many things, we call Manet a realist less because he represented everyday events than because he endowed with a radiant reality many potential qualities enclosed in the most ordinary objects.

After him there was a cleavage. The yearning for realism was split into superficial realism and profound realism. The former belongs to the Impressionists: Monet, Sisley, etc.; the latter to Cézanne.

The art of the Impressionists involves an absurdity: by diversity of color it tries to create life, yet its drawing is feeble and worthless. A dress shimmers, marvelous; forms disappear, atrophied. Here, even more than with Courbet, the retina predominates over the brain; they were aware of this and, to justify themselves, gave credit to the incompatibility of the intellectual faculties and artistic feeling.

However, no energy can thwart the general impulse from which it stems. We will stop short of considering Impressionism a false start. Imitation is the only error possible in art; it attacks the law of time, which is Law. Merely by the freedom with which they let the technique appear, or showed the constituent elements of a hue, Monet and his disciples helped widen the horizon. They never tried to make Painting decorative, symbolic, moral, etc. If they were not great painters, they were painters, and that is enough for us to venerate them.

People have tried to make Cézanne into a sort of genius *manqué:* they say that he knew admirable things but that he stuttered instead of singing out. The truth is that he was in bad company. Cézanne is one of the greatest of those who orient history, and it is inappropriate to compare him to Van Gogh or Gauguin. He recalls Rembrandt. Like the author of the *Pilgrims of Emmaus,* disregarding idle chatter, he plumbed reality with a stubborn eye and, if he did not himself reach those regions where profound realism merges insensibly into luminous spirituality, at least he dedicated himself to whoever really wants to attain a simple, yet prodigious method.

He teaches us how to dominate universal dynamism. He reveals to us the modifications that supposedly inanimate objects impose on one another. From him we learn that to change a body's coloration is to corrupt its structure. He prophesies that the study of primordial volumes will open up unheard-of horizons. His work, a homogeneous block, stirs under our glance; it contracts, withdraws, melts, or illuminates itself, and proves beyond all doubt that painting is not—or is no longer—the art of imitating an object by means of lines and colors, but the art of giving to our instinct a plastic consciousness.

He who understands Cézanne, is close to Cubism. From now on we are justified in saying that between this school and the previous manifestations there is only a difference of intensity, and that in order to assure ourselves of the fact we need only attentively regard the process of this realism which, departing from Courbet's superficial realism,

plunges with Cézanne into profound reality, growing luminous as it forces the unknowable to retreat.

Some maintain that such a tendency distorts the traditional curve. From where do they borrow their arguments, the future or the past? The future does not belong to them as far as we know, and one must be singularly naïve to seek to measure that which exists by that which exists no longer.

Under penalty of condemning all modern art, we must regard Cubism as legitimate, for it carries art forward and consequently is today the only possible conception of pictorial art. In other words, at present, Cubism is painting itself.

At this point we should like to destroy a widespread misapprehension to which we have already made allusion. Many consider that decorative preoccupations must govern the spirit of the new painters. Undoubtedly they are ignorant of the most obvious signs which make decorative work the antithesis of the picture. The decorative work of art exists only by virtue of its *destination;* it is animated only by the relations established between it and the given objects. Essentially dependent, necessarily incomplete, it must in the first place satisfy the mind so as not to distract it from the display which justifies and completes it. It is an organ.

A painting carries within itself its *raison d'être*. You may take it with impunity from a church to a drawing-room, from a museum to a study. Essentially independent, necessarily complete, it need not immediately satisfy the mind: on the contrary, it should lead it, little by little, toward the imaginative depths where burns the light of organization. It does not harmonize with this or that ensemble, it harmonizes with the totality of things, with the universe: it is an organism.

Not that we wish to belittle decoration in order to benefit painting; it is enough for us to prove that if wisdom is the science of putting everything in its place, then the majority of artists are far from possessing it. Enough decorative plastic art and pictorial decoration, enough confusion and ambiguity!

Let us not argue about the original goal of our art. Formerly the fresco incited the artist to present distinct objects which evoked a simple rhythm, and on which the light bloomed, serving a synchronic vision rendered necessary by the amplitude of the surfaces; today oil painting allows us to express supposedly inexpressible notions of depth, density, and duration, and encourages us to present, according to a complex rhythm, a veritable fusion of objects within a restricted space. As all preoccupation in art arises from the material employed, we ought to regard a preoccupation for decoration, if we find it in a painter, as an anachronistic artifice, useful only to conceal impotence.

Does the difficulty which even a sensible and cultivated public experiences in understanding art result from present conditions? It must be admitted, but it should lead to enjoyment. A man will enjoy

today what exasperated him yesterday. The transformation is extremely slow, and the slowness is easily explained: how could comprehension evolve as rapidly as the creative faculties? It follows in their wake.

II

Dissociating, for convenience, things that we know to be indissolubly united, let us study, by means of form and color, the integration of the plastic consciousness.

To discern a form implies, besides the visual function and the faculty of moving oneself, a certain development of the mind; to the eyes of most people the external world is amorphous.

To discern a form is to verify it by a pre-existing idea, an act that no one, save the man we call an artist, can accomplish without external assistance.

Before a natural spectacle, the child, in order to coordinate his sensations and to subject them to mental control, compares them with his picture-book; culture intervening, the adult refers himself to works of art.

The artist, having discerned a form which presents a certain intensity of analogy with his pre-existing idea, prefers it to other forms, and consequently—for we like to force our preferences on others—he endeavors to enclose the quality of this form (the unmeasurable sum of the affinities perceived between the visible manifestation and the tendency of his mind) in a symbol likely to affect others. When he succeeds he forces the crowd, confronted by his integrated plastic consciousness, to adopt the same relationship he established with nature. But while the painter, eager to create, rejects the natural image as soon as he has made use of it, the crowd long remains the slave of the painted image, and persists in seeing the world only through the adopted sign. That is why any new form seems monstrous, and why the most slavish imitations are admired.

Let the artist deepen his mission more than he broadens it. Let the forms which he discerns and the symbols in which he incorporates their qualities be sufficiently remote from the imagination of the crowd to prevent the truth which they convey from assuming a general character. Trouble results when the work is a kind of unit of measurement indefinitely applicable to several categories, both natural and artistic. We concede nothing to the past: why, then, should we favor the future by facilitating the task of the vulgarizer? Too much lucidity miscarries: let us beware of masterpieces. Propriety demands a certain degree of dimness, and propriety is one of the attributes of art.

Above all, let no one be decoyed by the appearance of objectivity with which many imprudent artists endow their pictures. There are no

direct means of evaluating the processes thanks to which the relations
between the world and the thought of a man are rendered perceptible
to us. The fact commonly invoked, that we find in a painting the
familiar characteristics of the sight which motivated it, proves noth-
ing at all. Let us imagine a landscape. The width of the river, the thick-
ness of the foliage, the height of the banks, the dimensions of each
object and the relations of these dimensions—these are secure guar-
antees. Well, if we find these intact upon the canvas, we shall have
learned nothing as to the talent or the genius of the painter. The worth
of river, foliage, and banks, despite a conscientious faithfulness to
scale, is no longer measured by width, thickness, and height, nor the
relations between these dimensions. Torn from natural space, they
have entered a different kind of space, which does not assimilate the
proportion observed. This remains an external matter. It has just as
much importance as a catalogue number, or a title at the bottom of a
picture-frame. To contest this is to deny the space of painters; it is to
deny painting.

The painter has the power of rendering enormous that which we
regard as minuscule, and as infinitesimal that which we know to be
considerable: he changes quantity into quality.

Only when decades and centuries have come to our aid, when thou-
sands of minds have corroborated one another, only when innumer-
able plagiarists have enfeebled the noble enigma that a picture is by
commenting upon it, then, perhaps, we shall be able to speak, with-
out ridicule, of objective criticism.

To whom shall we impute the misapprehension? To the painters
who disregard their rights. When from any spectacle they have sep-
arated the features which summarize it, they believe themselves con-
strained to observe an accuracy which is truly superfluous. Let us
remind them that we visit an exhibition to contemplate painting and
to enjoy it, not to enlarge our knowledge of geography, anatomy,
etc.

Let the picture imitate nothing and let it present nakedly its *raison
d'être!* Then we should indeed be ungrateful were we to deplore the
absence of all those things—flowers, or landscape, or faces—whose
mere reflection it might have been. Nevertheless, let us admit that the
reminiscence of natural forms cannot be absolutely banished; as yet,
at all events. An art cannot be raised all at once to the level of a pure
effusion.

This is understood by the Cubist painters, who tirelessly study pic-
torial form and the space which it engenders.

This space we have negligently confused with pure visual space or
with Euclidean space.

Euclid, in one of his postulates, speaks of the indeformability of fig-
ures in movement, so we need not insist upon this point.

If we wished to tie the painter's space to a particular geometry, we

should have to refer it to the non-Euclidean scientists; we should have to study, at some length, certain of Riemann's theorems.

As for visual space, we know that it results from the harmony of the sensations of convergence and accommodation of the eye.

For the picture, a flat surface, the accommodation is negative. Therefore the convergence which perspective teaches us to simulate cannot evoke the idea of depth. Moreover, we know that the most serious infractions of the rules of perspective will by no means compromise the spatiality of a painting. Do not the Chinese painters evoke space, despite their strong partiality for *divergence?*

To establish pictorial space, we must have recourse to tactile and motor sensations, indeed to all our faculties. It is our whole personality which, contracting or expanding, transforms the plane of the picture. As it reacts, this plane reflects the personality back upon the understanding of the spectator, and thus pictorial space is defined: a sensitive passage between two subjective spaces.

The forms which are situated within this space spring from a dynamism which we profess to dominate. In order that our intelligence may possess it, let us first exercise our sensitivity. There are only *nuances.* Form appears endowed with properties identical to those of color. It is tempered or augmented by contact with another form, it is destroyed or it flowers, it is multiplied or it disappears. An ellipse may change its circumference because it is inscribed in a polygon. A form more emphatic than those which surround it may govern the whole picture, may imprint its own effigy upon everything. Those picture-makers who minutely imitate one or two leaves in order that all the leaves of a tree may seem to be painted, show in a clumsy fashion that they suspect this truth. An illusion, perhaps, but we must take it into account. The eye quickly interests the mind in its errors. These analogies and contrasts are capable of all good and all evil; the masters felt this when they strove to compose with pyramids, crosses, circles, semicircles, etc.

To compose, to construct, to design, reduces itself to this: to determine by our own activity the dynamism of form.

Some, and they are not the least intelligent, see the aim of our technique in the exclusive study of volumes. If they were to add that because surfaces are the limits of volumes, and lines those of surfaces, it suffices to imitate a contour in order to represent a volume, we might agree with them; but they are thinking only of the *sensation of relief,* which we consider insufficient. We are neither geometers nor sculptors; for us, lines, surfaces, and volumes are only nuances of the notion of fullness. To imitate only volumes would be to deny these nuances for the benefit of a monotonous intensity. We might as well renounce at once our vow of variety.

Between sculpturally bold reliefs, let us throw slender shafts which do not define, but which suggest. Certain forms must remain implicit,

so that the mind of the spectator is the chosen place of their concrete birth.

Let us also contrive to cut by large restful surfaces any area where activity is exaggerated by excessive contiguities.

In short, the science of design consists in instituting relations between straight lines and curves. A picture which contained only straight lines or curves would not express existence.

It would be the same with a painting in which curves and straight lines exactly compensated one another, for exact equivalence is equal to zero.

The diversity of the relations of line to line must be indefinite; on this condition it incorporates quality, the unmeasurable sum of the affinities perceived between that which we discern and that which already existed within us; on this condition a work of art moves us.

What the curve is to the straight line, the cold tone is to the warm in the domain of color.

III

After the Impressionists had burned up the last Romantic bitumens, some believed in a renaissance, or at least the advent of a new art: the art of color. Some were delirious. They would have given the Louvre and all the museums of the world for a scrap of cardboard spotted with hazy pink and apple-green. We are not jesting. To these excesses we owe the experience of a bold and necessary experiment.

Seurat and Signac thought of schematizing the palette and, boldly breaking with an age-long habit of the eye, established optical mixture.

Noble works of art, by Seurat as well as by Signac, Cross, and certain others, testify to the fertility of the Neo-Impressionist method; but it appears contestable as soon as we cease to regard it on the plane of superficial realism.

Endeavoring to assimilate the colors of the palette with those of the prism, it is based on the exclusive use of pure elements. Now the colors of the prism are homogeneous, while those of the palette, being heterogeneous, can furnish pure elements only insofar as we accept the idea of a *relative purity*.

Suppose this were possible. A thousand little touches of pure color break down white light, and the resultant synthesis should take place in the eye of the spectator. They are so disposed that they are not reciprocally annihilated by the optical fusion of the complementaries; for, outside the prism, whether we form an optical mixture or a mixture on the palette, the result of the sum of complementaries is a troubled grey, not a luminous white. This contradiction stops us. On the one hand, we use a special procedure to reconstitute light; on the

other hand, it is implicitly admitted that this reconstitution is impossible.

The Neo-Impressionists will not claim that it is not light they have divided, but color; they know too well that color in art is a quality of light, and that one cannot divide a quality. It is still light that they divide. For their theory to be perfect, they ought to be able to produce the sensation of white with the seven fundamentals. Then, when they juxtapose a red and a blue, the violet obtained should be equivalent to the red plus the blue. It is nothing of the sort. Whether the mixture is effected on the palette or on the retina, the result always is less luminous and less intense than the components. However, let us not hasten to condemn the optical mixture; it causes a certain stimulation of the visual sense, and we cannot deny that herein lies a possible advantage. But in this latter case it is sufficient to juxtapose elements of the same hue, yet of unequal intensity, to give that color a highly seductive animation; it is sufficient to *graduate* them. On this point the Neo-Impressionists can readily convince us.

The most disturbing point of their theory is an obvious tendency to eliminate those elements called *neutral* which, on canvas or elsewhere, form the indefinite, and whose presence is betrayed by Fraunhofer rays even in the spectrum itself. Have we the right thus to suppress the innumerable combinations which separate a cadmium yellow from a cobalt violet? Is it permissible thus to reduce the limits imposed by the color-makers? Neither Seurat, Signac, nor Cross, fundamentally painters, went so far as this; but others, desirous of absolute equivalence, the negation of living beauty, renounced all mixtures, misunderstood the gradation of colors, and confided the task of lighting their paintings to the pre-selected chromatics [*précellences chromatiques*] exactly determined by industry.

The law of contrast, old as the human eye and on which Seurat judiciously insisted, was promulgated with much clamor. Among those who flattered themselves most on being sensitive to it, none was sufficiently so to perceive that to apply the law of complementaries without tact is to deny it, since it is only of value by the fact of automatic application, and only demands a delicate handling of values.

It was then that the Cubists taught a new way of imagining light.

According to them, to illuminate is to reveal; to color is to specify the mode of revelation. They call luminous that which strikes the mind, and dark that which the mind has to penetrate.

We do not automatically associate the sensation of white with the idea of light, any more than black with the idea of darkness. We admit that a black jewel, even if of a matte black, may be more luminous than the white or pink satin of its case. Loving light, we refuse to measure it, and we avoid the geometric ideas of focus and ray, which imply the repetition—contrary to the principle of variety which guides us—of light planes and dark intervals in a given direction. Loving

color, we refuse to limit it, and sober or dazzling, fresh or muddy, we accept all the possibilities contained between the two extreme points of the spectrum, between the cold and the warm tone. Here are a thousand tints which escape from the prism, and hasten to range themselves in the lucid region forbidden to those who are blinded by the immediate.

IV

If we consider only the bare fact of painting, we attain a common ground of understanding.

Who will deny that this fact consists in dividing the surface of the canvas and investing each part with a quality which must not be excluded by the nature of the whole?

Taste immediately dictates a rule: we must paint so that no two portions of the same extent ever meet in the picture. Common sense approves and explains: let one portion repeat another, and the whole becomes measurable. The art which ceases to be a fixation of our personality (unmeasurable, in which nothing is ever repeated), fails to do what we expect of it.

The inequality of parts being granted as a prime condition, there are two methods of regarding the division of the canvas. According to the first, all the parts are connected by a rhythmic artifice which is determined by one of them. This one—its position on the canvas matters little—gives the painting a center from which or toward which the gradations of color tend, according as the maximum or minimum of intensity resides there.

According to the second, in order that the spectator ready to establish unity himself may apprehend all the elements in the order assigned to them by creative intuition, the properties of each portion must be left independent, and the plastic continuity must be broken into a thousand surprises of light and shade.

Hence we have two methods apparently inimical.

However little we know of the history of art, we can readily find names which illustrate each. The interesting point is to reconcile them.

The Cubist painters endeavor to do so, and whether they partially interrupt the ties demanded by the first method or confine one of those forces which the second insists should be freely allowed to flash out, they achieve that superior disequilibrium without which we cannot conceive lyricism.

Both methods are based on the kinship of color and form.

Although of a hundred thousand living painters only four or five appear to perceive it, a law here asserts itself which is to be neither discussed nor interpreted, but rigorously followed:

Every inflection of form is accompanied by a modification of color, and every modification of color gives birth to a form.

There are tints which refuse to wed certain lines; there are surfaces which cannot support certain colors, repelling them to a distance or sinking under them as under too heavy a weight.

To simple forms the fundamental hues of the spectrum are allied, and fragmentary forms should assume sparkling colors.

Nothing surprises us so greatly as to hear every day someone praise the color of a picture and find fault with the drawing. The Impressionists provide no excuse for such absurdity. Although in their case we may have deplored the poverty of form and at the same time praised the beauties of their coloring, it was because we focused upon their role as precursors.

In any other case we flatly refuse to perpetrate a division contrary to the vital forces of the painter's art.

The impossibility of imagining form and color separately confers upon those that feel it the privilege of envisaging conventional reality in a useful manner.

There is nothing real outside ourselves, there is nothing real except the coincidence of a sensation and an individual mental direction. Far from us any thought of doubting the existence of the objects which strike our senses; but, being reasonable, we can only have certitude with regard to the images which they make blossom in our mind.

It therefore amazes us that well-meaning critics explain the remarkable difference between the forms attributed to nature and those of modern painting, by a desire to represent things not as they appear, but as they are. And how are they? According to them, the object possesses an absolute form, an essential form, and, in order to uncover it, we should suppress chiaroscuro and traditional perspective. What naïveté! An object has not one absolute form, it has several; it has as many as there are planes in the domain of meaning. The one which these writers point to is miraculously adapted to geometric form. Geometry is a science, painting is an art. The geometer measures, the painter savors. The absolute of the one is necessarily the relative of the other; if logic is alarmed at this, so much the worse! Will it ever prevent a wine from being different in the retort of the chemist and in the glass of the drinker?

We are frankly amused to think that many a novice may perhaps pay for his too literal comprehension of Cubist theory, and his faith in absolute truth, by arduously juxtaposing the six faces of a cube or the two ears of a model seen in profile.

Does it ensue from this that we should follow the example of the Impressionists and rely upon the senses alone? By no means. We seek the essential, but we seek it in our personality, and not in a sort of eternity, laboriously fitted out by mathematicians and philosophers.

Moreover, as we have said, the only difference between the Impressionists and ourselves is a difference of intensity, and we do not wish it to be otherwise.

As many images of the object as eyes to contemplate it, as many images of essence as minds to understand it.

But we cannot enjoy ourselves in isolation; we wish to dazzle others with that which we daily snatch from the sensate world, and in return we wish others to show us their trophies. From a reciprocity of concessions there will arise those mixed images, which we hasten to confront with artistic creations in order to calculate what they contain of the objective, that is, of the purely conventional.

If the artist has conceded nothing to common standards, his work will inevitably be unintelligible to those who cannot, with a single beat of their wings, lift themselves to unknown planes. If, on the contrary, by feebleness or lack of intellectual control, the painter remains enslaved to the forms in common use, his work will delight the crowd—his work? the crowd's work—and will sadden the individual.

Among so-called academic painters some may be gifted; but how could we know it? Their painting is so truthful that it founders in truth, in that negative truth, the mother of morals and everything insipid which, true for the many, is false for the individual.

Does this mean that a work of art must necessarily be unintelligible to the majority? No, it is only a consequence, merely temporary, and by no means a necessity.

We should be the first to blame those who, to hide their weaknesses, should attempt to fabricate puzzles. Systematic obscurity is betrayed by its persistence. Instead of a veil which the intellect gradually pushes aside as it adventures toward progressive richnesses, it is merely a curtain hiding a void.

Moreover, let us note that because all plastic qualities guarantee a built-in emotion, and because every emotion certifies a concrete existence, it is enough for a picture to be well painted to assure us of its author's veracity, and that our intellective [intellectif] effort will be rewarded.

That people unfamiliar with painting should not spontaneously share our assurance is hardly surprising; that they become irritated is certainly senseless. Must the painter, to please them, take his painting by the wrong end and restore to things the commonplace appearance which it is his mission to strip away?

From the fact that the object is truly transubstantiated, so that the most practiced eye has some difficulty in discovering it, a great charm results. The picture which only surrenders itself slowly seems always to wait until we interrogate it, as though it reserved an infinity of replies to an infinity of questions. On this point let Leonardo da Vinci defend Cubism:

"We know well," says Leonardo, "that our sight, by rapid observations, discovers from one vantage point an infinity of forms; nevertheless it only understands one thing at a time. Suppose that you, reader, were to see the whole of this page at a glance, and concluded

instantly that it is full of various letters; you would not at the same moment know what letters they are, nor what they would mean. You would have to go from one word to another and from line to line if you would wish to know these letters, just as you would have to climb step by step to reach the top of a building, or else never reach the top."

Not to discern at first contact the individuality of the objects which motivate a painting has its great charm, true, but it is also dangerous. We reject not only synchronistic and primary images, but also fanciful occultism, an easy way out; if we condemn the exclusive use of common signs it is not at all because we think of replacing them by cabalistic ones. We will even willingly confess that it is impossible to write without using clichés, and to paint while disregarding familiar signs completely. It is up to each one to decide whether he should disseminate them throughout his work, mix them intimately with personal signs, or boldly plaster them, magical dissonances, tatters of the great collective lie, on a single point of the plane of higher reality which he sets aside for his art. A true painter takes into account all the elements which experience reveals to him, even if they are neutral or vulgar. A simple question of tact.

But objective or conventional reality, this world intermediate between another's consciousness and our own, never ceases to fluctuate according to the will of race, religion, scientific theory, etc., although humanity has labored from time immemorial to hold it fast. Into the occasional gaps in the cycle, we can insert our personal discoveries and contribute surprising exceptions to the norm.

We do not doubt that those who measure with the handle of their paintbrush soon discover that roundness does more to represent a round object than do dimensions, which are always relative. We are certain that even the least wise will quickly recognize that the claim of configurating [de configurer] the weight of bodies and the time spent in enumerating their different points of view, is as legitimate as that of imitating daylight by the clash of orange and blue. Then the fact of moving around an object to seize from it several successive appearances, which, fused into a single image, reconstitute it in time, will no longer make reasoning people indignant.

And those who mistake the bustle of the street for plastic dynamism will eventually appreciate the differences. People will finally realize that there never was a Cubist technique, but simply a pictorial technique which a few painters exhibited with courage and diversity. In actual fact, they are reproached with displaying it to excess, and are urged to conceal their craft. How absurd! As though one were to tell a man to run, but not to stir his legs!

Moreover, all painters exhibit their craft, even those whose industrious delicacies upset the barbarians across the ocean. But one thing

is true of the painter's methods, as well as of the writer's: by passing from hand to hand they grow colorless, insipid, and abstract.

The Cubist methods are far from being this, although they do not still shine with the hard brilliancy of new coin, and although an attentive study of Michelangelo permits us to say that they have their patent of nobility.

<p style="text-align:center">V</p>

To carry out a work of art it is not enough to know the relations of color and form and to apply the laws that govern them; the artist must also contrive to free himself from the servitude inherent in such a task. Any painter of healthy sensitivity and sufficient intelligence can provide us with well-painted pictures; but only he can awaken beauty who is designated by Taste. We call thus the faculty thanks to which we become conscious of Quality, and we reject the notions of good taste and bad taste which correspond with nothing positive: a faculty is neither good nor bad, it is simply more or less developed.

We attribute a rudimentary taste to the savage who is delighted by glass beads, but we might with infinitely greater justice consider as a savage the so-called civilized man who, for example, can appreciate nothing but Italian painting or Louis XV furniture. Taste is valued according to the number of qualities it allows us to perceive; yet when this number exceeds a certain figure it diminishes in intensity and evaporates into eclecticism. Taste is innate; but like sensitivity, which enhances it, it is tributary to the will. Many deny this. What is more obvious, however, than the influence of the will on our senses? It is so apparent that as soon as we should wish it, we could isolate the high-pitched note of an oboe among the metallic thunders of an orchestra. Similarly we can succeed in savoring a certain quality whose existence is affirmed by reason alone.

Is the influence of the will upon taste intrinsically good or is it evil? The will can only develop taste along a plane parallel to that of the consciousness.

If a painter of mediocre intellect strives to savor qualities which for him are only the abstract products of a line of reasoning, and if he thus tries to augment his little talent, which he owes only to his sensitivity, then there is no doubt that his painting will become execrable, false, and stilted. If a man of superior mind sets himself the same goal, he will draw miraculous advantages from it.

The will exerted on taste with a view to a qualitative possession of the world derives its merit from the subjugation of every conquest to the nature of the chosen material.

Without using any allegorical or symbolic literary artifice, but with only inflections of lines and colors, a painter can show in the same

picture both a Chinese and a French city, together with the mountains, oceans, flora and fauna, peoples with their histories and their desires, everything which in exterior reality separates them. Distance or time, concrete thing or pure conception, nothing refuses to be said in the painter's tongue, any more than in that of the poet, the musician, or the scientist.

The more the notions that the painter subordinates to his art appear remote from it, the more its beauty is affirmed. Its difficulties grow proportionately. A mediocre artist shows some wisdom by contenting himself with acting upon notions long ago appropriated to painting. Is not a simple Impressionist notation preferable to these compositions brimful of literature, metaphysics, and geometry, all insufficiently *pictorialized* [*picturalisées*]? We want plastic integration: either it is perfect or it is not; we want style, and not a parody of style.

The action of the will on taste aids selection. By the way a neophyte supports the discipline we can verify his vocation.

Among the Cubist painters there are some who painfully pretend to be self-willed and profound; there are others who move freely in the highest planes. Among the latter—it is not our place to name them—restraint is only the clothing of fervor, as with the great Mystics.

Since it has been said that great painting died with the Primitives—why not great literature with Homer?—some, in order to resuscitate it, impudently plagiarize the old Italian, German, and French masters and, undoubtedly in order to modernize it, have chosen to bolster their industry by means which the ill-informed are tempted to attribute to Cubism. Because the language of these tricksters, a kind of Esperanto or Volapük, is understood by everyone, it was soon claimed that they speak, or at least that they are about to speak, that language of great art accessible to all. Let us have done with an irksome misunderstanding.

That the ultimate end of painting is to reach the masses, we have agreed; it is, however, not in the language of the masses that painting should address the masses, but in its own, in order to move, to dominate, to direct, and not in order to be understood. It is the same with religions and philosophies. The artist who abstains from any concessions, who does not explain himself and who tells nothing, builds up an internal strength whose radiance shines all around.

It is in consummating ourselves within ourselves that we shall purify humanity, it is by increasing our own riches that we shall enrich others, it is by setting fire to the heart of the star for our intimate joy that we shall exalt the universe.

To sum up, Cubism, which has been accused of being a system, condemns all systems.

The technical simplifications which have provoked such accusations denote a legitimate anxiety to eliminate everything that does not exactly correspond to the conditions of the plastic material, a noble

ed to vow

vow of purity. Let us grant that it is a method, but let us not permit the confusion of method with system.

For the partial liberties conquered by Courbet, Manet, Cézanne, and the Impressionists, Cubism substitutes an indefinite liberty.

Henceforth—objective knowledge at last regarded as chimerical, and all that the crowd understands by natural form proven to be convention—the painter will know no other laws than those of Taste.

From then on, by the study of all the manifestations of physical and mental life, he will learn to apply them. But if all the same he ventures into metaphysics, cosmogony, or mathematics, let him be content with obtaining their savor, and abstain from demanding of them certitudes which they do not possess. In their depths one finds nothing but love and desire.

A realist, he will fashion the real in the image of his mind, for there is only one truth, ours, when we impose it on everyone. And it is the faith in Beauty which provides the necessary strength.

Kandinsky

Reminiscences

Wassily Kandinsky (1866–1944) wrote extensively, and two of his essays have been as influential as his paintings: "Concerning the Spiritual in Art" (1912), and "Point and Line to Plane" (1926). "Reminiscences" (1913) is less well known but more revealing of his own life and art. Kandinsky, raised in Moscow, gave up a budding legal career in 1896 to become a painter. He left Russia for Munich that year, and by 1901 had already formed the Phalanx, one of several artists' associations he sponsored. After traveling widely from 1903 to 1908 in North Africa and Western Europe, he returned to Munich and settled in the nearby village of Murnau, where he remained until 1914. He returned to Russia at the outbreak of World War I and after the October Revolution was very active as teacher, lecturer, and administrator in the arts until his departure for Berlin at the end of 1921. A leading figure at the Bauhaus from 1922 until Hitler's rise, Kandinsky emigrated to Neuilly, near Paris, where he spent the remainder of his life.

"Reminiscences" appeared in 1913, in the midst of the Munich period of activity marked by the apocalyptic painting whose excitement Abstract Expressionism has taught us to relive, marked also by Kandinsky's role as the chief propagandist for German Expressionism, organizer of exhibitions, editor, essayist, and poet. Since 1911 he had been the chief figure in the famous *Blaue Reiter,* whose first exhibition had been held in the winter of 1911–1912. He and Franz Marc edited the *Blaue Reiter* almanac, and in 1912 also he published his most famous essay, "Concerning the Spiritual in Art."

"Reminiscences" has a remarkable calm, perhaps derived from the artist's satisfaction that at long last, now 47 years old, he had brought years of experience to fruition and was being recognized. The calm must also result from a markedly introspective mood. Although he was a native Russian, Kandinsky had lived in Munich for many years, and seems in this essay to be questioning his Russian origins; that is, by going back to his youth, he was seeking the "Russian" component of his art. The reader must anticipate some puzzling phrases, and anecdotes or metaphors difficult to fathom. Kandinsky chose to write in an evocative manner bordering upon a stream of consciousness, in which fragments from his youth well up without prior explanation.

"Reminiscences" *(Rückblicke)* was published in Berlin, in 1913, by Herwarth Walden, the energetic figure behind *Der Sturm,* whose publications and exhibitions were of great significance for the second and third decades of this century. It was the major text in an album entitled *Kandinsky 1901–1913;* the other writings were short notes on specific paintings. The entire album was translated by Hilla Rebay at the time of the Guggenheim Museum's memorial exhibition in 1945, and included in the folio publication *Kandinsky. Rückblicke,* there called "Retrospects," was given a quite

faithful, but somewhat awkward translation that has required a thorough reworking. I have preferred the *Der Sturm* edition to the amended revision Kandinsky published in Russian in 1918, because of its significance to the prewar years, and because it is the only version that has been influential in the history of modern art. Another translation of the 1913 German text is provided by Kenneth Lindsay and Peter Vergo in *Kandinsky, Complete Writings on Art* (Boston, 2 vols., 1992), I, pp. 355–82.

Reminiscences

The first colors that made a strong impression on me were bright, juicy green, white, carmine red, black, and yellow ochre. These memories go back to the third year of my life. I saw these colors on various objects which are no longer as clear in my mind as the colors themselves.

Like all children, I was passionately fond of "riding." For this purpose our coachman used to cut spiral stripes on thin branches, peeling both layers of bark off the first stripe and only the top layer from the second, so that my horse usually consisted of three colors: the brownish yellow of the outer bark (which I did not like and would gladly have seen replaced by another), the juicy green of the underlayer of the bark (which I especially liked and which in withered condition still had something enchanting about it) and finally the color of the ivory white wood of the stick (that smelled damp and tempted one to lick it, but soon became sadly shrivelled and dry, which spoiled my pleasure in this white from the very beginning).

It seems to me that shortly before my parents left for Italy (whither I, as a three-year-old, and my nurse were taken) my grandparents moved into a new house. I have the impression that this house was still entirely empty, that neither furniture nor people were in it. In a room that was not large, there was only a clock on the wall. I stood all alone in front of it and enjoyed the white of the dial and the carmine red of the rose painted on it.

My Muscovite nurse was very much surprised that my parents would make so long a trip to admire "ruined buildings and old stones": "We have enough of these in Moscow." Of all these "stones" in Rome I remember only an impenetrable forest of heavy columns, the frightful forest of St. Peter's from which, it seems to me, my nurse and I could find no way out for a long, long time.

And then all of Italy colors into two black impressions. I am travelling with my mother in a black coach over a bridge (water below—dirty yellow, I believe): I was taken to a kindergarten in Florence. And again black—down steps into the black water, upon it a terrible long black boat with a black box in the center: we board a gondola in the night. Here also I develop a talent which made me famous "all over Italy" and sob with all my might.

There was a piebald horse (with yellow ochre body and bright

19

yellow mane) in a game of horse race which my aunt[1] and I especial-
ly liked. We always followed a strict order: I was allowed one turn to
have this horse under my jockeys, then my aunt one. To this day I
have not lost my love for these horses. It is a joy for me to see one such
horse in the streets of Munich: he comes into sight every summer
when the streets are sprinkled. He awakens the sun living in me. He
is immortal, for in the fifteen years that I have known him he has not
aged. It was one of my first impressions when I moved to Munich that
long ago—and the strongest. I stood still and followed him for a long
time with my eyes. And a half-conscious but joyous promise stirred in
my heart. It aroused the little horse of lead within me and joined
Munich to the years of my childhood. This piebald horse suddenly
made me feel at home in Munich. As a child I spoke a great deal of
German (my maternal grandmother came from the Baltic). The
German fairy tales which I had so often heard as a child came to life.
The high, narrow roofs of the Promenaden Platz and the Maximilian
Platz, which have now disappeared, old Schwabing, and particularly
Au [a suburban district of Munich] which I once discovered by
chance, transformed these fairy tales into reality. The blue tramway
passed through the streets like the embodiment of a fairy breeze that
makes breathing light and joyful. The yellow mailboxes sang like
canary birds on the corners. I welcomed the inscription "Kunst-
mühle" [art mill] and felt that I was in a city of art, which was the
same to me as a city of fairies. From these impressions came the
medieval pictures which I later painted. Following good advice I vis-
ited Rothenburg ob der Tauber. I will never forget the constant chang-
ing, from the express train to the local, from the local to the trolley
with its grass-covered rails, the shrill whistle of the long-necked loco-
motive, the clatter and whining of the sleepy rails, with an old peas-
ant with large silver buttons who insisted on talking about Paris with
me and whom I could scarcely understand. It was an unreal trip. I felt
as if a magic power, against all the laws of nature, had set me back
century after century, ever deeper into the past. I leave the tiny
(improbable) station and go over a meadow into the city gate. Gates,
ditches, narrow houses that reach their heads across to each other
over the narrow lanes and look each other deep in the eye, the giant
door of the inn, which leads directly into the dark, massive dining
room, from the center of which heavy, broad, dark oak stairs lead to
the rooms; the tiny room, and the sea of bright red roofs which I see
from the window. It rained the whole time. Large, round rain drops
landed on my palette, teasingly stretched out their hands to each other
from afar, shivered and shook, suddenly and unexpectedly united,

1. Elisabeth Ticheeff, who had a great and ineradicable influence on my entire
development. She was my mother's oldest sister and played a very important part in her
education. Many others, too, who came in contact with her will never forget her lumi-
nous spirit.

forming thin, clever cords, running quickly and playfully among the colors to slide into my sleeves here and there. I do not know where these studies have gone, they have disappeared. Only one picture remained from this trip. It is "The Old City" which I painted from memory after my return to Munich. It is sunny and I made the roofs just as red as I then knew how.

Even in this painting I was really chasing after a particular hour which was and always will be the nicest hour of the Moscow day. The sun is already low and has reached its greatest power, for which it was searching the entire day, toward which it struggled the entire day. This image does not last long: a few minutes more and the sunlight will become red from exertion, ever redder, first cold, then warmer and warmer. The sun melts all Moscow into one spot which, like a mad tuba, sets one's whole inside, one's whole soul vibrating. No, this red unity is not the loveliest hour! It is only the final note of the symphony which brings every color to its greatest intensity, which lets, indeed forces, all Moscow to resound like the *fff* of a giant orchestra. Pink, lavender, yellow, white, blue, pistachio green, flame-red houses, churches—each an independent song—the raving green grass, the deep murmuring trees, or the snow, singing with a thousand voices, or the allegretto of the bare branches, the red, stiff, silent ring of the Kremlin walls, and above, towering over all like a cry of triumph, like a Hallelujah forgetful of itself, the long white, delicately earnest line of the Ivan Veliky Bell Tower. And upon its neck, stretched high and taut in eternal longing to the heavens, the golden head of the cupola, which is the Moscow sun amid the golden and colored stars of the other cupolas.

To paint this hour, I thought, would be the most impossible and the greatest joy of an artist.

These impressions repeated themselves every sunny day. They were a pleasure which shook me to the bottom of my soul, which raised me to ecstasy. And at the same time they were a torture because I felt that art in general and my powers in particular were far too weak in the face of nature. Many years were to pass before I came to the simple solution, through feeling and thinking, that the aims (and thus the means) of nature and art are essentially, organically, and by universal law different from each other—and equally great and equally strong. This solution, which today guides my work, which is so simple and utterly natural, does away with the unnecessary torture of the vain task that I had inwardly set myself in spite of its unattainability; it banished this torture, and as a result my joy in nature and art rose to untroubled heights. Since that time I have been able to enjoy both these world elements to the full. To this enjoyment is joined a tremendous feeling of thankfulness.

This solution liberated me and opened up new worlds. Everything "dead" trembled. Not only the stars, moon, woods, flowers of which

the poets sing, but also a cigarette butt lying in the ashtray, a patient white trouser button looking up from a puddle in the street, a submissive bit of bark that an ant drags through the high grass in its strong jaws to uncertain but important destinations, a page of a calendar toward which the conscious hand reaches to tear it forcibly from the warm companionship of the remaining block of pages—everything shows me its face, its innermost being, its secret soul, which is more often silent than heard. Thus every still and every moving point (= line) became equally alive and revealed its soul to me. It was sufficient for me to "grasp" with my whole being, with all my senses, the possibility and the existence of that art which today is called "abstract" in contrast to "objective."

But at that time, in my student days when I could only give my leisure hours to painting, I sought in spite of its apparent impossibility to capture on the canvas a "color chorus" (as I called it) which, bursting out of nature, forced itself into my very soul. I made desperate efforts to express the *full power* of this clamor—but in vain.

At the same time my soul was constantly kept in turmoil by other, purely human upheavals, so that I did not know a peaceful hour. It was the moment of the creation of an all-student organization which would embrace not only the student body of one university but also of all the Russian and ultimately all the western European universities. The struggle of the students against the cunning and undisguised University Law of 1885 continued unabated. "Unrests," violations of the old liberal Moscow traditions, the destruction of already existing organizations by the administration, our new groups, the subterranean rumbling of political movements, the development of spontaneity[2] on the part of the students, all produced continually new experiences and made the strings of the soul sensitive, receptive, especially susceptible to vibration.

Luckily politics did not completely ensnare me. Different studies gave me practice in "abstract" thinking, in learning to penetrate into fundamental questions. Aside from my chosen specialty (economics, in which I worked under the direction of a highly gifted teacher and one of the most singular men I ever met in my life, Prof.

2. This spontaneity or personal initiative is one of the happiest (unfortunately far too little cultivated) sides of a life that has been pressed into rigid forms. Every individual (corporate or personal) step is full of consequence because it shakes the rigidness of life—whether it aims at "practical results" or not. It creates an atmosphere critical of customary appearances, which through dull habit constantly deaden the soul and make it immovable. Thence the dullness of the masses about which freer spirits have always had reason for bitter complaint. Corporative organizations should be so constituted that they have the most open form possible and incline more to adapt to new phenomena and to adhere less to "precedent," than has hitherto been the case. Each organization should be conceived only as a transition to freedom, as a necessary bond which is, however, as loose as possible and does not hinder great strides toward a higher evolution.

A. J. Tschuproff), I was powerfully attracted, sometimes successively, sometimes simultaneously, to other, different fields: Roman law (which enchanted me by its fine, conscious and highly polished "construction," but which ultimately could not satisfy me as a Slav because its unbending logic was much too cold, much too rational), criminal law (which appealed to me particularly and perhaps too exclusively through the then-new theory of Lombroso), the history of Russian law and peasant law (which, in contrast to Roman law, won my admiration and profound love as a liberation and a happy solution to the fundamental problem of law),[3] ethnology, which touched upon this study (and through which I at first thought I would reach the soul of the people), all these claimed my attention and helped me to think in an abstract manner.

I loved all these studies and to this day I think with gratitude of the hours of enthusiasm and perhaps inspiration which they gave me. But these hours paled upon my first contact with art, which alone had the power to lift me beyond time and space. Scholarly work had never given me such experiences, inner tensions, and creative moments.

However I found my powers too weak to feel justified in renouncing other duties and leading what seemed to me at the time the infinitely happy life of the artist. Furthermore, Russian life was then especially dismal, my scholarly work was valued, and I decided to become a scholar. In my chosen field of economics, nevertheless, except for the profit question, I was only interested in purely abstract theory. Banking, the practical side of money matters, was to me insurmountably repulsive. However there was nothing for me to do but take this into the bargain also.

At the same time I underwent two experiences which stamped my entire life and which shook me to the marrow. They were the French Impressionist exhibition in Moscow—particularly the "Haystack" by Claude Monet—and a production of Wagner in the Hof Theater: *Lohengrin.*

Previously I had only known realistic art, in fact exclusively the Russians, having often stood for long periods before the hand of Franz Liszt in the portrait by Repin, and the like. And suddenly for the first time I saw a *painting.* That it was a haystack the catalogue informed me. I could not recognize it. This nonrecognition was painful to me. I considered that the painter had no right to paint

3. After the "emancipation" of the serfs in Russia, the regime gave them a system of economic self-government, which, unexpectedly for many, made the peasants politically mature, and their own tribunals where, within certain limits, judges chosen by the peasants could settle disputes and also punish criminal "offenses." And here the people found the most human principle, to punish minor guilt severely and major guilt lightly or not at all. The peasant's expression for this is: "According to the man." There was thus no development of rigid law (as for example in Roman law—especially *jus strictum!*), but an extremely flexible and free form which was *not* decided *by appearance* but *solely by the spirit.*

indistinctly. I dully felt that the object of the picture was missing. And
I noticed with astonishment and confusion that the picture not only
draws you but impresses itself indelibly on your memory and, com-
pletely unexpectedly, floats before your eyes even to the last detail. All
this was unclear to me, and I could not draw the simple conclusions
of this experience. But what was entirely clear to me—was the unsus-
pected power of the palette, which had up to now been hidden from
me, and which surpassed all my dreams. Painting acquired a fairy-tale
power and splendor. And unconsciously the object was discredited as
an indispensable element of a painting. All in all I had the impression,
though, that a tiny bit of my fairy-tale Moscow already existed on the
canvas.[4]

Lohengrin, however, seemed to me a full realization of this
Moscow. The violins, the deep bass tones, and, most especially, the
wind instruments embodied for me then the whole impact of the hour
of dusk. I saw all my colors in my mind's eye. Wild, almost insane
lines drew themselves before me. I did not dare use the expression that
Wagner had painted "my hour" musically. But it became entirely clear
to me that art in general is much more powerful than I had realized
and that, on the other hand, painting can develop just as much power
as music possesses. And my inability to discover these powers or even
to seek them made my renunciation all the bitterer.

However I was never strong enough to carry out my duties to the
disdain of all else and succumbed to the temptation that was too
strong for me.

A scientific event cleared my way of one of the greatest impedi-
ments. This was the further division of the atom. The crumbling of
the atom was to my soul like the crumbling of the whole world.
Suddenly the heaviest walls toppled. Everything became uncertain,
tottering and weak. I would not have been surprised if a stone had
dissolved in the air in front of me and become invisible. Science
seemed to me destroyed: its most important basis was only a delu-
sion, an error of the learned, who did not build their godly structures
stone by stone with a steady hand in transfigured light, but groped at
random in the darkness for truth and blindly mistook one object for
another.

Already as a child I knew the tormenting, happy hours of that inner
tension which promises to take on a concrete form. These hours of

4. The "light and air" problem of the Impressionists interested me little. I always
found that the clever speeches about this problem had very little to do with painting.
The theory of the Neo-Impressionists later appeared to me more important, since it was
ultimately concerned with the *effect of colors* and left air in peace. Nevertheless I felt at
first dimly, later quite consciously, that every theory that is founded on external means
represents only an individual case, alongside of which many other cases can exist with
equal validity; still later I understood that the external grows from the internal or is
stillborn.

inner trembling, of unclear longing calling for something we do not understand, which by day oppress the heart and fill the soul with unrest, and by night make us live through fantastic dreams full of horror and joy. Like many children and young people, I attempted to write poetry which sooner or later I tore up. I can remember that drawing released me from this condition, that is, that it let me live outside of time and space, so that I no longer felt myself. My father[5] noticed my love of drawing at an early age and had me take drawing lessons while still at the *Gymnasium.* I recall how I loved the material itself, how the colors and crayons were especially alluring, beautiful, and alive. From the mistakes I made, I drew lessons which still nearly all affect me with their original force. As a very small child I painted a piebald horse with watercolors; everything was finished down to the hoofs. My aunt who helped me with my painting had to go out and suggested I wait for the hoofs until her return. I remained alone in front of the unfinished picture and suffered from the impossibility of putting the last touches of color on the paper. This last task seemed so easy to me. I thought if I made the hoofs very black they would certainly be completely true to nature. I put as much black on the brush as I could. One instant—and I saw four black, disgusting, ugly spots utterly foreign to the paper, on the horse's feet. I felt desperate and horribly punished! Later I understood very well the Impressionists' fear of black, and still later it cost me a real struggle of the soul to put pure black on the canvas. Such a misfortune as a child casts a long shadow over many years of later life.

Other especially strong impressions that I experienced in my student years and which again had a decisive influence on later years were the Rembrandts in the Hermitage in St. Petersburg, and my trip to the government district of Vologda, whither I was sent as ethnographer and jurist by the Imperial Institute for Natural Sciences, Anthropology, and Ethnography. My task was two-fold: to study peasant criminal law among the Russian population (to find out the principles of primitive law), and to collect the remnants of their heathenish religion from the fishing and hunting tribes of the gradually disappearing Syrians.

Rembrandt moved me deeply. The great division of Light and Dark, the blending of secondary tones into the larger parts, the melting

5. With unusual patience my father allowed me to follow my dreams and whims during my entire life. When I was ten years old he tried to guide me to a choice between the Latin *Gymnasium* and the *Realschule:* by describing the differences between these schools, he helped me to make my choice as independently as possible. For many long years he very generously supported me financially. In the reorientations of my life he spoke to me as an older friend and never exercised a trace of force on me in important matters. His principles of education were complete trust and the relationship of a friend to me. He knows how grateful I am to him. These lines should be a guide to parents, who try forcibly to turn their children (and those gifted artistically in particular) away from their true careers and thereby make them unhappy.

together of these tones in these parts, which had the effect of a giant antiphony at every distance and immediately reminded me of Wagner's trumpets, revealed to me completely new possibilities, super-human powers of color in its own right and particularly the intensification of power through juxtapositions [*Zusammenstellungen*], that is, contrasts. I saw that every large surface in itself contained no fairy-tale quality, that each of these surfaces immediately betrayed its derivation from the palette, but that this surface actually acquired a fairy-tale effect through the other, contrasted surface, so that its origin on the palette seemed unbelievable at first glance. However it was not in my nature to apply a means observed without further ado. Unconsciously I approached strange pictures as I now approach "nature"; I greeted them with reverence and deep joy, but felt, nevertheless, that this was a power foreign to me. On the other hand I felt somewhat unconsciously that this great division gives Rembrandt's pictures a quality that I had never seen before. I felt that his pictures "last a long time," and explained it to myself that I had first to exhaust *one* part continuously and then the *other*. Later I understood that this division magically produces on the canvas an element which originally seems foreign and inaccessible to painting—*time*.[6]

The pictures I painted ten to twelve years ago in Munich were to achieve this quality. I painted only three or four such pictures in which I wished to bury in each part an "infinite" number of initially hidden color tones. They had to remain completely *hidden*[7] at first (especially in the dark part), and only as time went on show themselves at first unclearly and tentatively, to the studiously attentive viewer, then resound more and more with an increasingly *"mysterious"* power. To my great astonishment I noticed that I was working according to Rembrandt's principle. That was an hour of bitter disappointment and of gnawing doubt about my own powers, of doubt about the possibility of finding my own means of expression. Soon it seemed to me "too cheap" to incorporate in this manner the elements that were then dearest to me—the hidden, time, the mysterious.

At that time I was working especially hard, often until late at night, when I would be interrupted in my work by total exhaustion and

6. A simple case of the application of time.

7. During this period I acquired the habit of jotting down separate thoughts. Thus was composed *Concerning the Spiritual in Art* without my realizing it. The notes accumulated during a span of at least ten years. One of my first notes on the beauty of color in painting is the following: "The splendor of color in a painting must powerfully attract the viewer, and, at the same time, it must hide the underlying content." I meant by this the painterly content, though not yet in pure form (as I now understand it) but the feeling or feelings of the artist which he expresses in painting. At that time I still labored under the delusion that the viewer confronts the painting with an open soul and wants to harken to a language known to him. There exist such viewers (that is no delusion), but they are as rare as grains of gold in the sand. There are even viewers who, without any personal relationship to the language of the work, are able to give themselves to it and take from it. I have met such in my life.

forced to go quickly to bed. Days during which I had not worked (rare as they were!) I considered lost and tormented myself about them. When the weather was at all decent I painted for one or two hours a day, mainly in old Schwabing which was then gradually developing into a part of Munich. During the period of my disillusionment with studio work and of pictures painted from memory I painted many landscapes in particular, which, however, did not give me much satisfaction, so that I later made finished paintings of very few of them. Wandering about with a paintbox, feeling in my heart like a hunter, did not seem to me as responsible as painting pictures in which I searched already at that time, half consciously, half unconsciously, for the compositional element. The word *composition* moved me spiritually, and I later made it my aim in life to paint a *"composition."* This word affected me like a prayer. It filled me with awe. In painting sketches I let myself go. I thought little of houses and trees, with my palette knife I spread colored stripes and spots on the canvas and let them sing as loud as I could. Within me resounded the hour before sunset in Moscow, before my eyes was the strong colorful scale of the Munich atmosphere, thundering in its deep shadows. Later, especially at home, always a profound disappointment. My colors seemed to me weak, flat, the whole study—an unsuccessful effort to capture the power of nature. How odd it was for me to hear that I exaggerated the colors of nature, that this exaggeration made my paintings incomprehensible and that my only salvation would be to "divide colors." The Munich critics (some of whom were very favorable toward me, especially at first[8]) tried to explain the "splendor of my colors" by Byzantine influences. Russian criticism (which almost without exception attacked me in unparliamentary language) found that I was deteriorating under the influence of Munich art. I saw for the first time in those days the distorted, uninformed, and unrestrained manner in which most critics proceed. This explains also the *sang-froid* with which intelligent artists receive the nastiest articles about themselves.

My inclination toward the "hidden," the concealed, saved me from the harmful side of folk art, which I saw for the first time in its true setting and original form on my trip to the governmental district of Vologda. I traveled first by railroad with the feeling that I was journeying to another planet, then several days by steamer on the quiet and self-absorbed Suchona River, later in a primitive coach through endless woods, between brightly-colored hills, over morasses and through sandy deserts. I was traveling all alone, which was

8. Even today many critics see talent in my earlier paintings, which is a good proof of their weakness. In later ones and in the most recent they find a confusion, a dead end, a decline, and, very often, a deceit, which is a good proof of the ever-increasing power of these paintings. I naturally am not referring to the Munich critics alone: for them—with very few exceptions—my books are malicious bungling. It would be too bad if their judgment were otherwise.

immeasurably favorable for absorbing myself in my surroundings and
in myself. During the day it was often burning hot, at night frosty, and
I gratefully remember my coachmen often wrapping me up more
warmly in my carriage blanket which had fallen off me in the shaking
and bouncing of the springless coach. I came to villages where sud-
denly the whole population was clothed in gray from head to toe and
had yellow-green faces and hair, or suddenly colorful costumes
appeared which flitted about like bright, living pictures on two legs. I
shall never forget the large wooden houses covered with carvings. In
these wonderful houses I experienced something that has never
repeated itself since. They taught me to move in the *picture*, to live in
the picture. I still remember how I entered the room for the first time
and stopped short on the threshold before the unexpected vision. The
table, the benches, the great oven, important in Russian peasant
houses, the wardrobes and every object were painted with bright-
colored, large-figured decorations. On the walls folk paintings: a hero
in symbolic representation, a battle, a painted folk song. The "red"
corner ("red" is old Russian for "beautiful") thickly and completely
covered with painted and printed pictures of saints; in front of this, a
small, red-burning, hanging lamp which glowed and flourished like a
knowing, gently-speaking, modest star, proudly living in and for itself.
When I finally entered the room, I felt myself surrounded on all sides
by painting, into which I had thus penetrated. The same feeling slum-
bered within me, unconsciously up to then, when I was in churches in
Moscow and especially in the great cathedral of the Kremlin. On my
next visit to this church after my return from the trip, this feeling
revived in me perfectly clearly. Later I often had the same experience
in Bavarian and Tyrolean chapels. Naturally the impression was dif-
ferently colored each time since different elements formed this impres-
sion: Church! Russian Church! Chapel! Catholic Chapel!

I did many sketches—these tables and different ornaments. They
were never trivial, and so strongly painted that the *object dissolved*
itself in them. This impression, too, only became clear much later.

Probably not otherwise than through these impressions did my fur-
ther desires take shape within me, the aims of my own art. I have for
many years searched for the possibility of letting the viewer "stroll"
in the picture, forcing him to forget himself and dissolve into the
picture.

Often, too, I have succeeded: I have seen it in the observers. From
the unconsciously intended effect of painting on the painted object,
which can dissolve itself through being painted, derived my ability to
overlook the object within the painting. Much later, in Munich, I was
once enchanted by an unexpected view in my studio. It was the hour
of approaching dusk. I came home with my paintbox after making a
study, still dreaming and wrapped up in the work I had completed,
when suddenly I saw an indescribably beautiful picture drenched with

an inner glowing. At first I hesitated, then I rushed toward this mysterious picture, of which I saw nothing but forms and colors, and whose content was incomprehensible. Immediately I found the key to the puzzle: it was a picture I had painted, leaning against the wall, standing on its side. The next day I attempted to get the same effect by daylight. I was only half-successful: even on its side I always recognized the objects, and the fine finish of dusk was missing. Now I knew for certain that the object harmed my paintings.

A frightening depth of questions, weighted with responsibility, confronted me. And the most important: what should replace the missing object? The danger of ornamentation was clear, the dead make-believe existence of stylized forms could only frighten me away.

Only after many years of patient work, of strenuous thinking, of numerous careful efforts, of constantly evolving ability to experience painterly forms purely and abstractly, and to penetrate even deeper into these immeasurable depths did I arrive at the forms of painting with which I work today, on which I work today, and which, I hope and desire, will develop much further.

It took a very long time before this question "What should replace the object?" received a proper answer from within me. Often I look back into my past and am desolate to think how much time I took for the solution. I have only one consolation: I could never bring myself to use a form which developed out of the application of logic—not purely from *feeling* within me. I could not think up forms, and it repels me when I see such forms. All the forms which I ever used came "from themselves," they presented themselves complete before my eyes, and it only remained to me to copy them, or they created themselves while I was working, often surprising me. With the years, I have now learned somewhat to control this creative power. I have trained myself not simply to let myself go, but to bridle the power working within me, to guide it. With the years I have understood that working with a pounding heart, with a straining breast (and thus aching ribs later), and with tension in my whole body cannot suffice. It can, however, only exhaust the artist, not his work. The horse bears the rider with strength and speed. But the rider guides the horse. Talent carries the artist to great heights with strength and speed. But the artist guides his talent. This is the element of the "conscious," the "calculating" in his work, or whatever one wants to call it. The artist must know *his* talent through and through and, like a smart businessman, leave not the least bit unused and forgotten; instead he must exhaust, develop every particle to the maximum possible for him.

This development, this refinement of talent demands a great ability to concentrate, which on the other hand leads to the diminution of other abilities. I saw this clearly in myself. I never possessed a so-called good memory: in particular I was always incapable of learning numbers, names, even poems by heart. The multiplication table

always presented insuperable difficulties, which I have not yet over-
come and which brought my teachers to despair. From the outset I
had to summon the aid of my visual memory, then it went better. In
the state examination in statistics I quoted a whole page of numbers
only because in my excitement I saw this page *in my mind's eye.*
Similarly I was already able as a boy to paint pictures by heart at
home that had especially fascinated me at exhibitions, insofar as my
technical abilities permitted. Later I sometimes painted a landscape
"from memory" better than after nature. Thus I painted "The Old
City" and later made many colored Dutch and Arabian drawings.
Thus, too, in a long street I could name all the stores by heart, with-
out error, since I *saw* them before me. Entirely without consciousness
I steadily absorbed impressions, sometimes so intensively and inces-
santly that I felt as if my chest were cramped and my breathing diffi-
cult. I became so overtired and overstuffed that I often thought with
envy of clerks who were permitted and able to relax completely after
their day's work. I longed for dull-witted rest, for eyes which Boecklin
called "porter's eyes." I *had* however, to see without pause.

A few years ago I suddenly noticed that this ability had diminished.
At first I was horrified, but later I understood that the powers that
made continuous observation possible were being channeled in an-
other direction through my more highly developed ability to concen-
trate, and could accomplish other things now more necessary to me.
My capacity for absorbing myself in the spiritual life of art (and thus,
too, of my soul) increased so greatly that I often passed external phe-
nomena without noticing them, something that could never have hap-
pened before.

I did not force this ability on myself, as far as I understand it—it
always lived organically within me, but in embryonic form.

When I was thirteen or fourteen I bought a paintbox with oil paints
from money slowly saved up. The feeling I had at the time—or better:
the experience of the color coming out of the tube—is with me to this
day. A pressure of the fingers and jubilant, joyous, thoughtful,
dreamy, self-absorbed, with deep seriousness, with bubbling roguish-
ness, with the sigh of liberation, with the profound resonance of sor-
row, with defiant power and resistance, with yielding softness and
devotion, with stubborn self-control, with sensitive unstableness of
balance came one after another these unique beings we call colors—
each alive in and for itself, independent, endowed with all necessary
qualities for further independent life and ready and willing at every
moment to submit to new combinations, to mix among themselves
and create endless series of new worlds. Some lie there as if already
exhausted, weakened, petrified, as dead forces and living memories of
bygone possibilities, not decreed by fate. As in struggle, as in battle
fresh forces pour out of the tube, young forces replacing the old. In
the middle of the palette is a curious world of the remnants of colors

already used, which wander far from this source in their necessary embodiments on the canvas. Here is a world which, derived from the desires of pictures already painted, was also determined and created through accidents, through the puzzling play of forces alien to the artist. And I owe much to these accidents: they have taught me more than any teacher or master. Many an hour I studied them with love and admiration. The palette, which consists of the elements mentioned, which is itself a "work" and often more beautiful than many another work, should be valued for the pleasures which it offers. It sometimes seemed to me that the brush, which with unyielding will tore pieces from this living color creation, evoked a musical sound in this tearing process. Sometimes I heard a hissing of the colors as they were blending. It was like an experience that one could hear in the secret kitchen of the alchemist, cloaked in mystery.

How often and how maliciously this first paintbox jeered and laughed at me. One minute the color ran down from the canvas, another minute, a little later, it came in torn bits; one minute it was lighter, another darker; one minute it seemed to spring down from the canvas and swim in the air, another and it became gloomier and gloomier like a dead bird that draws near its disintegration—I do not know how all this happened.

Later I heard that a very well-known artist (I no longer remember who it was) said: "In painting one look at the canvas, half a look at the palette, and ten at the model." It sounded very nice, but I soon discovered that it must be the other way around for me: ten looks at the canvas, one at the palette, a half at nature. Thus I learned to battle with the canvas, to come to know it as a being resisting my wish (= dream), and to bend it forcibly to this wish. At first it stands there like a pure chaste virgin with clear eye and heavenly joy—this pure canvas which itself is as *beautiful* as a painting. And then comes the willful brush which first here, then there, gradually conquers it with all the energy peculiar to it, like a European colonist, who pushes into the wild virgin nature, hitherto untouched, using axe, spade, hammer, and saw to shape it to his wishes. I have gradually learned not to see the resistant white of the canvas, to notice it only for instants (as a control), instead of seeing in it the tones that are to replace it—thus one thing slowly followed another.

Painting is a thundering collision of different worlds, intended to create a new world in, and from, the struggle with one another, a new world which is the work of art. Each work originates just as does the cosmos—through catastrophes which out of the chaotic din of instruments ultimately create a symphony, the music of the spheres. The creation of works of art is the creation of the world.

Thus these sensations of colors on the palette (and also inside the tubes, which resemble humans, spiritually powerful but unassuming in appearance, who suddenly in time of need reveal and bring to bear

their hitherto concealed powers) became experiences of the soul. Furthermore, these experiences were the point of departure for ideas which ten to twelve years ago began consciously to assemble themselves and which led to the book *Concerning the Spiritual in Art*. This book was written by itself more than by me. I wrote down individual experiences which, I later noticed, hung together in an organic relationship. I felt more and more clearly that it is not a question in art of the "formal" but of an inner wish (= content) which imperatively determines the formal. A step forward—but which took me a shamefully long time—was the solution of the problem of art exclusively on the basis of internal necessity, which was capable of overthrowing all known rules and limitations at any moment.

Thus the realm of art drew farther and farther apart from the realm of nature for me, until I could thoroughly experience both as independent realms. This only happened in its full magnitude this year.

Here I touch on a recollection which in its time was a source of sorrows for me. When I came to Munich from Moscow with the feeling of being reborn, the forced labor behind me, the work of pleasure before me, I very soon ran up against a barrier to my emancipation which at least in the matter of time and in a new way enslaved me—working from a model.

I saw the then very famous school of Anton Azbé[9] crowded with students. Two or three models "sat for heads" or "stood as nudes." Students of both sexes and different nationalities gathered around these ill-smelling, indifferent, inexpressive, mostly characterless phenomena of nature being paid 50–70 pfennig per hour, covered the paper and the canvas carefully with a gentle rustling noise, and tried to copy precisely these people who meant nothing to them, anatomically, constructionally, and characteristically. They tried to convey the connection of the muscles through overlapping of lines, to show the modeling of the nostrils, of the lips through a special treatment of surfaces or line, to construct the whole head according to the "principle of the ball," and never thought for a moment, it seemed to me, about art. The play of lines of the nude often interested me a great deal. But sometimes it was repulsive to me. Some positions of certain bodies repelled me by the effect of the lines, and I had to force myself energetically to reproduce them. I was almost always fighting with myself. Only out on the street could I breathe freely again, and often succumbed to the temptation to "cut" school and capture Schwabing, the

9. Anton Azbé was a gifted artist and a rare and kind person. Many of his numerous pupils studied with him free of charge. His constant reply to the apology for inability to pay was: "Just work very hard." He evidently had a very unhappy life. One could hear him laugh but never see it: the corners of his mouth were hardly raised, his eyes always remained sad. I do not know if the enigma of his lonely life was known to anyone. And his death was just as lonely as his life: he died all alone in his studio. In spite of his very great income, he left only a few thousand marks. Not until after his death did it become known just how generous he was.

English garden, or the Isar parks after my fashion with my paintbox. Or I stayed home and tried to do a picture from memory, from study, or by imagination, that did not have all too much to do with the laws of nature. I was therefore considered lazy by my colleagues and often of little talent, which sometimes hurt me a great deal, since I clearly felt within me a love for work, diligence, and talent. Finally I isolated myself in these surroundings, felt myself a stranger and absorbed myself with all the greater intensity in my wishes.

However I considered it my duty to take the course in anatomy, something I did conscientiously and, in fact, twice. The second time I attended the colorful and vivacious course of Prof. Dr. Moillet. I drew the preparations, took lecture notes, smelled the air of corpses. But unconsciously it was peculiarly annoying to me to hear of the direct connection between anatomy and art. It even offended me—just as the instruction once offended me that the trunk of the tree "must always be represented joined to the ground." There was no one there who could help me out of these feelings, out of the entanglement in this darkness. It is true that I also never turned to anyone with my doubts. Even today I find that such doubts must be resolved alone within the soul and that otherwise one would profane one's own powerful solution.

Nevertheless, I soon found in those days that every head, no matter how "ugly" it seems in the beginning, is a perfected beauty. The natural law of construction which is manifested in each head so completely and indisputably gave the head its stroke of beauty. I often stood before an "ugly" model and said to myself: "How skillful." And it is endless skill that shows in every detail: each nostril for example always awakens in me the same feeling of admiration as the flight of the wild duck, the joining of the leaf with the branch, the swimming of the frog, the pouch of the pelican, etc., etc. This feeling of admiration for beauty, for skill, I immediately experienced at Prof. Moillet's lectures.

I had a dim feeling that I sensed secrets of a realm all its own. But I could not connect this realm with the realm of art. I visited the Alte Pinakothek and noticed that not one of the great masters had achieved the creative beauty and skill of the natural model: nature itself remained untouched. It seemed to me sometimes that it was laughing at these efforts. Much more often, though, it appeared to me in the abstract sense "divine": it wrought *its* creation, it went *its* way to *its* goals, which disappear in the mists, it lived in *its* realm, and I was strangely outside of it. How did it relate to art?

When some of my colleagues saw the work I had done at home they labelled me a "colorist." Some called me, not without malice, the "landscape painter." Both hurt me although I perceived the justice of these characterizations. All the more so! I sensed actually that I felt much more at home in the realm of color than in that of drawing. And I did not know how to help myself in the face of this threatening evil.

At that time Franz Stuck was "the foremost draughtsman in Germany" and I went to him—unfortunately only with my schoolwork. He found everything rather distorted and advised me to work in the drawing class at the Academy for a year. I failed in the examination, which only angered but did not discourage me: in this examination drawings were praised which I quite correctly found stupid, talentless, and completely devoid of knowledge. After a year of work at home I went to Franz Stuck for the second time—this time only with sketches of paintings that I was not yet able to finish and with several landscape studies. He accepted me in his painting class and when I asked about my drawing, I received the reply that it was expressive. Already during my first work at the Academy, Stuck energetically opposed my "extravagances" in color and advised me to paint in black and white first in order to study form alone. He spoke with surprising love about art, about the play of forms, about the flow of forms into each other, and won my complete sympathy. I wanted to learn only drawing from him, since I noticed right away that he had little sensitivity to color, and I yielded entirely to his counsels. In the final analysis I remember this year of work with him gratefully, although I sometimes became bitterly angry. Stuck spoke little and sometimes not very clearly. After his criticism I sometimes had to ponder his utterances for a long time—but later I found them almost always good. With a single remark he remedied my unfortunate effect of being unable to finish a painting. He told me that I work too nervously, that I pluck out what is interesting in the first moment and then spoil this through the dry part of the work which comes too late: "I awaken with the idea: today I am permitted to do thus and so." This "I am permitted" revealed to me not only Stuck's deep love for art and great respect for it, but also the secret of serious work. And at home I finished my first painting.

For many more years, however, I was like a monkey in a net: the organic law of construction entangled me in my desires, and only with great pain, effort, and struggle did I break through these "walls around art." Thus did I finally enter the realm of art, which like that of nature, science, political forms, etc., is a realm unto itself, is governed by its own laws proper to it alone, and which together with the other realms ultimately forms that great realm which we can only dimly divine.

Today is the great day of one of the revelations of this world. The interrelationships of these individual realms were illumined as by a flash of lightning; they burst unexpected, frightening, and joyous out of the darkness. Never were they so strongly tied together and never so sharply divided. This lightning is the child of the darkening of the spiritual heaven which hung over us, black, suffocating, and dead. Here begins the great epoch of the spiritual, the revelation of the spirit. Father-Son-Holy Spirit.

As time went on I very gradually recognized that "truth" in general and in art specifically is not an X, not an always imperfectly known but immovable quantity, but that this quantity is constantly moving in slow motion. It suddenly looked to me like a slowly moving snail that scarcely seems to leave the spot, and draws behind it a slimy trail to which shortsighted souls remain glued. Here, too, I first noticed this important fact in art, and later I saw that in this case the same law prevails in the other areas of life as well. This movement of truth is very complicated: the untrue becomes true, the true untrue, some parts fall away like the shell of a nut, time smoothes this shell; for this reason some people mistake the shell for the nut and bestow on the shell the life of the nut; many wrestle over this shell, and the nut rolls on; a new truth falls as if from heaven and seems so precise, so stiff and hard, appears so infinitely high that some scramble on it as on a long wooden pole and are certain that this time they will reach heaven . . . until it breaks and until the climbers fall back like frogs in the swamp, into the dark unknown. Man is often like a beetle, kept on its back: he waves his little arms in silent longing, grasps at every blade that anyone holds out to him, steadily believing he will find salvation in this blade. In the days of my "unbelief" I asked myself: who is holding me on my back? Whose hand is holding the blade before me and then snatching it away again? Or am I lying on the dusty, indifferent earth on my back and grasping after the blades that grow about me "of their own accord?" How often, however, did I feel this hand on my back and then another that pressed itself upon my eyes, so that I found myself in the darkness of night while the sun shone.

Art is like religion in many respects. Its development does not consist of new discoveries which strike out the old truths and label them errors (as is apparent in science). Its development consists of sudden illuminations, like lightning, of explosions, which burst like a fireworks in the heavens, strewing a whole "bouquet" of different shining stars about itself. This illumination shows new perspectives in a blinding light, new truths which are basically nothing more than the organic development, the organic growing of earlier wisdom which is not voided by the later, but as wisdom and truth continues to live and produce. The trunk of the tree does not become superfluous because of a new branch: it makes the branch possible. Would the New Testament have been possible without the Old? Would our epoch of the threshold of the "third" revelation be conceivable without the second? It is a branching of the original tree trunk in which "everything begins." And the branching out, the further growth and ramification which often seem confusing and despairing, are the necessary steps to the mighty crown; the steps which in the final analysis create the green tree.

Christ did not come, in his own words, to overthrow the old law.

When he declared: "You have been told . . . but I say unto you . . ." he brought the old material law as it had become his spiritual law: in contrast to the men of Moses' time, the men of his time had become capable of grasping and experiencing the laws "do not kill," "do not commit adultery," not only in the literal, material sense but also in the abstract form of the sin of thought.

The plain, precise, and hard idea, therefore, is not overthrown, but used as the step to further ideas growing from it. And these further, softer, less precise, and less material ideas are like tenderer, newer branches which pierce new holes in the air.

The worth of a fact is not determined on Christ's scale as an external, rigid deed but as an inner, flexible one. Here lies the root of the future revaluation of values which even today continues slowly, uninterruptedly to create, and at the same time is the root of the spirituality which we also gradually reach in the realm of art. In our time in a strongly revolutionary form. In this way I finally came to the point at which I considered non-objective art not as the abnegation of all earlier art but only as a vitally important division of an old trunk into two main branches[10] from which other branches grow that are essential for the formation of the green crown.

I felt this fact more or less clearly from the beginning and was always annoyed by the charge that I was trying to overthrow the old concept of painting. I never experienced this overthrow in my works: in them I felt only the inwardly logical, outwardly organic, unavoidable evolution of art. Gradually I became conscious of my earlier feelings of freedom, and the secondary demands that I made of art eventually disappeared. They disappeared in favor of a single demand: the demand of *inner* life in painting. To my astonishment I realized that this demand grew on the foundation which Christ set forth as the foundation for moral qualification. I realized that this view of art is Christian and that at the same time it shelters within itself the

10. By these two main branches I mean two different ways of executing art. *The virtuoso type* (which music has long known as a special approach and which in literature corresponds to the art of drama) rests on the more or less personal sensitivity and on the artistic, creative interpretation of "nature." (An important example—portraiture.) Nature is here also understood as meaning an already existing work created by another hand: the virtuoso work which grows out of it is of the same sort as a picture painted "after nature." Up to now, artists have as a rule suppressed the desire to create such virtuoso works, which is to be regretted. The so-called copy also belongs in this category: the copyist tries to come as close to the foreign piece of work as a very precise conductor to a foreign composition.

The other category is *the composition*, where the work derives mostly or exclusively "from within the artist," as has been the case in music for centuries. In this respect painting has caught up with music, and both have a constantly growing tendency to create "absolute" works, that is, completely "objective" works which, like the works of nature, grow "from themselves" purely according to laws as independent *beings*. These works are closer to an art of abstraction and perhaps they alone are destined to embody this art existing in abstraction in some unforeseeable time.

necessary elements for the reception of the "third" revelation, the revelation of the Holy Spirit.[11]

I consider it just as logical, however, that the painting of an object in art makes very great demands on the inner experience of the purely painterly form, that therefore an evolution of the observer in this direction is absolutely necessary and can in no way be avoided. Thus are created the conditions for a new atmosphere. In this atmosphere will be created much, much later the *pure art* which hovers before us in our fleeting dreams of today with an indescribable attraction.

I understood in time that my slowly developed (partly conquered) tolerance of other works does not harm me in any way, that, quite the reverse, it is very favorable to the one-sidedness of my endeavors. For this reason I would like partly to limit, partly to enlarge the saying "The artist should be one-sided," to read "The artist should be one-sided in his works." The ability to experience the works of others (which happens naturally and must happen in its own way) renders the soul more sensitive, more capable of vibration, thereby enriching, broadening, refining it and making it more able to achieve its own aims. Experiencing the works of others is in the broadest sense like experiencing nature. And can or should an artist be blind and deaf? I would say that one approaches one's own work with yet happier spirit, with calmer passion, when one sees that other possibilities (which are infinite) are correctly (or more or less correctly) exploited in art. As regards me personally, I love every form which necessarily derives from the spirit, which is created from the spirit. Just as I hate every form which is not.

I believe that the philosophy of the future besides studying the nature of things will also study their spirit with especial attention. Then will the atmosphere be created that will enable men as a whole to feel the spirit of things, to experience this spirit even if

11. In this sense Russian peasant law, mentioned previously, is also Christian and should be contrasted to heathen Roman law. The inner qualification can be thus explained by bold logic: this deed is not a crime when committed by this person, though in general it would be considered a crime when committed by other people. Therefore: in this case a crime is not a crime. And further: absolute crime does not exist. (What a contrast to *nulla poena sine lege!*) Still further: not the act (real) but its root (abstract) constitutes the evil (and good). And finally: every act is ambivalent. It balances on the edge. The will gives it the push—it falls to right or left. The external flexibility and the inner precision are highly developed in this case in the Russian people, and I do not believe I exaggerate when I recognize a strong capacity for this type of development in general in the Russians. It is also no surprise that peoples who have developed under the often valuable principles of the Roman spirit, formal, externally very precise (one need only think of the *jus strictum* of an *earlier* period), react either with a shake of the head or with scornful condemnation to Russian life. Superficial observation especially allows one to see in this life, so curious to the foreign eye, only the softness and external flexibility, which is taken for unruliness, because the inner precision lies at a depth. And this has the result that free-thinking Russians show much more tolerance of other peoples than is shown to them. And that this tolerance in many cases turns into admiration.

unconsciously, just as today the outward form of things is experienced unconsciously by mankind in general, which explains the public's enjoyment of representational art. Thus will mankind be enabled to experience first the spiritual in material objects and later the spiritual in abstract forms. And through this new capacity, which will be in the sign of the "spirit," the enjoyment of abstract = absolute art comes into being.

My book *Concerning the Spiritual in Art* and also *The Blue Rider* had as their main purpose to awaken this capacity, absolutely necessary in the future, for infinite experiences of the spiritual in material and in abstract things. The wish to arouse this blessed power in men, which they have never had, was the major goal of both publications.[12]

These two books were and are often misunderstood. They are taken as "programs" and their authors are branded as theorizing artists who have gone astray in brain-work and "perished." Nothing was farther from my mind than an appeal to the intellect, to the brain. This task would still have been premature today and will lie before artists as the next, important, and unavoidable aim (= step) in the further evolution of art. Nothing can and will be dangerous any longer to the spirit once it is established and deeply rooted, not even therefore the much-to-be-feared brain-work in art.

After our Italian trip, already mentioned, and after a brief return to Moscow when I was scarcely five years old, my parents and my aunt, Elisabeth Ticheeff, to whom I owe no less than to my parents, travelled to Southern Russia (Odessa) for reasons of my father's health. There I later attended the *Gymnasium*, but always felt a passing guest in a city that was foreign to my whole family. The desire never left us to be able to return to Moscow, and the city developed a longing in my heart similar to that which Chekhov describes in his "Three Sisters." From the time I was thirteen my father took me to Moscow every summer and thus I finally moved there at eighteen with the feeling that I was home again at last. My father hails from Eastern Siberia, whither his parents had been banished from Western Siberia for political reasons. He received his education in Moscow and learned to love this city no less than his home. His deeply human and loving soul understands the "spirit of Moscow" and he knows the external Moscow equally well. It is always a pleasure for me to listen as he enumerates in a solemn voice, for example, the countless churches with their wonderful old names. No doubt here sounds an artist's soul. My mother is a born Muscovite and unites within herself the qualities which to me symbolize Moscow: external, striking beauty, serious and strict through and through; aristocratic simplicity;

12. My *Concerning the Spiritual* lay written and finished for two years in my desk drawer. The possibilities of realizing *The Blue Rider* had not worked out. Franz Marc smoothed the practical way for the first book. The second he also supported through his fine, understanding, and talented spiritual cooperation and help.

inexhaustible energy; a unique union of tradition with true free thinking, woven out of great nervousness, imposing majestic calm, and heroic self-mastery. In sum—the "white-stone," "gold-headed," "Mother-Moscow" in human form. Moscow: two-sidedness, complexity, intense movement, collisions and confusion in outward appearance, which ultimately forms an individual, unitary image; the same peculiarities in its inner life, which is incomprehensible to the foreign eye (hence the many, contradictory judgments of foreigners about Moscow) and which is nevertheless just as individual and in the last analysis as perfectly unitary—this totality of the outer and inner Moscow I believe to be the origin of my artistic endeavors. It is my painter's tuning fork. I have the feeling that it was always so, and that as time goes on, and thanks to external formal advances, I have painted and am now painting this "model," only with an always stronger expression, in more perfect form, more fundamental form. The digressions that I have made, therefore, from this direct path were not harmful as a whole; a few dead signs where I lost my strength and which seemed to me sometimes the end of my work, were for the most part jumping-off points and rest stops, which made possible the next step.

In many things I must condemn myself, but I have always remained true to one thing—the inner voice, which set my goal in art and which I hope to follow to the last hour.

Boccioni

Futurist Sculpture

Umberto Boccioni (1882–1916), already established as one of the leading Futurist painters, began sculpture in the winter of 1911–1912. He had proven himself an able pamphleteer and was presumably the principal author of the Futurist painters' manifestos of 1910. His "Technical Manifesto of Futurist Sculpture" was published April 11, 1912, by the Direzione del Movimento Futurista in Milan, or at least it was given that date, the 11th being a superstitious preference of Marinetti, the founder of Futurism, whose lead Boccioni had followed since 1909. For an exhibition of his sculpture in the Galerie La Boëtie, Paris, June 20 to July 16, 1913. *"I^re exposition de sculpture futuriste du peintre et sculpteur Futuriste Boccioni,"* Boccioni provided a preface and reproduced in French, with some alterations, the sculpture manifesto. A list of works completed the catalogue, whose excellent French was beyond Boccioni's powers and might well be due to Marinetti. The poet had lived in Paris for many years, and was there at the time of the exhibition because the catalogue advertises lectures by him and by Boccioni, June 22 and 27. The preface appeared for the first time in the Paris exhibition catalogue, and was already slightly altered in its first Italian version, for the exhibition at the Galleria Sprovieri, Rome, from December 6, 1913, to January 5, 1914.

I have taken both preface and manifesto from the Paris text because they have unique elements not found in any Italian-language version. For example, in the La Boëtie version, Boccioni recommends the use of "transparent planes of glass or celluloid," the Italian variants dropping the mention of celluloid; he suggests that for the sake of a special movement, "a little motor" could be added to a sculpture, an engaging idea that in the Italian is merely *"un qualsiasi congegno."* The answer seems to be that when confronting the French, from whom he had earlier absorbed much and whom he was anxious to rival, he was more specific and more deliberately daring. The French text of the manifesto tends to emphasize that side of his sculpture, embodied in works most of which were later destroyed, which mixed wood, plaster, metal and other substances in a way that now reminds us a bit of the "junk sculpture" of our generation. The Paris version has whole sentences that were never included in any of the Italian variants.

I append the works as they were listed in the catalogue to complete the presentation Boccioni made to his French colleagues, and to give us an essential idea of the objects which embodied the texts. In the Museum of Modern Art's authoritative catalogue of its Futurist exhibition in 1961, two of Boccioni's eleven numbered conclusions were unaccountably omitted. A facsimile of the first Italian version of the sculpture manifesto is provided in Luciano Caruso, ed., *Manifest, proclami, interventi, et documenti teorici del futurismo 1909–1914* (Florence, 4 vols., 1980), vol. I, item 24. Further documentation for Boccioni is found in the *Archivi del Futurismo* edited by M. Drudi

Gambillo and T. Fiori (Vol. I, Rome, 1958), although the text of the Paris preface is taken from Boccioni's *Opera Completa* edited by Marinetti (Foligno, 1927), and the manifesto from *I Manifesti del Futurismo*, also edited by Marinetti (Milan, 1914).

Preface, First Exhibition of Futurist Sculpture

The works that I present to the Parisian public are the point of departure of my *Technical Manifesto of Futurist Sculpture* (Milan, 11 April 1912).

The traditional desire to capture a gesture in a line and, furthermore, the very nature and homogeneity of the materials employed (marble or bronze), have helped make sculpture the static art par excellence.

I therefore thought that one could obtain a basic dynamic element by breaking down this unity of material into a certain number of different substances, each of which could, by its very diversity, characterize a difference of weight and expansion of the molecular volumes.

The problem of dynamism in sculpture does not depend only on the diversity of materials, but above all upon the interpretation of the form. The search for naturalistic form removes sculpture (and painting also) from both its origins and its ultimate end: architecture.

Architecture is for sculpture what composition is for painting. The absolute absence of architecture is the gravest fault of impressionistic sculpture.

The pre-Impressionist study of form (following a process analogous to that of the Greeks and of all the primitives) leads fatally to dead form, and consequently to immobility. This immobility is the principal characteristic of Cubist sculpture.

Between the *real* form and the *ideal* form, between the new form (Impressionism) and the traditional concept (pre-Impressionist, that is always mechanically Greek), there is a form that is changing, evolving, and one that has nothing to do with all the forms conceived of until now. This double concept of form: *form in movement* (relative movement) and *movement of the form* (absolute movement) can alone render in the duration of time that instant of plastic life as it was materialized, without cutting it apart by drawing it from its vital atmosphere, without stopping it in the midst of its movement, in a word, without killing it.

All these convictions impel me to search in sculpture not pure form, but *pure plastic rhythm;* not the construction of bodies, but the *construction of the action of bodies.* Thus I have as my ideal not a pyramidal architecture (static state), but a spiral architecture (dynamism). This is why a body in movement is not for me a body studied when immobile and afterwards modeled as though it were in motion. It is,

42

on the contrary, a body in movement, a living reality absolutely *new* and *original*.

In order to present a body in movement, I take care not to give its trajectory, that is, its passage from one state of repose to another; instead I force myself to determine the unique form that expresses its *continuity in space*.

Every intelligent person will understand that this spiral, architectural construction must give birth to *sculptural simultaneity*, analogous to the pictorial simultaneity that we proclaimed and expressed in our first exhibition of Futurist painting in Paris (Galerie Bernheim, 5 February 1912).

Traditional sculptors make their statues revolve in front of the spectator, or the spectator around the statues. Any visual angle thus possible is limited to one side of the statue or sculptural group at a time. This process only serves to augment the immobility of the work. My spiral, architectural construction, on the other hand, creates before the spectator a continuity of forms which permit him to follow ideally (through the *form-force* sprung from the real form) a new, abstract contour which expresses the body in its material movements.

By its centrifugal direction, the form-force is the potential of the living form. It is thus in a more abstract way that one perceives form in my sculpture. The spectator should construct ideally a continuity (simultaneity) which is suggested to him by the form-forces equivalent to the expansive energy of the bodies.

My sculptural ensemble evolves in the space created by the depths of the volumes, while showing the thickness of each profile. Therefore my sculptural ensemble does not offer a series of rigid profiles, immobile silhouettes. Each profile carries in itself a clue to the other profiles, both those that precede and those that follow, forming altogether the sculptural whole.

My inspiration, moreover, seeks through assiduous research a complete fusion of environment and object, by means of the *interpenetration of the planes*. I propose to make the object live in its surroundings without making it the slave of fixed or artificial light, or of a supporting plane. I absolutely disdain the trompe-l'oeil procedure of impressionistic sculptors who, seeking distance from architectural severity, only succeeded in drawing too close to painting.

The conception of the sculptural object becomes the plastic result of the object and its environment, and thereby abolishes the distance which exists, for example, between a figure and a house 200 meters apart. This conception produces the extension of a body in the ray of light which strikes it, the penetration of a *void* into the *solid* which passes before it.

All this I obtain by uniting atmospheric blocks with more concrete elements of reality.

Therefore, if a spherical form (the plastic equivalent of a head) is traversed by the façade of a palace situated further back, the interrupted half-circle and the square façade which intercepted it will form a new unity, composed of environment + object.

One must completely forget the figure enclosed in its traditional line and, on the contrary, present it as the center of plastic directions in space.

Sculptors under the yoke of tradition and technique ask me with a frightened look how I could determine the outer contours of the sculptural ensemble, seeing that the figure's outer limit coincides with the very line determined by the material itself (clay, plaster, marble, bronze, wood or glass) isolated in space. The response is simple: in order that the outer edges of the sculptural entity die away little by little and lose themselves in space, I color in black or in grey the extreme edge of the contour, graduating and nuancing these colors until I obtain a central clarity. Thus I create an auxiliary chiaroscuro which forms a nucleus in the atmospheric environment (*first impressionistic result*). This nucleus serves to augment the force of the sculptural nucleus in its environment composed of plastic directions (*dynamism*).

When I think it inappropriate to use such colorations, I leave aside this material means of spreading out in nuances into space, and instead let live the sinuosities, the discontinuities, the burst of straight and curved lines, according to the direction which the movement of the body impresses on them.

We succeed therefore, in both cases, in rising finally above the loathsome continuity of the Greek, Gothic, and Michelangelesque figure.

Technical Manifesto
of Futurist Sculpture

The sculpture that we can see in the monuments and exhibitions of Europe affords us so lamentable a spectacle of barbarism and lumpishness that my Futurist eye withdraws from it in horror and disgust.

We see almost everywhere the blind and clumsy imitation of all the formulae inherited from the past: an imitation which the cowardice of tradition and the listlessness of facility have systematically encouraged. Sculptural art in Latin countries is perishing under the ignominious yoke of Greece and of Michelangelo, a yoke carried with the ease of skill in France and Belgium, but with the most dreary stupefaction in Italy. We find in Germanic countries a ridiculous obsession with a hellenized Gothic style that is industrialized in Berlin and enervated in Munich by heavy-handed professors. Slavic countries, on the other hand, are distinguished by a chaotic mixture of Greek archaisms, demons conceived by Nordic literature, and monsters born of oriental imagination. It is a tangle of influence ranging from the Sibylline and excessive detail of the Asiatic spirit to the puerile and grotesque ingenuity of Laplanders and Eskimos.

In all these manifestations of sculpture, from the most mechanical to those moved by innovating currents, there persists the same error: the artist copies live models and studies classical statues with the artless conviction that he can find a style corresponding to modern feeling, without giving up the traditional concept of sculptural form. One must add also that this concept, with its age-old ideal of beauty, never gets away from the period of Phidias and the artistic decadence which followed it.

It defies explanation how generations of sculptors can continue to construct dummies without asking themselves why all the exhibition halls of sculpture have become reservoirs of boredom and nausea, or why inaugurations of public monuments, rendezvous of uncontrollable hilarity. This is not born out by painting which, by its slow but continuous renovations, harshly condemns the plagiaristic and sterile work of all the sculptors of our time. When on earth will sculptors understand that to strive to build and to create with Egyptian, Greek, or Michelangelesque elements is just as absurd as trying to draw water from an empty well with a bottomless bucket?

45

There can be no renewal of an art if at the same time its essence is not renewed, that is, the vision and the concept of the line and masses which form its arabesque. It is not simply by reproducing the exterior aspects of life that art becomes the expression of its time; this is why sculpture as it was understood by artists of the past century and of today is a monstrous anachronism. Sculpture absolutely could not make progress in the narrow path it was assigned by the academic concept of the nude. An art which has to undress completely a man or woman in order to begin its emotive function, is stillborn.

Painting fortified, intensified, and enlarged itself thanks to the landscape and the surroundings that the Impressionist painters made act simultaneously on the human figure and on objects. It is by prolonging their efforts that we have enriched painting with our *interpenetration of planes (Technical Manifesto of Futurist Painting,* 11 April 1910). Sculpture will find a new source of emotion and, therefore, of style, by extending its plasticity into the immense domain which the human spirit has stupidly considered until now the realm of the subdivided, the impalpable, and the inexpressible.

One must start with the central nucleus of the object one wants to create, in order to discover the new forms which connect it invisibly and mathematically to the *visible plastic infinite* and to the *interior plastic infinite.* The new plasticity will thus be the translation in plaster, bronze, glass, wood, or any other material, of atmospheric planes that link and intersect things. What I have called *physical transcendentalism (Lecture on Futurist Painting* at the *Circolo artistico* in Rome, May 1911) can render plastically the sympathies and mysterious affinities which produce the reciprocal and formal influences of the objects' planes.

Sculpture should give life to objects by rendering their extension into space palpable, systematic, and plastic, because no one can deny any longer that one object continues at the point another begins, and that everything surrounding our body (bottle, automobile, house, tree, street) intersects it and divides it into sections by forming an arabesque of curves and straight lines.

There have been two modern attempts to renew sculpture: one is decorative, for the sake of the style, the other is decidedly plastic, for the sake of the materials. The first remained anonymous and disordered, due to the lack of a technical spirit capable of coordinating it. It remained linked to the economic necessities of officialdom and only produced traditional pieces of sculpture more or less decoratively synthesized, and surrounded by architectural or decorative forms. All the houses and big buildings constructed with modern taste and intentions manifest this attempt in marble, cement, or sheets of metal.

The second attempt, more serious, disinterested, and poetic, but too isolated and fragmentary, lacked the synthesizing spirit capable of imposing a law. In any work of renovation, it is not enough to believe

with fervor; one must also choose, hollow out, and then impose the route to be followed. I am referring to a great Italian sculptor: to Medardo Rosso, the only great modern sculptor who tried to enlarge the horizon of sculpture by rendering into plastic form the influences of a given environment and the invisible atmospheric links which attach it to the subject.

Constantin Meunier contributed absolutely nothing new to sculptural feeling. His statues are nearly always powerful fusions of the heroic Greek style and the athletic humility of the stevedore, the sailor, or the miner. His concept of plasticity and structure of sculpture in the round and bas-relief remained that of the Parthenon and the classical hero. He has, nevertheless, the very great merit of having been the first to try to ennoble subjects that before his time were despised, or else abandoned to realistic reproduction.

Bourdelle displays his personality by giving to the sculptural block a passionate and violent severity of masses that are abstractly architectonic. Endowed with the passionate, somber, and sincere temperament of a seeker, he could not, unfortunately, deliver himself from a certain archaicizing influence, nor of the anonymous influence of all the stone sculptors of Gothic cathedrals.

Rodin unfolded a greater intellectual agility, which permitted him to pass with ease from the Impressionism of his Balzac to the irresolution of his Burghers of Calais, and to all his other works marked by the heavy influence of Michelangelo. He displays in his sculpture a disquieting inspiration, a grandiose lyrical power, which would be truly modern if Michelangelo and Donatello had not already preceded him with nearly identical forms some four hundred years ago, and if his gifts could have brought to life a completely re-created reality.

One finds then in the work of these three talents the three influences of three different periods: Greek in Meunier's work, Gothic in Bourdelle's, Italian Renaissance in Rodin's.

The work of Medardo Rosso, on the other hand, is revolutionary, very modern, more profound, and of necessity restricted. There are hardly any heroes or symbols in his sculptural work, instead the plane of the forehead of one of his women or children embodies and points to a release toward space which one day will have in the history of the human mind an importance far superior to that now acknowledged by contemporary critics. Unfortunately, the inevitably Impressionistic laws of his endeavor limited the researches of Medardo Rosso to a sort of high or low relief; it is proof that he still conceived of the figure as an isolated world, with a traditional essence and episodic intentions.

The artistic revolution of Medardo Rosso, although very important, starts from a pictorial point of view too much concerned with the exterior, and entirely neglects the problem of a new construction of planes. His sensual modeling, which tries to imitate the lightness of the Impressionists' brushstroke, creates a fine effect of intense and

immediate sensation, but it makes him work too quickly after nature, and deprives his art of any mark of universality. The artistic revolution of Medardo Rosso thus has both the virtues and the faults of Impressionism in painting. Our Futurist revolution also began there but, although continuing Impressionism, it has come to the opposite pole.

In sculpture as well as in painting, one can renew art only by seeking the *style of movement*, that is, by forming systematically and definitively into a synthesis that which Impressionism offered in a fragmentary, accidental, and consequently analytical way. This systematization of the vibration of light and of the interpenetrations of planes will produce Futurist sculpture: it will be architectonic in character, not only from the point of view of the construction of the masses, but also because the sculptural block will contain the architectonic elements of the sculptural milieu in which the subject lives.

Naturally we will create a *sculpture of environment*. A Futurist sculptural composition will contain in itself the marvelous mathematical and geometric elements of modern objects. These objects will not be placed alongside the statue, like so many explanatory attributes or separate decorative elements but, following the laws of a new conception of harmony, they will be embedded in the muscular lines of a body. We will see, for example, the wheel of a motor projecting from the armpit of a machinist, or the line of a table cutting through the head of a man who is reading, his book in turn subdividing his stomach with the spread fan of its sharp-edged pages.

In the current tradition of sculpture, the statue's form is etched sharply against the atmospheric background of the milieu in which it stands. Futurist painting has surpassed this conception of the rhythmic continuity of lines in a figure and of its absolute isolation, without contact with the background and the *enveloping invisible space*. "Futurist poetry," according to the poet Marinetti, "after having destroyed traditional prosody and created free verse, now abolishes syntax and the Latin interval. Futurist poetry is a spontaneous flow uninterrupted by analogies, each of which is intuitively summed up in its essential substantive. From this come *untrammeled imagination and liberated words*." "The Futurist music of Balilla Pratella destroys the chronometric tyranny of rhythm."

Why, then, should sculpture remain shackled by laws which have no justification? Let us break them courageously and proclaim the *complete abolition of the finished line and the closed statue. Let us open up the figure like a window and enclose within it the environment in which it lives.* Let us proclaim that the environment must form part of the plastic block as a special world regulated by its own laws. Let us proclaim that the sidewalk can climb up your table, that your head can cross the street, and that at the same time your household lamp can suspend between one house and another the immense spider-web of its dusty rays.

Let us proclaim that all the perceptible world must hurry toward us, amalgamating itself with us, creating a harmony that will be governed only by creative intuition. A leg, an arm, or any object whatsoever, being considered important only if an element of plastic rhythm, can easily be abolished in Futurist sculpture, not in order to imitate a Greek or Roman fragment, but to obey a harmony the sculptor wishes to create. A sculptural ensemble, like a painting, can only resemble itself, because in art the human figure and the objects should live outside of and despite all logic of appearances.

A figure can have an arm clothed and the rest of the body nude. The different lines of a vase of flowers can follow one another nimbly while blending with the lines of the hat and neck.

Transparent planes of glass or celluloid, strips of metal, wire, interior or exterior electric lights can indicate the planes, the tendencies, the tones and half-tones of a new reality. By the same token, a new intuitive modulation of white, grey, and black can augment the emotive force of the planes, while a colored plane can accentuate violently the abstract signification of a plastic value.

What we have already said about *line-forces* in painting (Preface-Manifesto of the Catalogue of the First Futurist Exhibition in Paris, October 1911) applies equally to sculpture. In effect, we will give life to the static muscular line by merging it with the dynamic line-force. It will nearly always be a straight line, which is the only one corresponding to the interior simplicity of the synthesis that we oppose to the baroque exterior of analysis. However, the straight line will not lead us to imitate the Egyptians, the Primitives, and the savages, by following the absurd example of certain modern sculptors who have hoped that way to deliver themselves from Greek influence. Our straight line will be alive and palpitating; it will lend itself to the demands of the infinite expressions of materials, and its fundamental, naked severity will express the severity of steel, which characterizes the lines of modern machinism. Finally, we can affirm that the sculptor must not shrink from any means in order to obtain a *reality*. Nothing is more stupid than to fear to deviate from the art we practice. There is neither painting, nor sculpture, nor music, nor poetry. The only truth is creation. Consequently, if a sculptural composition needs a special rhythm of movement to augment or contrast the fixed rhythm of the *sculptural ensemble* (necessity of the work of art), then one could use a little motor which would provide a rhythmic movement adapted to a given plane and a given line.

One must not forget that the tick-tock and the movement of the hands of a clock, the rise and fall of a piston in its cylinder, the meshing and unmeshing of two gears with the continual disappearance and reappearance of their little steel rectangles, the frenzy of a fly-wheel, the whirl of a propeller, all these are plastic and pictorial elements of

which Futurist sculptural work must make use. For example: a valve opening and closing creates a rhythm as beautiful but infinitely newer than that of a living eyelid.

Conclusions

1. The aim of sculpture is the abstract reconstruction of the planes and volumes which determine form, not their figurative value.

2. One must *abolish in sculpture,* as in all the arts, the *traditionally exalted place of subject matter.*

3. Sculpture cannot make its goal the episodic reconstruction of reality. It should use absolutely all realities in order to reconquer the essential elements of plastic feeling. Consequently, the Futurist sculptor perceives the body and its parts as *plastic zones,* and will introduce into the sculptural composition planes of wood or metal, immobile or made to move, to embody an object; spherical and hairy forms for heads of hair; half-circles of glass, if it is a question of a vase; iron wires or trellises, to indicate an atmospheric plane, etc., etc.

4. It is necessary to destroy the pretended nobility, entirely literary and traditional, of marble and bronze, and to deny squarely that one must use a single material for a sculptural ensemble. The sculptor can use twenty different materials, or even more, in a single work, provided that the plastic emotion requires it. Here is a modest sample of these materials: glass, wood, cardboard, cement, concrete, horsehair, leather, cloth, mirrors, electric lights, etc.

5. It is necessary to proclaim loudly that in the intersection of the planes of a book and the angles of a table, in the straight lines of a match, in the frame of a window, there is more truth than in all the tangle of muscles, the breasts and thighs of heroes and Venuses which enrapture the incurable stupidity of contemporary sculptors.

6. It is only by a very modern choice of subject that one can succeed in discovering *new plastic ideas.*

7. The straight line is the only means that can lead us to the primitive virginity of a new architectonic construction of sculptural masses and zones.

8. There can be a reawakening only if we make a *sculpture of milieu or environment,* because only this way can plasticity be developed, by being extended into space in order to model it. By means of the sculptor's clay, the Futurist today can at last *model the atmosphere* which surrounds things.

9. What the Futurist sculptor creates is to a certain extent an ideal bridge which joins the exterior plastic infinite to the interior plastic infinite. It is why objects never end; they intersect with innumerable combinations of attraction and innumerable shocks of aversion. The spectator's emotions will occupy the center of the sculptural work.

10. One must systematically destroy the nude and the traditional concept of the statue and the monument.

11. Finally, one must at all cost refuse commissions of subjects determined in advance, and which therefore cannot contain a pure construction of completely renewed plastic elements.

Umberto Boccioni
Painter and sculptor
Milan, 11 April 1912

Plastic Ensembles

1. Muscles moving swiftly.
2. Synthesis of human dynamism.
3. Spiral expansion of muscles in motion.
4. Head + Houses + Light.
5. Fusion of a head and a window-frame.
6. Development by form of a bottle in space (Still life).
7. Form-forces of a bottle (Still life).
8. Abstract voids and solids of a head.
9. Antigracious [*antigracieux*].
10. Unique forms of continuity in space.
11. Development by color of a bottle in space (Still life).

Drawings

1 to 6: I wish to synthesize the unique forms of continuity in space.
7 to 15: I wish to capture human forms in motion.
16: I wish to make a head merge with its environment.
17: I wish to extend objects into space.
18 to 22: I wish to model light and air.

Le Corbusier and Ozenfant

Purism

"Purism" is the most succinct essay of many in which Jeanneret and Ozenfant defined their new movement. (In his role as architect, Jeanneret took the name "Le Corbusier" beginning in 1921.) The two artists apparently met for the first time in 1917. Charles-Édouard Jeanneret (1887–1965), a Swiss who took French citizenship, had behind him a decade of architectural study and work. From 1912 to 1916, after a long period of travel, he settled in La Chaux-de-Fonds, and then in 1917 came to Paris. Amédée Ozenfant (1886–1966) had been painting in the capital, and the same year had published a retrospective critique of Cubism in the review *L'Élan*. The two men began a close collaboration, whose first fruits included the book *Après le Cubisme* (Paris, 1918), and the formal establishment of Purism as a movement with the first Purist exhibition, also in 1918, in the Galerie Thomas. From 1920 to 1925, their review *L'Esprit Nouveau* was one of the focuses for the rationalist, post-Cubist strain that opposed itself to Dada and Surrealism. Their book *La Peinture Moderne,* published in 1925, marked the end of their association. Le Corbusier thereafter pursued a career that has given him worldwide fame as an architect, painting being essentially an avocation for him. Ozenfant published *Foundations of Modern Art* in 1928. This most delightful and stimulating book has gone through several English editions.

"Le Purisme" appeared in the fourth issue of *L'Esprit Nouveau,* 1920, pp. 369–386. Although it is hard to choose from the many essays in which Ozenfant and Jeanneret set forth their ideas, this one seems to embody the essence of Purism in the most perfect form. It is the ideal coupling of their respective origins in painting and architecture, so much so that even after a careful reading of their earlier and later individual writings, it is hard to pluck from the essay each man's independent contribution. Lest Jeanneret-Corbusier's subsequent fame lead the reader to assume his role was pre-eminent, one need only look at Ozenfant's writings in *L'Élan* of 1917. The admirer of Le Corbusier might well be surprised to find that this joint essay of 1920 contains already—some in full statement, others in embryo—all the cardinal principles of his esthetic.

This, the first translation, maintains with great care the clipped and precise language that so beautifully suited the "machine esthetic" of Purism. It also uses equivalents for the coined words that help form the essay's spirit: "architecturé" is rendered "architectured," for example, because the artists deliberately chose it in preference to the correct "architectural," which had less force for them.

I am most grateful to Ozenfant and Le Corbusier for authorizing me to translate and publish this essay.

Purism

Introduction

Logic, born of human constants and without which nothing is human, is an instrument of control and, for he who is inventive, a guide toward discovery; it controls and corrects the sometimes capricious march of intuition and permits one to go ahead with certainty.

It is the guide that sometimes precedes and sometimes follows the explorer; but without intuition it is a sterile device; nourished by intuition, it allows one "to dance in his fetters."

Nothing is worthwhile which is not general, nothing is worthwhile which is not transmittable. We have attempted to establish an esthetic that is rational, and therefore human.

It is impossible to construct without fixed points. We already sought in an earlier article[1] to determine some of these.

The Work of Art

The work of art is an artificial object which permits the creator to place the spectator in the state he wishes; later we will study the means the creator has at his disposal to attain this result.

With regard to man, esthetic sensations are not all of the same degree of intensity or quality; we might say that there is a hierarchy.

The highest level of this hierarchy seems to us to be that special state of a mathematical sort to which we are raised, for example, by the clear perception of a great general law (the state of mathematical lyricism, one might say); it is superior to the brute pleasure of the

1. "Sur la plastique," *L'Esprit Nouveau* [I], 1, 15 October 1920 [pp. 38–48].

senses; the senses are involved, however, because every being in this state is as if in a state of beatitude.

The goal of art is not simple pleasure, rather it partakes of *the nature of happiness.*

It is true that plastic art has to address itself more directly to the senses than pure mathematics which only acts by symbols, these symbols sufficing to trigger in the mind consequences of a superior order; in plastic art, the senses should be strongly moved in order to predispose the mind to the release into play of subjective reactions without which there is no work of art. But there is no art worth having without this excitement of an intellectual order, of a mathematical order; architecture is the art which up until now has most strongly induced the states of this category. The reason is that everything in architecture is expressed by order and economy.

The means of executing a work of art is a transmittable and universal language.

One of the highest delights of the human mind is to perceive the order of nature and to measure its own participation in the scheme of things; the work of art seems to us to be a labor of putting into order, a masterpiece of human order.

Now the world only appears to man from the human vantage point, that is, the world seems to obey the laws man has been able to assign to it; when man creates a work of art, he has the feeling of acting as a "god."

Now a law is nothing other than the vertification of an order.

In summary, a work of art should induce a sensation of a mathematical order, and the means of inducing this mathematical order should be sought among universal means.

System

One cannot, therefore, hope to obtain these results by the empirical and infinitely impure means that are used habitually.

Plastic art, modern architecture, modern painting, modern sculpture, use a language encumbered by terms that are confused, poorly defined, undefinable. This language is a heterogeneous mixture of means used by different and successive schools of esthetics, nearly all of which considered only the release of the sensations of immediate feeling; it does not suit the creation of works which shall have what we demand.

We established in our article "On the Plastic" that there are two quite distinct orders of sensation:

1. Primary sensations determined in all human beings by the simple play of forms and primary colors. *Example:* If I show to everyone on Earth—a Frenchman, a Negro, a Laplander—a sphere in the form of a billiard ball (one of the most perfect human materializations of the

sphere), I release in each of these individuals an identical sensation inherent in the spherical form: *this is the constant primary sensation.* The Frenchman will associate with it ideas of sport, billiards, the pleasures or displeasures of playing, etc.—variables. The Laplander or the Negro may not associate any idea with it at all or, on the other hand, they might associate with it an idea of divinity: *there is thus a constant, fixed sensation released by the primary form.*

[2.] There are secondary sensations, varying with the individual because they depend upon his cultural or hereditary capital. *Example:* If I hold up a primary cubic form, I release in each individual the same primary sensation of the cube; but if I place some black geometric spots on the cube, I immediately release in a civilized man an idea of dice to play with, and the whole series of associations which would follow.

A Papuan would only see an ornament.

There are, therefore, besides the primary sensation, infinitely numerous and variable secondary sensations. The primary sensation is constant for every individual, it is universal, it can be differentiated by quantity, but it is *constant in quality:* there are some people who have thick skins. This is a capital point, a fixed point.

What we have said for the cube and the sphere is true for all the other primary forms, for all the primary colors, for all the primary lines; it is just as true for the cube, the sphere, the cylinder, the cone and the pyramid as for the constituent elements of these bodies, the triangle, the square, the circle, as for straight, broken or curved lines, as for obtuse, right, or acute angles, etc.—all the primary elements which react unthinkingly, uniformly, in the same way, on all individuals.

The sensations of a secondary order graft themselves on these primary sensations, producing the intervention of the subject's hereditary or cultural contribution. If brute sensations are of a universal, intrinsic order, secondary sensations are of an individual, extrinsic order. Primary sensations constitute the bases of the plastic language; these are the *fixed words* of the plastic language; it is a fixed, formal, explicit, universal language determining subjective reactions of an individual order which permit the erection on these raw foundations of a sensitive work, rich in emotion.

It does not seem necessary to expatiate at length on this elementary truth that anything of universal value is worth more than anything of merely individual value. It is the condemnation of "individualistic" art to the benefit of "universal" art.

It then becomes clear that to realize this proposed goal it is necessary right now to make an inventory of the plastic vocabulary and to purify it in order to create a transmittable language.

An art that would be based only upon primary sensations, using

uniquely primary elements, would be only a primary art, rich, it is true, in geometric aspects, but denuded of all sufficient human resonance: it would be an ornamental art.[2]

An art that would be based only upon the use of secondary sensations (an art of allusions) would be an art without a plastic base. The mind of some individuals—only those in intimate resonance with the creator—could be satisfied with it: an art of the initiated, an art requiring knowledge of a key, an art of symbols. This is the critique of most contemporary art; it is this art which, stripped of universal primary elements, has provoked the creation of an immense literature around these works and these schools, a literature whose goal is to explain, to give the key, to reveal the secret language, to permit comprehension.

The great works of the past are those based on primary elements, and this is the only reason why they endure.

Superior sensations of a mathematical order can be born only of a choice of primary elements with secondary resonance.

Having shown that the use of primary elements by themselves can lead only to an ornamental art, we think that to paint means to create constructions: formal and colored organizations based on the theme-objects endowed with elementary properties rich in subjective trigger actions. Thus it will be well to choose those theme-objects whose secondary trigger actions are the most universal. The list of these objects would have at its head: man, the beings organized by and the objects fabricated by man, particularly those which one might consider as complements of the human organism.

Man and organized beings are products of *natural selection*. In every evolution on earth, the organs of beings are more and more adapted and purified, and the entire forward march of evolution is a function of purification. The human body seems to be the highest product of natural selection.

When examining these selected forms, one finds a tendency toward certain identical aspects, corresponding to constant functions, functions which are of maximum efficiency, maximum strength, maximum capacity, etc., that is, maximum economy. ECONOMY is the law of natural selection.

It is easy to calculate that it is also the great law which governs what we will call "mechanical selection."

Mechanical selection began with the earliest times and from those times provided objects whose general laws have endured; only the means of making them changed, the rules endured.

In all ages and with all people, man has created for his use objects of prime necessity which responded to his imperative needs; these objects

2. See *Après le Cubisme*, Ozenfant and Jeanneret, 1918.

were associated with his organism and helped complete it. In all ages, for example, man has created containers: vases, glasses, bottles, plates, which were built to suit the needs of maximum capacity, maximum strength, maximum economy of materials, maximum economy of effort. In all ages, man has created objects of transport: boats, cars; objects of defense: arms; objects of pleasure: musical instruments, etc., all of which have always obeyed the law of selection: economy.

One discovers that all these objects are true extensions of human limbs and are, for this reason, of human scale, harmonizing both among themselves and with man.

The machine was born in the last century. The problem of selection was posed more imperatively than ever (commercial rivalry, cost price); one might say that the machine has led fatally to the strictest respect for, and application of, the laws of economy.

M. Jacques-Emile Blanche will think that these considerations lead us far from painting. On the contrary! It is by the phenomenon of mechanical selection that the forms are established which can almost be called permanent, all interrelated, associated with human scale, containing curves of a mathematical order, curves of the greatest capacity, curves of the greatest strength, curves of the greatest elasticity, etc. These curves obey the laws which govern matter. They lead us quite naturally to satisfactions of a mathematical order.

Modern mechanization would appear to have created objects decidedly remote from what man had hitherto known and practiced. It was believed that he had thus retreated from natural products and entered into an arbitrary order; our epoch decries the misdeeds of mechanization. We must not be mistaken, this is a complete error: the machine has applied with a rigor greater than ever the physical laws of the world's structure. To tell the truth, contemporary poets have only lamented one thing, the peasants' embroidered shirts and the Papuans' tattoos. If blind nature, who produces eggs, were also to make bottles, they would certainly be like those made by the machine born of man's intelligence.

From all this comes a fundamental conclusion: that respect for the laws of physics and of economy has in every age created highly selected objects; that these objects contain analogous mathematical curves with deep resonances; that these artificial objects obey the same laws as the products of natural selection and that, consequently, there thus reigns a total harmony, bringing together the only two things that interest the human being: himself and what he makes.

Both natural selection and mechanical selection are manifestations of purification.

From this it would be easy to conclude that the artist will again find elitist themes in the objects of natural and mechanical selection. As it happens, artists of our period have taken pleasure in ornamental art and have chosen ornamented objects.

A work of art is an association, a symphony of consonant and architectured forms, in architecture and sculpture as well as in painting.

To use as theme anything other than the objects of selection, for example, objects of decorative art, is to introduce a second symphony into the first; it would be redundant, surcharged, it would diminish the intensity and adulterate the quality of the emotion.

Of all recent schools of painting, only Cubism foresaw the advantages of choosing selected objects, and of their inevitable associations. But, by a paradoxical error, instead of sifting out the general laws of these objects, Cubism only showed their accidental aspects, to such an extent that on the basis of this erroneous idea it even re-created arbitrary and fantastic forms. Cubism made square pipes to associate with matchboxes, and triangular bottles to associate with conical glasses.

From this critique and all the foregoing analyses, one comes logically to the necessity of a reform, the necessity of a logical choice of themes, and the necessity of their association not by deformation, but *by formation.*

If the Cubists were mistaken, it is because they did not seek out the invariable constituents of their chosen themes, which could have formed a universal, transmittable language.

Between the chosen theme-object and the plastic organism which the creator's imagination derives from it, there intervenes the necessary labor of total plastic re-creation.

Our concept of the object comes from total knowledge of it, a knowledge acquired by the experience of our senses, tactile knowledge, knowledge of its materials, its volume, its profile, of all its properties. And the usual perspective view only acts as the shutter-release for the memory of these experiences.

Ordinary perspective with its theoretical rigor only gives an accidental view of objects: the one which an eye, having never before seen the object, would see if placed in the precise visual angle of this perspective, always a particular and hence an incomplete angle.

A painting constructed with exact perspective appeals nearly exclusively to sensations of a secondary order and is consequently deprived of what could be universal and durable.

There are, then, good grounds for creating images, organizations of form and color which bear the invariable, fundamental properties of the object-themes. It is by a skillful, synthesizing figuration of these invariable elements that the painter will, upon bases of primary sensations, make his disposition of secondary sensations that are transmittable and universal: the *"Purist"* quest.

The Purist element is like a plastic word duly formed, complete, with precise and universal reactions.

Of course it must not be assumed that Purist elements are like so

many stencils that one could juxtapose on the surface of a painting; but we do wish to say that the Purist element, a bottle-element for example, ought always to embody the characteristic and invariant constants of the object-theme, subject to the modifications demanded by the composition.

Purism would never permit a bottle of triangular shape, because a triangular bottle, which eventually could be produced by a glass-blower, is only an exceptional object, a fantasy, like the idea behind it.

Conception

We have already said that the goal of art is to put the spectator in a state of a mathematical quality, that is, a state of an elevated order. To conceive, it is first necessary to know what one wishes to do and to specify the proposed goal; to know if one wishes to settle for pleasing the senses, or if one wishes the painting to be a simple pleasure for the eyes, or to know if one wishes to satisfy the senses and the mind at the same time.

There are obviously those arts whose only ambition is to please the senses; we call them "arts of pleasure." Purism offers an art that is perhaps severe, but one that addresses itself to the elevated faculties of the mind.

This is stated to make it clear that the creator should put himself in a certain state of mind before picking up his paintbrush.

Conception is, in effect, an operation of the mind which foreshadows the general look of the art work.

Possessed of a method whose elements are like the words of a language, the creator chooses among these words those that he will group together to create a symphony of sensations in the spectator, a symphony that will place the spectator in a state of a particular quality, joy, gaiety, sadness, etc.

Often there is a confusion between conception and composition. These are two entirely different things, conception being a state of mind; composition, a technical means.

Conception is the choice, the decision of which emotion to transmit; composition is the choice of means capable of transmitting this emotion.

Composition

Composition is our stock-in-trade; it involves tasks of an exclusively physical order. Composition comprises choice of surface, division of the surface, co-modulation, relationships of density, color scheme.

A painting is an association of purified, related, and architectured elements.

A painting should not be a fragment, a painting is a whole. A viable organ is a whole: a viable organ is not a fragment.

Space is needed for architectural composition; space means three dimensions. Therefore we think of the painting not as a surface, but *as a space*.

It is customary to choose the format of the painting rather arbitrarily. Many painters unthinkingly adopt very elongated surfaces, fragmentary surfaces which pass beyond the eye's normal field.

Now there is a correlation between the eye's visual cone and the painting it covers.

The eye should be confronted with a space which gives the impression of a whole. A landscape seen through a high window, a bull's-eye or a square window gives a painful impression because it is fragmentary: the window of a sleeping-car offers a satisfying visual field corresponding to normal vision.

If Ingres paper and Whatman paper have a fixed format, and if canvases of 40 x 32, for example, have a format unchanged for so many years, it is because their proportions satisfy physiological needs. These formats correspond to the visual cone and their whole extent can be grasped in a single glance; a natural philosopher would perhaps demonstrate that these slightly oblong proportions harmonize with the visual cone which is not circular, but slightly oval, and one could thus explain that vertical paintings are less satisfying than horizontal.

The square format is a particular case resulting in a truncated space. Moreover, it is deprived of one of the fundamental plastic necessities, that of rhythm, precluded by the equal sides.

For physiological reasons we cannot develop here, one could also verify that the vertical line has dynamic properties opposed to the static properties of the horizontal. The eye becomes tired climbing up a vertical, and comes rapidly back down. This explains the dynamic property of the vertical line, contrary to the horizontal which generates feelings of stability, calm, and repose, sensations resulting from the slight energy necessitated by the journey. This explains why surfaces of vertical extent possess properties very different from those of horizontal surfaces.

Moreover, the painter should not concentrate on particular surfaces which necessarily determine sensations of an accidental order. A painting surface should make one forget its limits, it should be *indifferent*.

As for us, we have chosen surfaces similar to the 40 x 32 canvas, considering it to be of an indifferent order of surface.

Further, this surface has important geometric properties; it permits various regulating lines which determine geometric locations of the highest plastic value. These regulating lines are those of the equilateral triangle which neatly fits on a canvas and determines on its axes two *right-angle locations* of the highest constructive value.

The painting is thus divided into segments with like angles and contains lines which lead the eye to the most sensitive points. These sensitive points constitute truly strategic and organic centers of the composition.

This is a capital fact for plastic art because in all ages and times, great works of architecture as well as of painting have been composed by imperious regulating lines of this nature.

Compositions thus endowed, instead of following the caprices of an effervescent imagination, will have generous directives in the subdividing of the painting which will determine its concordances, amplify its resonances, discipline the grouping of its masses, and locate its capital points.

The choice of surface for such geometric determinations has been a preoccupation of every age. Memory of it remains in the famous term *golden section* which haunts studios like the specter of the philosophical stone. The golden section is not a portion of the surface. It is a mathematical section permitting the division of a straight line so that a harmonious relation reigns between the two segments.

A triangle is constructed on this division called the *golden section triangle,* and this triangle, peddled in cardboard in all the studios, is used as a unifier of angles; it has some benefits, but pushing it about on the painting without a coherent orientation with the format does not realize the plastic condition, which demands that the directive lines of a painting proceed from the geometric properties of the surface.

The old masters used the golden section, as well as others, such as the *harmonic section,* to modulate their works: but they used them as divisions of lines, not of surfaces.

Once the composition is built upon the formal bases of this firm geometry, there is still unity to attain, the factor of order. The *module* comes in at this point.

Unity in plastic art, the homogeneity of the creator's ideas with his means, is the homogeneous relationship of surface or volume with each of the elements brought into play. The modular method is the only sensible way of bringing about order; it lets the smallest element measure the largest (give or take the necessary corrections and optical illusions); it provides what the old masters called proportion.

"Co-modulation" permits organization; without it, there is no plastic art, only piles of stones or spots of color.[3]

3. Cézanne had the habit of saying that he had to *modulate* his canvas. This term has been misinterpreted in our epoch when "sensitivity" holds such a high place. It is not understood that Cézanne, when he spoke of a module, thought of it as would an architect and was seeking to give unity to his formal conceptions; it has been thought that to modulate meant to work musically, to add nuances, to warble. It was a case of form, not of sound.

Values: Once the composition is solidly built upon directives imposed by the format of the canvas, co-modulated by the intervention of a unifying agent, one must still determine the exact play of densities and the values of light and shade. This play of values is composed of two factors: shadow and light; it creates a rhythm whose relationships shall be dictated by the nature of the feeling to be stimulated.

An analysis of old works shows certain constants in the distribution of density of light and shade, following the intention of the painting, constants that we have easily shown to exist by a method of weighing (used also in astronomy, but which we have applied to painting).

When one says painting, inevitably he says color. But color has properties of shock (sensory order) which strike the eye before form (which is a creation already cerebral in part).

Now painting is a question of architecture, and therefore volume is its means.

In the expression of volume, color is a perilous agent; often it destroys or disorganizes volume because the intrinsic properties of color are very different, some being radiant and pushing forward, others receding, still others being massive and staying in the real plane of the canvas, etc.; citron yellow, ultramarine blue, earths and vermilions all act very differently, so differently that one can admit without error a certain classification by family.

One can by hierarchy determine the *major scale,* formed of ochre yellows, reds, earths, white, black, ultramarine blue, and, of course, certain of their derivatives; this scale is a strong, stable scale giving unity and holding the plane of the picture since these colors keep one another in balance. They are thus essentially constructive colors; it is these that all the great periods employed; it is these that whoever wishes to paint in volume should use.

Second scale.—The *dynamic scale,* including citron yellow, the oranges (chrome and cadmium), vermilions, Veronese green, light cobalt blues. An essentially animated, agitated scale, giving the sensation of a perpetual change of plane; these colors do not keep to one plane; sometimes they seem in front of the surface plane, sometimes behind. They are the disturbing elements.

Finally there is the *transitional scale,* the madders, emerald green, all the lakes which have properties of tinting, not of construction.

This analysis leads to a formal conclusion; on the use of one or another of these categories, or their intermixing, rest the three great methods of plastic realization which have shared the favor of artists, who pursued different goals according as their esthetic was more or less architectural.

There are in effect two strong, and totally different manners of pictorial expression, either using the exclusive aid of light and shade and uniting all objects by the unique factor of luminous intensity, or else

accepting objects in their qualifying color and painting them in this local qualifying hue (local tone). A painting cannot be made without color. Neither Cubism—black-and-white period of Picasso, among others— nor the Last Judgment in the Sistine Chapel were able to do without it. The painters resolved this formidable fatality of color in both cases by harmonizing it with the first great need of a plastic work, unity. Artists of the first manner mentioned above, Michelangelo, Rembrandt, El Greco, Delacroix, found harmony by judiciously arranging tinted light; the others, Raphael, Ingres, Fouquet, accepted local qualifiers and attempted to maintain the expression of volume, despite the disaggregating force of color. Thus, with El Greco, the same yellow lightens the edge of an angel's wing, the knee of a figure, the lines of a face, and the convexities of a cloud; the same madder red colors clothing, ground, or buildings; the same thing in Renoir's case. With Ingres, as with Raphael, a figure is in flesh tone, a drapery is blue or red, a pavement is black, brown or white, a sky is blue or grey. As for Cézanne, who practiced the obstinate and maniacal search for volume with all the confusion and trouble which animated his being, his work became monochromatic; all his beautiful, vivid greens,[4] all the precious vermilions, all the chrome yellows and azure blues of his palette were in the end broken to such a degree that his painting is one of the most monochromatic of any period: the paradoxical activity of an orchestra leader (this latter a really contemporary figure) who tries to make violin music with an English horn, and bassoon sounds with a violin.

Finally there are painters of recent times who have mixed the two manners and who, not possessed of an architectural esthetic, use indifferently all the families of colors, happy that they produce a vibrato adjudged pleasant but which in the long run brings their work back to the esthetic of printed cloth (virtue of dyes).

In summary, in a true and durable plastic work, it is *form* which comes first and everything else should be subordinated to it. Everything should help establish the architectural achievement. Cézanne's imitators were quite right to see the error of their master, who accepted without examination the attractive offer of the color-vendor, in a period marked by a fad for color-chemistry, a science with no possible effect on great painting.

Let us leave to the clothes-dyers the sensory jubilations of the paint tube.

As for us, we find that the *major scale* alone furnishes unlimited richnesses, and that an impression of vermilion can be given not just sufficiently, but yet more powerfully, by the use of burnt ochre. In accepting this discipline, we have the certitude of confining color to its hierarchical place; even then, with this carefully picked scale, what discernment it takes to mat the colors!

4. See *L'Esprit Nouveau*, Number 2, p. 144.

To conclude the problem of color, it is well to specify certain purely rational investigations which add reassuring certitudes based upon our visual functions, our experience, and our habits. Our mind reacts to colors as it reacts to basic forms. There are brutal colors and suave colors, each appropriate to its object. Moreover, given the play of memory, acquired in looking at nature, logical and organic habits are created in us which confer on each object a qualifying, and hence constructive color; thus blue cannot be used to create a volume that should "come forward," because our eye, accustomed to seeing blue in depths (sky, sea), in backgrounds and in distant objects (horizons), does not permit with impunity the reversing of these conditions. Hence a plane that comes forward can never be blue; it could be green (grass), brown (earth); in summary, colors should be disciplined while taking account of these two incontestable standards:

1. The primary sensory standard, immediate excitation of the senses (red and the bull, black and sadness).

2. The secondary standard of memory, recall of visual experience and of our harmonization of the world (soil is not blue, the sky is not brown, and if sometimes they may seem so, it would only be an accident to be disregarded by an art of invariables).

Sensitivity

At last we come to sensitivity.

Until now, if M. Jacques-Emile Blanche has been willing to follow us, he must have found in all this a good many "platitudes," and little place for exquisite and noble sensitivity.

Until now, we have spoken only of the means of making works of art, because it is there that ideas must command respect. For the question of individual talent, there is really little that can be said; it is a gift of God and not of esthetics. We are here in full harmony of thought with M. J.-E. Blanche: that an art deprived of sensitivity does not exist, and that sensitivity gives life to a work of art. All the same, we affirm that the mind claims imperative rights in what is called a work of art, the work of art being one of the highest manifestations of the human mind. In admitting this postulate, we acknowledge the necessity of architectured painting; we have sought to push aside all factors of futility or disaggregation; we have sought to bring together the constructive means; we have kept to physical questions and have tried that way to throw out bridges toward mathematical order.

Purism

The highest delectation of the human mind is the perception of order, and the greatest human satisfaction is the feeling of collaboration or participation in this order. The work of art is an artificial

object which lets the spectator be placed in the state desired by the creator. The sensation of order is of a mathematical quality. The creation of a work of art should utilize means for specified results. Here is how we have tried to create a language possessing these means:

Primary forms and colors have standard properties (universal properties which permit the creation of a transmittable plastic language). But the utilization of primary forms does not suffice to place the spectator in the sought-for state of mathematical order. For that one must bring to bear the associations of natural or artificial forms, and the criterion for their choice is the degree of selection at which certain elements have arrived (natural selection and mechanical selection). The Purist element issued from the purification of standard forms is not a copy, but a creation whose end is to materialize the object in all its generality and its invariability. Purist elements are thus comparable to words of carefully defined meaning; Purist syntax is the application of constructive and modular means; it is the application of the laws which control pictorial space. A painting is a whole (unity); a painting is an artificial formation which, by appropriate means, should lead to the objectification of an entire "world." One could make an art of allusions, an art of fashion, based upon surprise and the conventions of the initiated. Purism strives for an art free of conventions which will utilize plastic constants and address itself above all to the universal properties of the senses and the mind.

Schwitters
Merz

Kurt Schwitters (1887–1948) was trained in Dresden and Berlin art schools before World War I. In the waning months of the war—he had served as military clerk—he joined Herwarth Walden's Berlin group "Sturm." His work was then a blend of international Cubism and German Expressionism, but by 1919, more appropriately for the nascent Dada movement, he invented "Merz," a name ostensibly chosen arbitrarily from the middle syllable of the German for "commercial," but with amusing resonance in French. Merz consisted of relief assemblages of disparate materials: sculptures, collages, rubber-stamp drawings, prints, prose, and poems (most famously "*An Anna Blume*," published by *Der Sturm* in 1919). Believing that art, not social action, was the proper vehicle of change, Schwitters was opposed by the politically minded artists of Berlin's "Club Dada." Subsequently he, Hans Arp, Tristan Tzara, and Theo Van Doesburg cosigned a manifesto that declared art's independence from politics.

Schwitters settled in Hanover, which became the scene of his prolific activity, including his long-lived review *Merz* (1923–32), to which he invited collaborators including Lissitzky, Arp, and Van Doesburg. In 1920 he began the construction of his "Merzbau," a constantly growing transformation of the interior of his living quarters (destroyed in 1943). Equally subversive of the traditional separation of the arts, his poetry was a form of verbal music. Through his friendship with Raoul Hausmann he had become fascinated with phonetic poetry that stressed the sounds of words and detached syllables and letters. In *Merz* in 1925 (vol. 13) he published a "Merz-Grammaphonplatte" on which he intoned his masterwork of sound poetry, "*Scherzo der Ursonate*," which he also performed publicly. Over the course of the decade he published poems and essays in many avant-garde journals in France, Belgium, Holland, and Germany. In 1937 he moved to Norway to escape Hitler and then, when the Germans invaded that country in 1940, he fled to Great Britain and remained there until his death. His last major work was a later form of "Merzbau" constructed at his residence in Ambleside in the Lake District.

In 1920, on the occasion of an exhibition of his work in Munich, Schwitters published the essay "Merz," in part to defend his art against the attacks of Richard Huelsenbeck and other Berlin Dadaists ("husk Dadas" instead of "kernel Dadas"). Its tone is not that of a polemic; it is a well-reasoned, rather pedagogical account of his art and beliefs. His dispassionate prose was an intentional contrast with the explosive Dada of his art, much as one might wear a tuxedo to a flea market. Merz is identified with freedom, "not lack of restraint, but the product of strict artistic discipline." In such words we already find hints of the neat geometry of many of his collages, prints, and assemblages, which by 1922 often were closely related to

international Constructivism. Furthermore, Merz was conceived as a defense of abstraction and of creative art, "and is an enemy of kitsch." The less conservative side of Schwitters shows in the long section on Merz theater, interpolated from an essay he had recently published in *Sturmbühne*, vol. 8. "Merz" was translated by Ralph Manheim from *Der Ararat* 2 (1921) for Robert Motherwell, ed., *The Dada Painters and Poets*, published in 1951 by Wittenborn, Schultz (pp. 57–65). I thank Wittenborn Art Books for permission to reprint it here. The original text and Manheim's translation were reprinted in Schwitters' collected works, edited by Friedhelm Lach, *Kurt Schwitters: Das literarisches Werk* (Cologne, 5 vols., 1973–81), vol. 5, pp. 74–82, 404–409.

Merz

I was born on June 20, 1887 in Hanover. As a child I had a little garden with roses and strawberries in it. After I had graduated from the *Realgymnasium* [scientific high school] in Hanover, I studied the technique of painting in Dresden with Bantzer, Kühl and Hegenbarth. It was in Bantzer's studio that I painted my Still Life with Chalice. The selection of my works now [1920] on exhibit at the Hans Goltz Gallery, Briennerstrasse 8, Munich, is intended to show how I progressed from the closest possible imitation of nature with oil paint, brush and canvas, to the conscious elaboration of purely artistic components in the Merz object, and how an unbroken line of development leads from the naturalistic studies to the Merz abstractions.

To paint after nature is to transfer three-dimensional corporeality to a two-dimensional surface. This you can learn if you are in good health and not color blind. Oil paint, canvas and brush are material and tools. It is possible by expedient distribution of oil paint on canvas to copy natural impressions; under favorable conditions you can do it so accurately that the picture cannot be distinguished from the model. You start, let us say, with a white canvas primed for oil painting and sketch in with charcoal the most discernible lines of the natural form you have chosen. Only the first line may be drawn more or less arbitrarily, all the others must form with the first the angle prescribed by the natural model. By constant comparison of the sketch with the model, the lines can be so adjusted that the lines of the sketch will correspond to those of the model. Lines are now drawn by feeling, the accuracy of the feeling is checked and measured by comparison of the estimated angle of the line with the perpendicular in nature and in the sketch. Then, according to the apparent proportions between the parts of the model, you sketch in the proportions between parts on the canvas, preferably by means of broken lines delimiting these parts. The size of the first part is arbitrary, unless your plan is to represent a part, such as the head, in "life size." In that case you measure with a compass an imaginary line running parallel to a plane on the natural object conceived as a plane on the picture, and use this measurement in representing the first part. You adjust all the remaining parts to the first through feeling, according to the corresponding parts of the model, and check your feeling by measurement; to do this, you place the picture so far away from you that the first part appears as large in the painting as in the model, and then you compare. In order to check a given proportion, you hold

out the handle of your paint brush at arm's length towards this proportion in such a way that the end of the handle appears to coincide with one end of the proportion; then you place your thumb on the brush handle so that the position of the thumbnail on the handle coincides with the other end of the proportion. If then you hold the paint brush out towards the picture, again at arm's length, you can, by the measurement thus obtained, determine with photographic accuracy whether your feeling has deceived you. If the sketch is correct, you fill in the parts of the picture with color, according to nature. The most expedient method is to begin with a clearly recognizable color of large area, perhaps with a somewhat broken blue. You estimate the degree of matness and break the luminosity with a complementary color, ultramarine, for example, with light ochre. By addition of white you can make the color light, by addition of black dark. All this can be learned. The best way of checking for accuracy is to place the picture directly beside the projected picture surface in nature, return to your old place and compare the color in your picture with the natural color. By breaking those tones that are too bright and adding those that are still lacking, you will achieve a color tonality as close as possible to that in nature. If one tone is correct, you can put the picture back in its place and adjust the other colors to the first by feeling. You can check your feeling by comparing every tone directly with nature, after setting the picture back beside the model. If you have patience and adjust all large and small lines, all forms and color tones according to nature, you will have an exact reproduction of nature. This can be learned. This can be taught. And in addition, you can avoid making too many mistakes in "feeling" by studying nature itself through anatomy and perspective and your medium through color theory. That is academy.

I beg the reader's pardon for having discussed photographic painting at such length. I had to do this in order to show that it is a labor of patience, that it can be learned, that it rests essentially on measurement and adjustment and provides no food for artistic creation. For me it was essential to learn adjustment, and I gradually learned that the adjustment of the elements in painting is the aim of art, not a means to an end, such as checking for accuracy. It was not a short road. In order to achieve insight, you must work. And your insight extends only for a small space, then mist covers the horizon. And it is only from that point that you can go on and achieve further insight. And I believe that there is no end. Here the academy can no longer help you. There is no means of checking your insight.

First I succeeded in freeing myself from the literal reproduction of all details. I contented myself with the intensive treatment of light effects through sketch-like painting (impressionism).

With passionate love of nature (love is subjective) I emphasized the main lines by exaggeration, the forms by limiting myself to what was

most essential and by outlining, and the color tones by breaking them down into complementary colors.

The personal grasp of nature now seemed to me the most important thing. The picture became an intermediary between myself and the spectator. I had impressions, painted a picture in accordance with them; the picture had expression.

One might write a catechism of the media of expression if it were not useless, as useless as the desire to achieve expression in a work of art. Every line, color, form has a definite expression. Every combination of lines, colors, forms has a definite expression. Expression can be given only to a particular structure, it cannot be translated. The expression of a picture cannot be put into words, any more than the expression of a word, such as the word "and" for example, can be painted.

Nevertheless, the expression of a picture is so essential that it is worth while to strive for it consistently. Any desire to reproduce natural forms limits one's force and consistency in working out an expression. I abandoned all reproduction of natural elements and painted only with pictorial elements. These are my abstractions. I adjusted the elements of the picture to one another, just as I had formerly done at the academy, yet not for the purpose of reproducing nature but with a view to expression.

Today the striving for expression in a work of art also seems to me injurious to art. Art is a primordial concept, exalted as the godhead, inexplicable as life, indefinable and without purpose. The work of art comes into being through artistic evaluation of its elements. I know only how I make it, I know only my medium, of which I partake, to what end I know not.

The medium is as unimportant as I myself. Essential is only the forming. Because the medium is unimportant, I take any material whatsoever if the picture demands it. When I adjust materials of different kinds to one another, I have taken a step in advance of mere oil painting, for in addition to playing off color against color, line against line, form against form, etc., I play off material against material, for example, wood against sackcloth. I call the *weltanschauung* from which this mode of artistic creation arose "Merz."

The word "Merz" had no meaning when I formed it. Now it has the meaning which I gave it. The meaning of the concept "Merz" changes with the change in the insight of those who continue to work with it.

Merz stands for freedom from all fetters, for the sake of artistic creation. Freedom is not lack of restraint, but the product of strict artistic discipline. Merz also means tolerance towards any artistically motivated limitation. Every artist must be allowed to mold a picture out of nothing but blotting paper for example, provided he is capable of molding a picture.

The reproduction of natural elements is not essential to a work of art. But representations of nature, inartistic in themselves, can be elements in a picture, if they are played off against other elements in the picture. At first I concerned myself with other art forms, poetry for example. Elements of poetry are letters, syllables, words, sentences. Poetry arises from the interaction of these elements. Meaning is important only if it is employed as one such factor. I play off sense against nonsense. I prefer nonsense but that is a purely personal matter. I feel sorry for nonsense, because up to now it has so seldom been artistically molded, that is why I love nonsense.

Here I must mention Dadaism, which like myself cultivates nonsense. There are two groups of Dadaists, the kernel Dadas and the husk Dadas. Originally there were only kernel Dadaists, the husk Dadaists peeled off from this original kernel under their leader Huelsenbeck [Huelse is German for husk, Tr.] and in so doing took part of the kernel with them. The peeling process took place amid loud howls, singing of the *Marseillaise,* and distribution of kicks with the elbows, a tactic which Huelsenbeck still employs. . . . In the history of Dadaism Huelsenbeck writes: "All in all art should get a sound thrashing." In his introduction to the recent *Dada Almanach,* Huelsenbeck writes: "Dada is carrying on a kind of propaganda against culture." Thus Huelsendadaism is oriented towards politics and against art and against culture. I am tolerant and allow every man his own opinions, but I am compelled to state that such an outlook is alien to Merz. As a matter of principle, Merz aims only at art, because no man can serve two masters.

But "the Dadaists' conception of Dadaism varies greatly," as Huelsenbeck himself admits. Tristan Tzara, leader of the kernel Dadaists, writes in his *Dada manifesto 1918:* "Everyone makes his art in his own way," and further "Dada is the watchword of abstraction." I wish to state that Merz maintains a close artistic friendship with kernel Dadaism as thus conceived and with the kernel Dadaists Hans Arp, of whom I am particularly fond, Picabia, Ribemont-Dessaignes and Archipenko. In Huelsenbeck's own words, Huelsendada has made itself into "God's clown," while kernel Dadaism holds to the good old traditions of abstract art. Huelsendada "foresees its end and laughs about it," while kernel Dadaism will live as long as art lives. Merz also strives towards art and is an enemy of *kitsch,* even if it calls itself Dadaism under the leadership of Huelsenbeck. Every man who lacks artistic judgment is not entitled to write about art: "quod licet jovi non licet bovi." Merz energetically and as a matter of principle rejects Herr Richard Huelsenbeck's inconsequential and dilettantish views on art, while it officially recognizes the above-mentioned views of Tristan Tzara.

Here I must clear up a misunderstanding that might arise through

my friendship with certain kernel Dadaists. It might be thought that I call myself a Dadaist, especially as the word "dada" is written on the jacket of my collection of poems, *Anna Blume,* published by Paul Steegemann.

On the same jacket is a windmill, a head, a locomotive running backwards and a man hanging in the air. This only means that in the world in which Anna Blume lives, in which people walk on their heads, windmills turn and locomotives run backwards, Dada also exists. In order to avoid misunderstandings, I have inscribed "Antidada" on the outside of my Cathedral. This does not mean that I am against Dada, but that there also exists in this world a current opposed to Dadaism. Locomotives run in both directions. Why shouldn't a locomotive run backwards now and then?

As long as I paint, I also model. Now I am doing Merz plastics: Pleasure Gallows and Cult-pump. Like Merz pictures, the Merz plastics are composed of various materials. They are conceived as round plastics and present any desired number of aspects.

Merz House was my first piece of Merz architecture. Spengemann writes in *Zweeman,* No. 8–12: "In Merz House I see the cathedral: *the* cathedral. Not as a church, no, this is art as a truly spiritual expression of the force that raises us up to the unthinkable: absolute art. This cathedral cannot be used. Its interior is so filled with wheels that there is no room for people . . . that is absolute architecture, it has an artistic meaning and no other."

To busy myself with various branches of art was for me an artistic need. The reason for this was not any urge to broaden the scope of my activity, it was my desire not to be a specialist in one branch of art, but an artist. My aim is the Merz composite art work, that embraces all branches of art in an artistic unit. First I combined individual categories of art. I pasted words and sentences into poems in such a way as to produce a rhythmic design. Reversing the process, I pasted up pictures and drawings so that sentences could be read in them. I drove nails into pictures in such a way as to produce a plastic relief aside from the pictorial quality of the painting. I did this in order to efface the boundaries between the arts. The composite Merz work of art, par excellence, however, is the Merz stage which so far I have only been able to work out theoretically. The first published statement about it appeared in *Sturmbühne,* No. 8: "The Merz stage serves for the performance of the Merz drama. The Merz drama is an abstract work of art. The drama and the opera grow, as a rule, out of the form of the written text, which is a well-rounded work in itself, without the stage. Stage-set, music and performance serve only to illustrate this text, which is itself an illustration of the action. In contrast to the drama or the opera, all parts of the Merz stage-work are inseparably bound up together; it cannot be written, read or listened to, it can only be produced in the theatre. Up until now, a distinction was made between

stage-set, text, and score in theatrical performances. Each factor was separately prepared and could also be separately enjoyed. The Merz stage knows only the fusing of all factors into a composite work. Materials for the stage-set are all solid, liquid and gaseous bodies, such as white wall, man, barbed wire entanglement, blue distance, light cone. Use is made of compressible surfaces, or surfaces capable of dissolving into meshes; surfaces that fold like curtains, expand or shrink. Objects will be allowed to move and revolve, and lines will be allowed to broaden into surfaces. Parts will be inserted into the set and parts will be taken out. Materials for the score are all tones and noises capable of being produced by violin, drum, trombone, sewing machine, grandfather clock, stream of water, etc. Materials for the text are all experiences that provoke the intelligence and emotions. The materials are not to be used logically in their objective relationships, but only within the logic of the work of art. The more intensively the work of art destroys rational objective logic, the greater become the possibilities of artistic building. As in poetry word is played off against word, here factor is played against factor, material against material. The stage-set can be conceived in approximately the same terms as a Merz picture. The parts of the set move and change, and the set lives its life. The movement of the set takes place silently or accompanied by noises or music. I want the Merz stage. Where is the experimental stage?

"Take gigantic surfaces, conceived as infinite, cloak them in color, shift them menacingly and vault their smooth pudency. Shatter and embroil finite parts and bend drilling parts of the void infinitely together. Paste smoothing surfaces over one another. Wire lines movement, real movement rises real tow-rope of a wire mesh. Flaming lines, creeping lines, surfacing lines. Make lines fight together and caress one another in generous tenderness. Let points burst like stars among them, dance a whirling round, and realize each other to form a line. Bend the lines, crack and smash angles, choking revolving around a point. In waves of whirling storm let a line rush by, tangible in wire. Roll globes whirling air they touch one another. Interpermeating surfaces seep away. Crates corners up, straight and crooked and painted. Collapsible top hats fall strangled crates boxes. Make lines pulling sketch a net ultramarining. Nets embrace compress Antony's torment. Make nets firewave and run off into lines, thicken into surfaces. Net the nets. Make veils blow, soft folds fall, make cotton drip and water gush. Hurl up air soft and white through thousand candle power arc lamps. Then take wheels and axles, hurl them up and make them sing (mighty erections of aquatic giants). Axles dance mid-wheel roll globes barrel. Cogs flair teeth, find a sewing machine that yawns. Turning upward or bowed down the sewing machine beheads itself, feet up. Take a dentist's drill, a meat grinder, a car-track scraper, take buses and pleasure cars, bicycles, tandems and their tires,

also war-time ersatz tires and deform them. Take lights and deform them as brutally as you can. Make locomotives crash into one another, curtains and portières make threads of spider webs dance with window frames and break whimpering glass. Explode steam boilers to make railroad mist. Take petticoats and other kindred articles, shoes and false hair, also ice skates and throw them into place where they belong, and always at the right time. For all I care, take man-traps, automatic pistols, infernal machines, the tinfish and the funnel, all of course in an artistically deformed condition. Inner tubes are highly recommended. Take in short everything from the hairnet of the high class lady to the propeller of the S.S. *Leviathan,* always bearing in mind the dimensions required by the work.

"Even people can be used.

"People can even be tied to backdrops.

"People can even appear actively, even in their everyday position, they can speak on two legs, even in sensible sentences.

"Now begin to wed your materials to one another. For example, you marry the oilcloth table cover to the home owners' loan association, you bring the lamp cleaner into a relationship with the marriage between Anna Blume and A-natural, concert pitch. You give the globe to the surface to gobble up and you cause a cracked angle to be destroyed by the beam of a 22-thousand candle power arc lamp. You make a human walk on his (her) hands and wear a hat on his (her) feet, like Anna Blume. (Cataracts.) A splashing of foam.

"And now begins the fire of musical saturation. Organs backstage sing and say: 'Futt, futt.' The sewing machine rattles along in the lead. A man in the wings says: 'Bah.' Another suddenly enters and says: 'I am stupid.' (All rights reserved.) Between them a clergyman kneels upside down and cries out and prays in a loud voice: 'Oh mercy seethe and swarm disintegration of amazement Halleluia boy, boy marry drop of water.' A water pipe drips with uninhibited monotony. Eight.

"Drums and flutes flash death and a streetcar conductor's whistle gleams bright. A stream of ice cold water runs down the back of the man in one wing and into a pot. In accompaniment he sings c-sharp d, d-sharp e-flat, the whole proletarian song. Under the pot a gas flame has been lit to boil the water and a melody of violins shimmers pure and virgin-tender. A veil spreads breadths. The center cooks up a deep dark-red flame. A soft rustling. Long sighs violins swell and expire. Light darkens stage, even the sewing machine is dark."

Meanwhile this publication aroused the interest of the actor and theatrical director Franz Rolan who had related ideas, that is, he thought of making the theatre independent and of making the productions grow out of the material available in the modern theatre: stage, backdrops, color, light, actors, director, stage designer, and audience, and assume artistic form. We proceeded to work out in detail the idea of the Merz stage in relation to its practical possibilities,

theoretically for the present. The result was a voluminous manuscript which was soon ready for the printer. At some future date perhaps we shall witness the birth of the Merz composite work of art. We can not create it, for we ourselves would only be parts of it, in fact we would be mere material.

P.S. I should now like to print a couple of unpublished poems:

Herbst (1909)

Es schweigt der Wald in Weh.
Er muss geduldig leiden,
Dass nun sein lieber Bräutigam,
Der Sommer, wird scheiden.

Noch hält er zärtlich ihn im Arm
Und quälet sich mit Schmerzen.
Du klagtest, Liebchen, wenn ich schied,
Ruht ich noch dir am Herzen.

Autumn (1909)

The forest is silent in grief.
She must patiently suffer
Her dear betrothed,
The summer, to depart.

In grief and anguish still
She holds him in her arms.
You, my love, wept when I departed.
Could I now but rest on your heart!

Gedicht No. 48 (1920?)

Wanken.
Regenwurm.
Fische.
Uhren.
Die Kuh.
Der Wald blättert die Blätter.
Ein Tropfen Asphalt in den Schnee.
Cry, cry, cry, cry, cry.
Ein weiser Mann platzt ohne Gage.

Poem No. 48 (1920?)

Staggering.
Earthworm.
Fishes.
Clocks.
The cow.
The forest leafs the leaves.
A drop of asphalt in the snow.
Cry, cry, cry, cry, cry.
A wise man bursts without wages.

Lissitzky

New Russian Art

"New Russian Art" is the text of a lecture El Lissitzky gave in Germany, first
published from his typescript by his widow, Sophie Lissitzky-Küppers,
Lissitzky: Life, Letters, Texts (London and Greenwich, Conn., 1968, trans-
lated from the 1967 German edition by Helene Aldwinckle and Mary
Whittall). I am very grateful to Thames and Hudson Ltd. for permission to
reprint this lecture. In it, addressing himself to a non-Russian audience,
Lissitzky places radical Soviet art in the context of modern Russian art and of
European developments like Cubism and Futurism. In doing so, he sets out
the main lines of the history of art of the Revolutionary era that have been
followed to the present day. With Malevich as his acknowledged hero, he
defends geometric abstraction as an entirely new and autonomous language
which embodies the dynamic tensions of the new society.

El Lissitzky (Lazar Mordukhovich Lisitskii, 1890–1941) left his native
Russia to study architectural engineering in Germany, at Darmstadt's
Technical College, from 1909 to the onset of the First World War. In Moscow
during the war he earned his diploma as engineer-architect, and became
engaged in the "Jewish Renaissance," working as illustrator for Jewish pub-
lishing houses. Invited to Vitebsk in 1919 by Chagall, Lissitzky quickly turned
to abstract art under the influence of Malevich, the charismatic deviser of
"Suprematism." He began producing his "Prouns," a name for his pictures
that he coined from the acronym of the Russian words "for the new art." His
forms sprang from Suprematist geometry but consist of a striking three-
dimensionality in contrast to Malevich's flat colors. Devoted to the new Soviet
society and to radical art, Lissitzky designed some visionary structures as well
as many posters, book covers, and whole books. Eventually he became one of
the most influential graphic designers of the twentieth century, with works
like his own *The Story of Two Squares* (1920, published 1922), Mayakovsky's
For the Voice (1923), and albums of lithographs, most famously *Victory over
the Sun* (1923).

Lissitzky went to Germany late in 1921 and did not return to Russia until
May 1925. Unofficial spokesperson for vanguard Soviet art, he resided first
in Berlin, then for a longer period in Hanover, and eventually in Switzerland,
where he sought care for his tuberculosis. His most influential Prouns and
graphic designs were produced during these years, when he met and collabo-
rated with a number of German, Dutch, and Swiss artists. He published essays
in avant-garde journals he helped design and edit, such as *Veshch-
Gegenstand-Object*, 1922; *ABC*, 1923; *G*, 1923, and Kurt Schwitters' *Merz*,
1924. He took part in symposia and exhibitions and lectured and wrote about
recent Soviet art; "New Russian Art" apparently encapsulates the ideas he
was then transmitting. After his return to Russia in 1925, he turned increas-
ingly to the design of exhibitions, including the spectacular Soviet trade fair

Pressa in Cologne in 1928. In 1930 he published *Russia: Architecture for World Revolution,* a treatise on modern architecture from the vantage point of revolutionary Soviet art. His final decade was spent in Moscow where, unlike Malevich, he did not break with the Soviet government.

New Russian Art

The West has now discovered the art of the Negro, the Mexican, the Javanese, etc. They have not, of course, inquired of the Negro, the Mexican, the Javanese, etc., what was the will which inspired the deed. They have taken the end-products and fabricated a theory of life into them, inventing a philosophy of life for them; it is not the attitude to life of the East that is manifested there, but the reflection of the West.

Russia is not Africa, Mexico, or Java. We and Western Europe are living in the same age, and not far distant from each other. This report is going to furnish material for *our* theory of life. I should like to show here what has been achieved in our country in recent years in the field of plastic design. I should like to examine the forces and the events which have directed this work into a specific channel.

The Revolution

Six years ago, in 1917, the Revolution broke out in Russia, and not in Russia alone. The whole of the rest of the world stood against us, and thus we were completely isolated. Then it became clear to us that the world was only just coming into existence, and everything must be re-created from scratch, including art. At the same time the question arose as to whether art is really necessary; whether the expression and the forms of art are eternal; whether art is a self-contained, independent domain, or a part of the whole remaining pattern of life. The idea that art is a religion and the artist the priest of this religion we rejected forthwith. We then went on to establish that expression and form in art are not eternal, and that no one epoch in art stands in any relationship to the following one, and that in art there is no such thing as evolution.

The question of whether art is really necessary has the following significance in our country:

In the new order of society, in which work will cease to be slavery, in which there will no longer be small groups producing luxuries for a restricted stratum of society, but where work is being done *by everyone for everyone,* in such a society work is given free scope and everything which is produced is art. Thus the conception of art as something with its own separate existence is abolished. These views are the basis of the development which we have accomplished in recent years. We have stopped just rolling our eyes, we have turned

78

our head round, to face quite a different direction. We witnessed a sudden decisive change in all life's relationships; a reorganization of the State, of the economy, of science; a miraculous technology; the invention of things which even yesterday were still considered as Utopian. Where did art stand?

This question was posed only by the youngest generation among us. The intellectuals, the highly educated, were expecting the "new era" to arrive in the shape of a Messiah, with aureole and white robes, with manicured hands, mounted on a white horse. But in reality the new era came in the shape of the Russian Ivan, with tousled hair, tattered and dirty clothes, barefoot, and with hands that were bleeding and torn by work. These people did not recognize the new era in an apparition like this. They turned their backs on him, ran away and hid. Only the youngest stayed put. But this youngest generation was not born in October 1917; the October Revolution in art originated much earlier.

In Russia, during her own individual Middle Ages, there was a high standard of painting—in the painting of icons. With the epoch of revolution carried through by Peter the Great, Western influences began to play a decisive role. But the art of the West was itself on the downward path at that time. It was certainly not in a position to promote the growth of Russian art. There began a long period of sterility. Art no longer grew naturally from the people, but was cultivated from the top downwards, by the State Academy. The first standard of revolt against the Academy was raised in 1865 by the so-called "Wanderers," that is to say those participating in the touring exhibitions, the apostles of the "naturalistic," educational painting. These popular wanderers were pushed aside by the aristocratism of the Group known as "Mir Iskusstva" ("World of Art"). The distinguishing characteristics of this Petersburg group were archaism of theme and a complete break with painting, which was replaced by coloured illustration.

At the beginning of the twentieth century the germination of a new culture of painting attracted attention in Moscow. The place of germination is significant. Moscow was not enervated by the Petersburg Academy and had retained some healthy blood of the people. There arose an interrelation between Russia and the international hotbed of the new art, Paris. In Moscow a new group of painters was formed, the "Bubnovy Valet" ("Knave of Diamonds"). Its members acknowledged neither the elucidatory efforts of the "Wanderers" nor the rococo of the art world as the painter's means of expression.

They believed the most elementary form of the composition of the picture was to be found in popular and icon painting, in sign painting, in Persian and Indian miniatures, in Gauguin. In contrast to the beauty and smoothness of the "art-world" pictures, these of the Bubnovy Valet group startled one by the intensity and brutality

of their lines and colours. This group was organized by Larionov, Goncharova, Konchalovsky, and others. The initial alliance of these young painters soon fell into two natural groupings, the one inclining to the problems of colour, plane and space, in other words, pictorial construction, while the other tended toward the fostering of the picture as such. Whilst the former, in spite of their chaotic initial experiments, carried on evolving and developing, the latter gained strength at their starting-point, which was the study of the problems raised by Cézanne. He stepped in front of his canvas as if he were surveying a field, which the painter tills, ploughs, and sows, making the new fruits of nature grow upon it. The museums still worried him. "I will create an art which is eternal, like the art of the museums." And yet his work shattered the eternal passivity of museum art. Cézanne still painted objects, still lifes, landscapes, but for him these were only the scaffolding, for his sky flourishes in the same colours as his earth, his trees, his people. The representatives of the Russian Cézannists, Konchalovsky, Falk, Mashkov, and others, differ from their master in respect of their bold application of colour. This could have been their strength, but remained no more than their peculiarity. Some members of the Bubnovy Valet group—Rozhdestvensky, for example—who had not confined themselves to the study of the Cézannian principles, tried to draw wider conclusions.

After the first experiments, instinctual and chaotic, there followed the necessity for an analysis. This period saw the birth in the West of Cubism and Futurism. Russian painters were approaching the same problems at the same time. They began to submit nature to analysis, dissection, deformation, and this in the name of the independent existence of the picture. Here starts the period of the overthrow of the object. The tasks at which Russian painters worked during those years have been taken up at various times almost all over Europe. It can be said that the analytical period was the first illuminating example of the internationalization of the new art.

In 1910 there began a series of polemical exhibitions, arranged by groups with names like "Donkey's Tail," "Target," "0.10," "Tramway V," and "Magazine" and so on. These exhibitions were platforms for those painters who had broken with Cézannism. They were submitted to the most severe ideological and administrative persecution.

Here the following facts have become clear:

Firstly: What is the painter? This is a man through whom flows a colour-stream, so that he has to create for himself, with the materials of his profession, an organized form.

Secondly: This is a man who stands before his easel and in that same time in which a carpenter makes a table, a locksmith a lock, a weaver a fabric, a builder a house, he creates his own particular product. He creates something which has never existed before, something

which neither grows on the trees nor blooms in the fields nor springs from the soil, but is a new object: the picture.

Thirdly: He did not copy this picture, but started creatively to form it. The metalworker takes a sheet of metal, cuts out a circle, bends it together into a cylinder, makes a handle, and solders everything together. Thus an object is created according to a definite plan. In this way the painter began to select the elements which he required for his picture, placed them together, working to a uniform system, according to which he built up his picture. It was with this that Cubism started. These early works found no appreciation from the public at first, on the contrary they were rejected. Thereupon a campaign against public inertia was started, waged under the name of "Alogism." In 1912, Malevich and Morgunov had executed a series of works which bore no relation to the logic of the mind. Take, for example, the picture *Englishman in Moscow.* This movement demonstrated that the logic of painting is something different from the logic of the mind. So the methods of Dadaism were already being employed in Russia in 1912.

The analytical period led painters to abolish representational painting. Larionov creates the theory of luchism (or "ray art"), the representation not of things but of the rays emanating from them. Kandinsky achieves a kind of musical painting, in which he expresses the state of his soul at any moment by stenographic splotches of colour. Malevich shapes Suprematism.

Then war breaks out, and the relationship between Russia and the West is severed and has remained so almost to the present time. The further development of Russian art takes place as it follows paths which are isolated from the world outside. Let us examine the basis on which Russian painting has grown up during the last decade. Two opposite forces characterize present-day Russia and these are given expression. There is the village, close to the soil, colourful, still enclosed in medieval manner; and the town, not yet clearly defined, but even now showing a strong tendency towards Americanization, and expanding to the outermost limits. The artists do not direct their attention to the colours, but concentrate on the materials. The character of the village, its colourfulness, the slow rhythm of life, which permits of contemplation, bring forth a painting of pure colour and abstract form. These features have been definitively crystallized in the pure Russian school of suprematism, of which we shall speak later. The influences of the town were naturally of a different kind and have brought the Russian painters closer to those of Western Europe and in particular to the Paris painters, who, during that period, were nearing the consummation of Cubism and looking for its logical sequel. So we have considered matters in this way. The painter is the master, who works with colour as his material. Absolute painting demands that the canvas should no longer be painted with the colours of the palette.

Surfaces should be so prepared, chemically and physically, that they capture the true spectral ray and reflect it. Only then, through the differences in wavelengths of the light rays, do we obtain the pure impression of colour.

Hitherto the painter has set about things differently. He takes the pigment, the coloured earths and powders, binds them with oil, with lime, or with egg-yolk, which gives the colour an appropriate intensity. This the painters apply to the canvas. By this method we obtain an equivalent of the absolute colour-impression and not the colour as such. That the painter should restrict himself to taking his colour-material only from ready-to-use tubes is a prejudice created by the colour-manufacturers. The new painters have employed for their artistic purposes, for their colour and surface-effects, not only cinnabar, ochre or cadmium, but also paper, chalk, cement, glass, and copper. Then artists started to dissociate the colour material from the flat surface, resulting in the painted relief. In Russia, however, attention was soon transferred from the artistic properties of the material to its organic properties. The new artist, in his struggle against aestheticism, found a strong point in the new technical material. This is the achievement of Tatlin, who discovered material not only for the eyes, but also for the touch. His problem was the adjustment of the eye to the sense of touch.

In 1914 he creates some reliefs, still basically Cubistic, but he is already modelling from stucco, glass, iron, and wood. He goes on to make a complete break with everything related to flat-surface pictures. In 1916 he creates the "angular contre-relief," a body tensed in space, on wires. In the West, this thing was erroneously termed machine-art, on the strength of a superficial analogy. Technology has surely exerted its influence on the new artists. We have suddenly realized that the plastic art of our time is not created by the artist, but by the engineer. The vitality, the uniformity, the monumental quality, the accuracy, and perhaps the beauty of the machine were an exhortation to the artist. There was a desire to be an inventor, to be materialistic; but people had not perceived that they still remained in the romantic period. They seized on material, regarding it as they had previously considered the still life, that is from the point of view of its beauty. They made use of its elastic properties for playing with form. Finally they even endowed this material with a symbolic meaning: *Iron* is strong, like the will of the proletariat, *glass* is clear, like its conscience. So they put together a new body, which was not a machine, did not accomplish any task, and did not directly serve any useful purpose. One thing, however, this art did achieve; it cut a way into the old idea of art, thereby launching the operation for the conquest of art.

It was the economy of the age which created the machine. The machine showed us movement, showed us circulation. It showed us life and how it vibrates and palpitates from the forces that flow

through it. Futurism sought to build up a kind of painting which places the spectator at the central point of what is happening. We were taught anatomy from anatomical atlases or by the dissecting of corpses; but what an anatomy we would have learned if we had been able to penetrate the living, pulsating body of a human being or of a plant.

The artist's standpoint in the world was altered, the material of his trade became richer, within him were generated new possibilities for assimilating things, and yet he continued to move about on the same old path. He kept revolving round the object which had already been created by others. Yet something definite was certainly accomplished in that he no longer stood in admiration in front of the object, but moved all round it, that is to say he absorbed and then endeavoured to represent his impression—not only in three but in four dimensions. It was high time to break this circle of admiration. The simple solution was to plunge into the abyss with conviction, so as to reach the bottom not as a corpse but as a newborn man. This was not to be done in desperation, but with full consciousness and utmost force.

In 1913 Malevich exhibited a black square painted on a white canvas. Here a form was displayed which was opposed to everything that was understood by "pictures" or "painting" or "art." Its creator wanted to reduce all forms, all painting to zero. For us, however, this zero was the turning-point. When we have a series of numbers coming from infinity . . . 6, 5, 4, 3, 2, 1, 0 . . . it comes right down to the 0, then begins the ascending line 0, 1, 2, 3, 4, 5, 6 . . .

These lines are ascending, but already from the other side of the picture. It has been said that the centuries have brought painting right up to the square, so that here they can find their way down. We are saying that if on the one side the stone of the square has blocked the narrowing canal of painting, then on the other side it becomes the foundation-stone for the new spatial construction of reality.

The merit of Tatlin and his colleagues lies in the fact that they accustomed the painter to working in actual space and on contemporary materials. They approached constructive art. But this group reached a kind of material-fetishism and forgot the necessity of creating a new plan.

At times this reminds one of building a concrete railway-station from a Gothic design.

The necessary warning emanated from suprematism.

At a time when painting was being harassed by everything possible, by everyone not involved in it, it was essential to start with a purge. Suprematism had set out to free painting from all the classifications imposed on its essential nature—that means from those based on the immediate effect of colour on the eye. But colour is always confined to a flat surface. Thus the form is created. It is essential that it be unequivocal. The form which is unequivocal—and that means

immediately recognizable to everyone—is the geometric form. No one is going to confuse a square with a circle, or a circle with a triangle. At that moment when the square or the circle is dissected and distributed over the flat surface in a mass of colourful fragments, a relationship is formed between the individual parts. This relationship had to be organized.

The result was not a personal affair concerning one individual artist: the intention was to create a system of universal validity. To be effective, this system had to formulate for itself its own individual interpretation of space. That is the white plane—infinity. Suprematism indicated both of the possibilities for the forming of this space, namely the static and the dynamic. The static was the partition of the plane, the given flat surface, by means of a vertical and horizontal axis into a set of component parts, which built themselves up on the same axes in a clear relationship to each other. The dynamic was the placing in infinite space of such complex colour-shapes as would convey to us the impression of movement, of powerful forces in operation. This developed on a diagonal axis and between two intersecting axes. In the history of the evolution of painting the white surface of the Suprematist canvas is the ultimate expression of space. The blue and gold background of Byzantine and Gothic painting took the initiative in making the eye penetrate into the depth of the picture. The perspective of Renaissance painting made the surface area of the canvas recede as far as the horizon. (In the *Last Supper* by Leonardo, one can measure the exact number of metres from the table to the horizon.) The Impressionists created their space through the undisguised, vibrating brushstroke, dominating the whole canvas. The Futurists shattered the single vanishing-point of the lines of perspective and scattered the fragments all over the canvas. Suprematism swept away all the fragments and opened the way to infinity. Suprematism favoured reality, *which is contacted only with the eyes*. So it achieved illusionism. Thus, in the history of painting we observe a chain of impressions of space, and Suprematism is the last link in the chain. The new impressions of space are removed from the canvas, with its flat surface covered with painting. Suprematism has confined the dynamic within itself, the dynamic as the origin of tensile forces. Suprematism has not, like Impressionism, portrayed movement; it has not, like Futurism, depicted the appearances of movement. It has formed dynamic tensions by means of the relations between flat surfaces and colours. As a result of Suprematism, a canvas has been created which carries an inner vitality. This canvas has grown out of the artist just as organically as a flower out of the soil, just as pure in colour, as exactly and clearly cut in all its parts as a plant. Every flat surface designed is a sign—not a mystical symbol, but a concrete sketch of reality. A sign is a form through which we express phenomena. It can originate in two ways.

Firstly: By agreement as to what meaning these signs shall have. We have the design for a mountain city, in all its diversity, drawn on a flat piece of paper in the form of a town-plan; we understand the sketch, because we had established the signs on it in advance. We have expressed the whole terrestrial globe in two circles, and the infinity of the firmament in a scattering of dots as fine as dust on a cosmographic atlas. But with these signs we have expressed what was there already in the world, what had already been built. These signs were created by us and became clear to us once our brain had emerged from its primitive state and reached its present labyrinthine complexity.

Now the second possibility: A sign is designed, much later it is given its name, and later still its meaning becomes clear. So we do not understand the signs, the shapes, which the artist created, because man's brain has not yet reached the corresponding stage of development.

Suprematism has a new criterion for evaluating everything created in plastic design. Instead of beauty it is economy. If, on the one hand, Suprematism is a result of the whole culture of painting, on the other hand, the intensity of its colours and its observation of life are deeply rooted in the Russian village. At the same time it may be remarked that the Russian village, for its part, recognized itself in Suprematism. So it was that the cover of the album for the "Conference on Rural Poverty," which had been selected by the delegates themselves in the year 1918, hung in many huts in the northern provinces, alongside their icons and their coloured prints. Suprematist painting created a style which is finding expression in embroidery, metalwork, woodwork, posters, and even in the painting of houses. However, Suprematism was not content with this and did not wish to remain merely a decorative style, so it continued on the road toward the annihilation of painting. It seems to have begun to appreciate the relative lack of colour in the town by comparison with the village. This idea found expression in the final creations of the Suprematists, and in 1918 Malevich exhibited a white canvas on which a plane was indicated with another white colour. By forsaking the colourful and going over to the colourless aspect, the Suprematists concentrated their attention on arranging flat, geometric planes, which were to serve as ground plans for further spatial construction.

This is the contribution of Suprematism and of the Proun to the general trend of constructive design resulting from the work of the two fundamental groups led by Tatlin and Malevich. Belonging to the first Suprematist group there was, besides Malevich, a very gifted female painter, Olga Rozanova, who died suddenly while we were preparing artistic works for the first October Revolution jubilee. In Little Russia a whole series of villages did weaving and embroidery on a large scale, under the direction of Rozanova, Davidova, and

Alexandra Exter. Then there was Ivan Klyun, who not only produced paintings but also spatial creations, and also Drevin, Lyubov Popova and others.

There appeared, parallel with the movements referred to, some painters who worked without specific objects. They aspired to the pure subjective portrayal of their emotions by means of colour-combinations. By comparison with the work of the Suprematists their pictures reminded one of rubbish-heaps placed next to regularly formed crystals. At best they were tapestries, fine wallpapers. The typical representative of this group was Kandinsky. He introduced the artistic formulas of contemporary German metaphysics, and therefore in Russia he remained a purely episodic phenomenon. But the necessity, so strongly felt by young Russian painters, for an established order as a basis for all art instigated other nonobjective painters—Rozanova in her latest works, Rodchenko, and others—to renounce subjective expression and take the third road to the same Rome, the road to constructive art.

Let us consider the plan of this "Rome." Its foundation-wall was the Russian Revolution. It began as a powerful, elemental movement of the peasantry, and surged onward to organization and reconstruction. On the other hand, the young painters, who up till 1917 had been a small sect, were glad to have the opportunity, for the first time, of transforming their laboratory into a factory. To them their basic purpose was the extension of the foundations and the introduction of art into living. Life posed questions and demanded immediate replies to them: what role does art play in the new society, in which the field of creative activity becomes common property? The first answer was the solution: in productive art, which means transferring the tasks of the painters from the studio to the factories and works. It is not the task of the painter to embellish things already created, but he should take part himself in bringing them into existence. In this way the practice of classifying art as "pure" or "applied," which had prevailed up to that time, disappeared entirely of its own accord. Regrettably the disorganization of Russian industry and the lack of raw materials prevented the success of this campaign. One was left in an intermediate space between studio and factory. That is the transition stage from subjective to universal design. Now comes the period of construction. This movement came to life spontaneously, and the question of its legitimacy is now being elucidated not only in Russia, but also here in the West. Two groups claimed Constructivism, the Obmokhu (the brothers Stenberg, Myedunyesky, Yoganson, and others) and the Unovis (Syenkin, Chashnik, Klutsis, Ermolayeva, Khidekel, Kogan, Noshov, and others led by Malevich and Lissitzky).

The former group worked in material and space, the latter in material and a plane. Both strove to attain the same result, namely the creation of the real object and of architecture. They are opposed to

each other in their concepts of the practicality and utility of created things. Some members of the Obmokhu group (Yoganson, supporter of the idea of direct usefulness) went as far as a complete disavowal of art and in their urge to be inventors, devoted their energies to pure technology. Unovis distinguished between the concept of functionality, meaning the necessity for the creation of new forms, and the question of direct serviceableness. They represented the view that the new form is the lever which sets life in motion, if it is based on the suitability of the material and on economy. This new form gives birth to other forms which are totally functional, and through them it is itself enriched, modified and further developed. The painter was formerly secluded from the world, so he concerned himself with compositions, that is with the combining of various factors. Nowadays, on the contrary, he constructs, that is he creates substance. Composition is a bunch of different flowers. Construction is the safety-razor, composed of individual parts.

Both groups propagated their ideas with great vigour, through exhibitions, conferences, pamphlets, public meetings, and debates. I will quote here, as an example, an extract from an Obmokhu pamphlet: "Every man born on this earth could, before his return to the soil, go by the shortest route into the factory where the real body of life is fashioned. This route is called Constructivism, the highest springboard for the leap into universal human culture. The great seducers of the human race, the aesthetes and artists, have demolished the bridges on this rigorous route and through a haze of mawkish narcosis they have offered art and beauty in exchange. Man's brains, the essence of the world, are being wasted and dissipated to swell the morass of aestheticism. Having weighed the facts on the balance of their honest relationship to the world's inhabitants, we declare art and its bosses to be outside the law."

Unovis realized the necessity of creating propaganda for the organization, not of a movement or school, but of a party.

For a 1920 pamphlet I wrote: "The artists must organize their ranks, must form themselves into a party. It is a mistake to think that the tactics which one learned at school are a means of expressing personal freedom. This freedom is an abstraction, which exists only in interplanetary space. Here on earth what we achieve with the means at our disposal is not our freedom, but our philosophy of life. At the present time, whoever wants to create something must first forge a new consciousness, then if he wants to take part in the process of creating the new culture, he must study the elements of present-day experience, for only then can he attain the new objectives and apply them to daily life along the lines of party organization. For life acknowledges no separate individuality."

Alongside all these groups were some who wished to continue cultivating painting and the picture. They sought to find themselves new

methods of expression by representing the object in the simplest manner and relying on contrasting treatments of style in painting. A characteristic advocate of this method is Sterenberg, in his still lifes. Altmann attempted to create abstract forms using all the subtleties of the material and to link them with specific words which give meaning to the work. This resulted in a kind of illustrated poster. So it is obvious how, in our country, unity has been built out of contradiction. Anthitheses have engendered a tension which has raised the general movement of our art to the highest level. That, in broad outlines, is the condition of the inner life of art. Now I will say a few words about the effect of art in general.

In the early days of the Revolution a newspaper entitled *The Revolution of the Spirit* was stuck up in the streets of Moscow. It was published by the poets Mayakovsky and Kamensky and the painter Burlyuk. They challenged painters to take large brushes and buckets of paint and use them to paint the whole town. They said the poets should go out into the streets and read their works aloud, that the musicians should place their grand pianos on the squares and give their concerts there. This seemed to be Utopian and yet subsequently it came to pass. At the Commissariat for Mass Education an artist-collegiate body was constituted, for which Malevich drew up the following programme:

(1) War on academies.

(2) Directorate composed of Innovators.

(3) Establishment of an art-collective to deal with the affairs of art.

(4) Exchange of state-authorized representatives of art between all countries (Art Ambassadors).

(5) Foundation of Museums of Art throughout the whole country (State Art Collections).

(6) Working out of a uniform plan for the whole Republic in respect of touring exhibitions, where on every occasion the latest products of the new art should be shown (dynamic art collections).

(7) In Moscow, the foundation of a Central Museum for the cultivation of painting.

(8) Nomination of Commissars for Artistic Affairs in all provincial towns.

(9) International press-agency to disseminate information about cultural life.

(10) Publication of a mass-circulation art journal.

Then an international bureau was established, for forming direct associations with all the new artists in the world. During the war, in the period of complete isolation, this bureau sent out radio-telegrams to the whole world. I am now going to quote an extract from a radio appeal:

"*To all, all, all.* The World War requires us to reassess all values. At a time when there is a huge reconstruction going on in life at a

tremendous pace, when consciousness cannot catch up with creation, art is left behind at the freezing-point of the old prewar state of affairs. Both the millions of victims and the world-wide social revolution require a powerful impetus from art.

"We recognize the primary value of the *element* and of *invention* as being the only channel for this impetus.

"We call upon all artists to accord with the times and recognize that all schools which have outlived their primary source, invention, belong to the past.

"The moment demands the convening of an international conference to discuss the progress and potentialities of the inventions which are not only required by the present but also by the future . . ."

To these appeals we received a succession of enthusiastic replies from our Eastern European comrades: but this support was prevented from developing towards an exchange of visits by the blockade, which lasted for almost three years.

All the achievements and practical experiences of the groups I have been describing were put to effect in decorating the towns for the great festivals. These are the works created by the new Russian art; these are the great monuments of our time, born together with the great day, and with it they also die. These are not "eternal" monuments like the Pyramids; this is the time for a constant flow of monuments like the constant flow of life. A trace of them could well be preserved on film, but we have not even had enough photographic plates for that. In Petersburg there is a Museum of the Revolution, in which there are five large rooms full of the designs on which the decoration of the town was based on the occasion of the first anniversary of the October Revolution. Streets, bridges, squares were remodelled. The same thing took place in Moscow and all the provincial towns. Thus in Vitebsk, for example, for a factory-festival, Malevich and I painted fifteen hundred square metres of canvas, designed three buildings, built a stage in the civic theatre for a ceremonial session of the factory committee. The best designs were executed in Moscow, as a salute to the Congress of the Comintern. The pressing urge for architecture was a characteristic of the new artists and found its outlet in these works.

Yet exhibitions of art were still taking place indoors, with pictures hung on the walls of exhibition rooms. These were all centralized and arranged by the State. Every man had the right and freedom to exhibit; and exhibitors offered interpretations of their works to the visitors—workers, students, members of the Red Army. Some artists tried to find other methods of demonstrating their work. Pevsner, Gabo, and Klutsis displayed their works in an open bandstand on one of the busiest boulevards in Moscow, and in the evenings they held lectures for the public; and the whole town was placarded with their realistic manifesto.

At the time of the great international congress in the summer of 1921, we set up one of the most modern exhibitions in the reading-room and dining-hall, for the benefit of foreign delegates. The Central Exhibition Office in Moscow assembled exhibitions which were sent out to the provinces. A museum for the cultivation of painting was founded and, in association with it, an institute to promote the culture of painting, which united artists, writers, and scientists. There, all the problems of new design were dealt with, both in theory and in practice.

Within the sphere of architecture proper, the most important work was accomplished only on theoretical territory, in consequence of the absolute paralysis of building. Preliminary researches are finding their practical realization in the State workshops (Vkhutemas), i.e. the former academy, which I shall discuss later.

One of the few architectonic manifestations of recent years is the sketch-plan of a monument to the Third International, designed by Tatlin, who is not, in fact, an architect but a painter. This is a new instance of the systematic progression from painting along the path of work to materials, then on to construction, and leading finally to the creation of useful objects. Here the skeleton of the construction ought to remain completely naked. The material is iron and glass, the shape as a whole is a tower formed by a diagonal column and two spirals rising in opposite directions. These primary forms are supported by a three-dimensional framework. This skeleton contains three glass bodies, a cube, a pyramid and a cylinder. In the iron spirals museums are to be installed, and the glass areas will provide space for committee-rooms and suchlike. Here Tatlin wanted to try and solve the problem of the dynamic design by making these bodies each revolve at a different velocity. All technical advances should find their application here. Radio and projection systems should be made to operate at the top of the tower, transmitting news by electronic, optical, and acoustic waves. Naturally there can be many objections to this design and there was plenty of sharp debate about it among us. What must be taken into consideration, however, is that this is the first work of the new generation, which is demanding of itself invention, elementary design, clear construction, and mastery of material. The height of the tower is supposed to reach three hundred metres. So far, only a model five metres high has been realized.

From several competitions I will make mention of the design for a newspaper-kiosk by Rodchenko. Although this is still very decorative, Rodchenko has endeavoured to design space.

In Russia, as everywhere else, sculpture followed on painting. A State commission for a whole series of monuments inspired multifarious quests after a new plastic form: but the stamp which all these experiments bore was a superficial treatment of Cubism, not as a method but as a mannerism. Splitting up the form, which was

practised by some sculptors who had taken over the idea from contre-relief, immediately altered the character of the sculpture. In their larger works, these sculptors—Gabo, Lavinsky, Chaikov, and others—joined forces with the Constructivists, in view of the fact that they shared a common task. Gabo made use of glass for his plastics; he calls for the inclusion of movement in plastic art, a feature which he has tried to achieve in a few works.

A great store of creative energy had accumulated, which could not be released in architecture, because there was no building. This energy found its release in the theatre. Originally the painters found satisfaction in the theatre because it afforded opportunities for painting decorative canvases on a large scale and having them enriched by the effects of artificial light. Examples were the stage-settings of Lentulov, Fedotov, and others, but this did not satisfy them for long. Soon the painters themselves began, in accordance with the evolution of painting, to push forward three-dimensional, spatial ideas of decoration. The painter on the stage progressed toward architecture. Many such stage-settings materialized at the Kamerny Theatre in Moscow. In the great successes of the Russian theatre the highest credit belongs to the painters. Typical examples were the settings created by such artists as Exter, Georgy Yakulov, A. Vesnin, Popova, and others. In the latest work by Vesnin, the stage-setting for Chesterton's *The Man Who Was Thursday*, it is interesting to trace how the principles of the Tatlin tower have been applied to the theatre. Meyerhold, the director, completely abandoned the wings; in the setting for Mayakovsky's *Mystery bouffe* he designs the whole expanse of the stage architectonically and extends it into the auditorium. Also interesting is the latest work of the Constructivist brothers Stenberg and Myedunyesky, which is an innovation in stage design. They constructed a curtain from vertical wood mouldings (like a venetian blind), which divided on opening, receded into a semi-circle and thus formed the background. The surfaces were not painted but illuminated by coloured beams of light as the occasion demanded. The first presentation on this stage will be the play "The Yellow Jacket."

The basic principles of the artists in creating the decor were as follows:

Firstly: the scenic, acrobatic movements of the actors modify the apparatus of the play.

Secondly: the apparatus, which is modified as a result of its mechanical construction, conditions for its part the movements of the actors which are deduced from this.

Thirdly: these factors simultaneously give to the whole structure the illusion of reality.

An attempt was made to transfer the theatre from its enclosed space out into the street. In Petersburg and other towns the architectural features of the town were supplemented by means of specially erected

buildings and used for the magnificent staging of open-air plays, which were attended by thousands upon thousands of people.

All the experiments and achievements cited by me here were continued and developed in the works of the Higher State Technical Art Workshops, Vkhutemas.

At the start of the Revolution, immediately after the abolition of the official academy, questions were raised as to a new method of art-study. The first stage was that of free, individual workshops. Here every person who intends to study art can himself choose the teacher under whose guidance he works without either examinations or restraints. This soon degenerates into individual caprice and a state of chaos. From this it clearly followed that for the training of qualified masters a general, strictly scientific plan would have to be devised. At the same time, by "masters" they did not mean unconditionally the painters who create "pictures," but rather every man with the creative talent to fructify the different branches of the tree of production.

The workshops are divided into the following faculties: painting, sculpture, architecture, woodwork, metalwork, graphics, textiles, ceramics, and theatre.

The painting faculty falls into branches, such as: Colour, Plane, Space, Construction, and so on, which also have to be studied by the students in the rest of the faculties. The realization of the production plans of these workshops followed in the form of the execution of State commissions: posters and books were printed, porcelain made, furniture produced, and so on.

These workshops, which have been established not only in Moscow and Petersburg but in several provincial towns and which are sought out by thousands of young people, remain the firm strongholds and the future hope of the new company of artists.

I am about to conclude; but I just want to refer to a few very characteristic facts. From the earliest days of the war we and Western Europe were practically cut off from each other; we knew nothing of each other's works. Only now do we realize that in Europe the same problems were arising at the same time as in our country. I refer to De Stijl in Holland, the new Hungarian movement, Germany, and so on.

But those things which in the West remained as studio and laboratory projects were made to materialize on a large scale in Russia, by the design of history. After the period of great impetus the world is now moving into a stagnant rut. Yet we are sure that our vitality and our instinct for self-preservation will again set all our forces in motion.

Then not only our achievements but also our unsuccessful experiments will bear fruit for those masters in every country who are consciously creating.

Léger

The Machine Aesthetic

Fernand Léger (1881–1955), that rare artist who wrote extensively, published many dozens of essays, beginning in 1913 and continuing until 1954. "The Machine Aesthetic: The Manufactured Object, the Artisan, and the Artist," which appeared in 1924, is one of several essays in which he stated his belief that advanced art had to make creative use of the underlying principles of the modern machine. Long a nonparty man of the left (he joined the Communist Party after World War II), Léger credited the anonymous modern artisan and the engineer, not the genius-inventor, with the new objects which help free humans from the premodern domination of nature and naturalistic representation. He extended these ideas in several other essays, including "The Machine Aesthetic: Geometric Order and Truth" (in *Propos d'artistes*, 1925).

For a time Léger was an architectural draftsman, but he began to study painting in 1903 and emerged in 1910 as one of the painters about to be baptized "cubists." Before World War I he developed a distinctive style based on illusions of cones, tubes, and other solids, and he began to publish essays on modern art. Until he was invalided by gas attacks, he served in the engineering corps in the First World War. From 1918 onward his modified Cubist vocabulary was devoted to contemporary subjects of urban architecture, circuses, factories, machinelike forms, steam tugs, and still lifes. He collaborated with a number of other artists, including Blaise Cendrars, Abel Gance, Rolf de Maré, Darius Milhaud, and Le Corbusier, providing them with illustrations, paintings, and designs. By the late 1920s his constantly evolving art showed an awareness of Surrealism without giving up his penchant for a populist realism that made him one of the major artists of the Popular Front of the 1930s. Large mural-scale paintings revealed his ambitions as a painter of civic settings, and after World War II he carried out several commissions for public murals and mosaics.

"The Machine Aesthetic: The Manufactured Object, the Artisan, and the Artist" first appeared in Léonce Rosenberg's *Bulletin de l'Effort Moderne*, January–February 1924, as "L'Esthétique de la machine: l'objet fabriqué, l'artisan et l'artiste." It was translated by Alexandra Anderson for Edward F. Fry, *Functions of Painting by Fernand Léger* (New York, 1973), pp. 52–61. I am grateful to Viking Penguin for permission to include the translation here. The original French text was reprinted in *Fernand Léger, fonctions de la peinture* (Paris, 1965), pp. 53–62.

The Machine Aesthetic: The Manufactured Object, the Artisan, and the Artist

Modern man lives more and more in a preponderantly geometric order.

All mechanical and industrial human creation is subject to geometric forces.

I want to discuss first of all the *prejudices* that blind three-quarters of mankind and totally prevent it from making a free judgment of the beautiful or ugly phenomena that surround them.

I consider plastic beauty in general to be completely independent from sentimental, descriptive, and imitative values. Every object, picture, architectural work, and ornamental arrangement has an intrinsic value that is strictly absolute, independent of what it represents.

Many individuals would be *unintentionally* sensitive to beauty (of a visual object) if the preconceived idea of the *objet d'art* did not act as a blindfold. Bad visual education is the cause of it, along with the modern mania for classifications at any price, for categorizing individuals as if they were tools. Men are *afraid of free will,* which is, after all, the only state of mind possible for registering beauty. Victims of a critical, skeptical, intellectual epoch, people persist in wanting to understand instead of giving in to their sensibilities. "They believe in the *makers of art,*" because these are professionals. Titles, honors dazzle them and obstruct their view. My aim is to try to lay down this notion: that there are no categories or hierarchies of Beauty—this is the worst possible error. The Beautiful is everywhere; perhaps more in the arrangement of your saucepans on the white walls of your kitchen than in your eighteenth-century living room or in the official museums.

I would, then, bring about a new architectural order: *the architecture of the mechanical.* Architecture, both traditional and modern, also originates from geometric forces.

Greek art made horizontal lines dominant. It influenced the entire French seventeenth century. Romanesque art emphasized vertical lines. The Gothic achieved an often perfect balance between the play of curves and straight lines. The Gothic even achieved this amazing thing: moving architectural surfaces. There are Gothic façades that

shift like a dynamic picture. It is the play of complementary lines, which interact, set in opposition by contrast.

One can assert this: a machine or a machine-made object can be beautiful when the relationship of lines describing its volumes is balanced in an order equivalent to that of earlier architectures. We are not now confronting the phenomenon of a new order, properly speaking; it is simply one architectural manifestation like the others.

Where the question becomes most subtle is where one imagines mechanical creation with all its consequences, that is, its *aim*. If the goal of earlier monumental architecture was to make Beauty predominate over utility, it is undeniable that in the mechanical order the dominant aim is *utility*, strictly utility. Everything is directed toward utility with the utmost possible rigor. *The thrust toward utility does not prevent the advent of a state of beauty.*

I offer as a fascinating example the case of the evolution of automotive form. It is even curious because of the fact that the more the car has fulfilled its functional ends, the more beautiful it has become. That is, in the beginning, when vertical lines dominated its form (which was then contrary to its purpose), the automobile was ugly. People were still looking for the horse, and automobiles were called horseless carriages. When, because of the necessity for speed, the car was lowered and elongated, when, consequently, horizontal lines balanced by curves became dominant, it became a perfect whole, logically organized toward its purpose; and it was beautiful.

This evidence of the relationship between the beauty and utility of the car does not mean that perfect utility automatically leads to perfect beauty; I deny it until there is a conclusive demonstration to the contrary. I have seen frequent examples, though I cannot offhand recall them now, of the loss of beauty through the accentuation of function.

Chance alone governs beauty's occurrence in the manufactured object.

Perhaps you regret the loss of fantasy; the state of geometric coldness that has not agreed with you is offset by the play of light on bare metal. Every machine object possesses two qualities of materials: one, often painted and light-absorbent, that remains static (an architectural value), and another (most often bare metal) that reflects light and fills the role of unlimited fantasy (pictorial value). So it is light that determines the degree of variety in the machine object. Another aspect of color leads me to consider a second plastic occurrence connected with the machine: *the occurrence of polychromed mechanical architecture.*

Here, certainly, we find ourselves witnessing the birth of a fairly obscure, but nevertheless definite plastic taste: *a rebirth of the artisan* or, if you prefer, the birth of a new artisan.

The absolutely indispensable manufactured object did not need to

be colored for either functional or commercial purposes; it sold any-
way, in response to an absolute need. *Before this occurrence, what do
we see?* Putting color on the useful object has always more or less
existed, from the peasant who decorated his knife handle to the mod-
ern industries producing "decorative art." The aim was and still is to
create a hierarchy of objects and thus increased commercial and artis-
tic value for the object.

This is the area exploited in the production of objects (decorative
arts). It is done with the aim of creating *the deluxe object* (which is a
mistake, to my mind) and strengthening the market by creating a hier-
archy of objects. This has led us (the professional artists) to such deca-
dence in the "decorative object" that the few people who have sure
and healthy taste become discouraged and quite naturally turn to the
mass-produced object in plain wood or unpolished metal, which is
inherently beautiful or which they can work on or make work to their
taste. *The polychromed machine object is a new beginning. It is a kind
of rebirth of the original object.*

I know that the machine itself also creates ornaments. However,
since it is condemned by its function to work within the geometric
order, I put more confidence in it than in the gentleman with long hair
and windsor knot in his tie, intoxicated with his own personality and
his own imagination.

The charm of color works; this is by no means a negligible point.
Commercially, in terms of sales, the manufacturer knows this very
well. It is so important that we must examine the question from this
aspect: "*the public's reaction to a given object.*" How does the public
judge an object offered to it? Does it judge beauty or utility first?
What is the sequence of its judgment? Personally I think that the ini-
tial judgment of the manufactured object, particularly among the
masses, frequently concerns its degree of beauty. It is indisputable that
the child judges beauty, so much so that he puts the thing he likes in
his mouth and wants to eat it in order to show his desire to possess it.
The young man says: "The good-looking bicycle," and only afterward
does he examine it from the viewpoint of usefulness. One says: "The
beautiful automobile" about the car that passes by and disappears
(the birth, consequently, of the judgment of beauty, free will above
and beyond professional aesthetic prejudices).

The manufacturer has become aware of this value judgment and
uses it more and more for his commercial ends. He has gone so far as
to put color on strictly utilitarian objects. We are now witness to an
unprecedented invasion of the multicolored utilitarian object. Farm
machinery itself has developed an attractive character and is decked
out like a butterfly or a bird. Color is such a vital necessity that it is
recapturing its rights everywhere.

All these colored objects compensate for the loss of color that can
be observed in modern dress. The old, very colorful fashions have

disappeared; contemporary clothing is gray and black. The machine is dressed up and has become a spectacle and a compensation. This observation leads us to envisage the *inherently beautiful* manufactured object as something of ornamental value in the street. For, after the manufacturer, who has used color as a means of making the object attractive and salable, there is the retailer, the shopkeeper, who in turn arranges his store window.

We arrive at *the art of window display,* which has assumed substantial importance over the last several years. The street has become a permanent spectacle of increasing intensity.

The display-window spectacle has become a major source of anxiety in the retailer's activity. Frantic competition reigns there: *to be looked at more than the neighboring store is the violent desire* that animates our streets. Can you yourself doubt the extreme care that goes into preparing these displays?

My friend Maurice Raynal and I have witnessed this labor of ants. Not even on the boulevards in the brilliance of the streetlights, but at the end of a badly lit arcade. The objects were modest (in the famous hierarchical sense of the word); *they were waistcoats,* in a haberdasher's small display window. This man, this artisan, had seventeen waistcoats to arrange in his window, with as many sets of cufflinks and neckties surrounding them. He spent about eleven minutes on each; we timed him. We left, tired out, after the sixth item. We had been there for *one hour* in front of that man, who would come out to see the effect after having adjusted these things one millimeter. Each time he came out, he was so absorbed that he did not see us. With the dexterity of a fitter, he arranged his spectacle, brow wrinkled, eyes fixed, as if his whole future life depended on it. When I think of the carelessness and lack of discipline in the work of certain artists, well-known painters, whose pictures are sold for so much money, we should deeply admire this *worthy craftsman,* forging his own work with difficulty and conscientiousness, which is more valuable than those expensive canvases; they are going to disappear, but he will have to renew his work in a few days with the same care and the same keenness. Men like this, such artisans, incontestably have a concept of art—one closely tied to commercial purposes, but one that is a plastic achievement of a new order and the equivalent of existing artistic manifestations, whatever they may be.

We find ourselves in the presence of a thoroughly admirable rebirth of a world of creative artisans who make joy for our eyes and transform the street into a permanent and endlessly varied spectacle. I really believe that the entertainment halls would empty and disappear, and people would spend their time outside, if there were no *hierarchical prejudices in art.* On the day when the work of this whole world of laborers is understood and appreciated by people who are free from prejudices, who will have eyes to see, we will truly witness

an extraordinary revolution. The false great men will fall from their pedestals, and values will finally be put in their proper place. *I repeat, there is no* hierarchy of art. A work is worth what it is worth in itself, and it is impossible to establish a criterion. That is a matter of taste and of individual emotive capacity.

In the face of these artisans' achievements, what is the situation of the so-called professional artist?

Before considering the situation in question, I will allow myself a backward glance at a monstrous plastic error that still weighs heavily on people's artistic judgments.

The advent of mechanical beauty, with all its beautiful objects not intending to be art, justifies my making a quick examination of the traditional values of intention that were once considered definitive.

The Italian Renaissance (the *Mona Lisa,* the sixteenth century) is considered by the whole world as an apogee, a summit, an ideal to strive for. The École des Beaux-Arts bases its reason for existence on the slavish imitation of that period. *This is the most colossal error possible.* The sixteenth century is a period of nearly total decadence in all the plastic areas.

It is the error of *imitation,* of the servile copy of the subject, as opposed to the so-called primitive epoch that is great and immortal precisely because it invented its forms and methods. The Renaissance mistook means for ends and believed also in the beautiful subject. It thus combined two major errors: the spirit of imitation and the copy of the *beautiful subject.*

The men of the Renaissance have been considered superior to their predecessors, the primitives. In imitating natural forms instead of seeking their equivalents, they produced immense pictures that complacently described the most striking and theatrical gestures and actions of their epoch. *They were victims of the beautiful subject. If a subject is beautiful,* if a form is beautiful, it is a value absolute in itself, rigorous, intangible.

A beautiful thing cannot be copied; it can be admired, and that is all. At the very most, one can, through one's talent, create an equivalent work.

The Renaissance is responsible for engendering that malady that is the École des Beaux-Arts, which runs ecstatically after *the beautiful subject.* They wanted something that is even materially impossible; a beautiful subject is uncopiable. It cannot be reproduced in the scientific sense of the word. The everyday experience of thirty students in front of a beautiful object, all in the same light at the same time, but each producing a different copy, is conclusive enough. Scientific methods of imitation such as casting or photography are not the most successful. Every manifestation of beauty, whatever it may be, contains an unknown element that will always be mysterious for the admirer. It is already there for the creator, who, caught between his conscious

and his unconscious, is incapable of defining the boundaries of these two realms; the objective and the subjective continually collide with each other, interpenetrating in such a way that the creative event remains always a partial enigma for the artist. *The beautiful machine is the modern beautiful subject*; it too is uncopiable. *Two producers then face each other. Are they going to destroy each other?*

I believe that the need for beauty is more widespread than it appears to be. From childhood to adult life, the demand for Beauty is considerable; three-quarters of our daily gestures and aspirations are plagued with the desire for it. Here, too, the law of supply and demand functions, but at the present time, it is directed mostly toward *the professional artist,* thanks to the prejudice I mentioned earlier, from which he benefits and which keeps people's eyes still barely open to the very beautiful object manufactured by the artisan, because it is not the work of an "artist."

I have just seen the Paris Fair, a spectacle where invention boils over at every step, where a prodigious effort is made to emphasize the quality of execution.

I am amazed to see that all these men who arranged, for example, those admirable panels of mechanical parts, those astonishing fountains of letters and lights, those powerful and awesome machines, do not understand, do not feel that they are true artists, that they have overturned all the received conditions of modern plasticity. They ignore the plastic quality they create; they are unaware of it.

In such a case, perhaps ignorance is healthy, but it is truly a sad matter—this most disturbing lack of consciousness in artistic creation—and it will disturb those who evoke the mystery for a long time to come.

Let us suppose all the same, as I just said, that this whole, immense world of engineers, workers, shopkeepers, and display artists became conscious of all the beauty they create and in which they live. The demand for beauty would almost be satisfied by them; the peasant would be satisfied with his beautiful colored mowing machine, and the salesman with his melody of neckties. *Why is it necessary for these people to go into ecstasies on Sunday over the dubious pictures in the Louvre or elsewhere? Among a thousand pictures are there two beautiful ones? Among a hundred machine-made objects, thirty are beautiful,* and they resolve the problem of Art, being beautiful and useful at the same time.

The artisan regains his place, which he should always have kept, for he is the true creator. It is he who daily, modestly, unconsciously creates and invents the pretty trinkets and beautiful machines that enable us to live. His unconsciousness saves him. The vast majority of professional artists are detestable for their individual pride and their self-consciousness; they make everything wither. In these periods of

decadence one always observes the hideous hypertrophy of the individual in false artists (the Renaissance).

Take a tour of the Machine Exhibitions, for the machine has its annual exhibitions, just like those fine gentlemen the artists. Go to see the Automobile Show or the Aviation Show, the Paris Fair, which are the most beautiful spectacles in the world. Look at the work very carefully. Every time its execution is the work of an artisan, it is good. Every time it is desecrated by a professional, it is bad.

It should never be necessary for the manufacturers to leave their own terrain and address themselves to professional artists; *that is where all the mischief comes from.* These fine men believe that there is a category of demigods above them who make wonderful things, much more beautiful than theirs, who annually exhibit these immortal masterpieces at the Salon des Artistes Français, at the Salon de la Nationale, or somewhere else. They go to these openings in evening dress and humbly throw themselves into raptures over these imbeciles who should not be mentioned in the same breath with themselves.

If they were able to destroy their stupid prejudice, *they would know that the most beautiful annual salons of plastic art are their own.* They would have confidence in the admirable men who surround them, *the artisans,* and they would not go out looking for the pretentious incompetents who massacre their work.

What definitive conclusion can be drawn from all that? That the artisan is everything? No. I think there are some men above him, very few, who are capable of elevating him through their plastic concept to a height that towers over the primary level of Beauty. Those men must be capable of viewing the work of the artisan and of nature as raw material, to be ordered, absorbed and fused in their brains, with a perfect balance between the two values: the conscious and the unconscious, the objective and the subjective.

The plastic life is terribly dangerous; its ambiguity is perpetual. No criterion is possible, no tribunal of arbitration exists to settle contentions about the Beautiful.

When the Impressionist painter Sisley was shown two of his own pictures that were not quite identical, he could not tell which one was a fake. We must live and create in a perpetual turmoil, in this continuous ambiguity. Those who deal in beautiful things ignore it. In this connection, I will always remember that one year, showing at the Salon d'Automne, I had the advantage of being next to the Aviation Show, which was about to open. Through the partition, I listened to the hammers and the mechanics' songs. I jumped over the barrier, and never, in spite of my familiarity with these spectacles, had I been so impressed. Never had such a stark contrast assailed my eyes. I left vast surfaces, dismal and gray, pretentious in their frames, for beautiful, metallic objects, hard, permanent, and useful, in pure local colors;

infinite varieties of steel surfaces at play next to vermilions and blues. The power of geometric forms dominated it all.

The mechanics saw me come in; they knew that they had artists as neighbors. They in turn asked permission to go to the other side, and these worthy men, who had never seen an exhibition of painting in their lives, who were clean and fine, brought up amid beautiful raw materials, fell into raptures over works that I would not want to comment on.

I will always see a sixteen-year-old with fiery red hair, a new blue canvas coat, orange pants, and a hand spattered with Prussian blue blissfully contemplating the nude women in gold frames; without the slightest doubt, he—in his clothes of a modern worker, blazing with color—killed the whole exhibition. Nothing more remained on the walls than vaporous shadows in old frames. The dazzling kid who looked as though he had been fathered by a piece of farm machinery was the symbol of the neighboring exhibition, of the life of tomorrow, when Prejudice will be destroyed.

Klee

On Modern Art

Paul Klee's "On Modern Art" was not published until 1945, twenty-one years after it was delivered as a lecture. It has therefore not had such wide currency as the *Pedagogical Sketchbook* of 1925, his most famous writing.

Klee (1879–1940) was a native of Switzerland who came to Munich to study art in 1898, but he seems not to have known Kandinsky, though they were both in the Bavarian capital for several years. They finally met in 1911, and Klee joined the second *Blaue Reiter* exhibition the following year. Equally important was his visit with Robert Delaunay in Paris in 1912. Klee translated Delaunay's essay on light for the January 1913 issue of *Der Sturm,* and began to unfold his sense of color which, with his already developed graphic gifts, helped bring him to fame. In 1920 Klee wrote the introspective "Creative Credo" (*Schöpferische Konfession*). The following year he went to the Bauhaus at Weimar, where he was again associated with Kandinsky. His *Pedagogical Sketchbook* of 1925, like Kandinsky's *Point and Line to Plane* of 1926, was a Bauhaus publication that came directly from his teaching. It is essentially a series of provocative speculations upon the linear diagrams and forms which dominate its pages. In "On Modern Art," Klee speaks more directly of his esthetic, but not in a metaphysical manner. This genial essay is instead a fusion of sensitive poetry and common sense. It is one of the most beautiful apologias for that modern art which is not entirely abstract, but whose images are at a far remove from those of the accepted, everyday world.

"On Modern Art" was a lecture to the Jena Kunstverein in 1924. The notes which he used for the lecture—presumably embellished extemporaneously—were first published by the Verlag Benteli, Bern-Bümpliz, in 1945, as *Paul Klee: Über die moderne Kunst.* The first English edition was published by Faber and Faber, London, in 1948 (with subsequent printings) as *Paul Klee: On Modern Art,* translated by Paul Findlay, with a foreword by Sir Herbert Read. I am indebted to Faber and Faber for permission to reprint the essay here.

On Modern Art

SPEAKING here in the presence of my work, which should really express itself in its own language, I feel a little anxious as to whether I am justified in doing so and whether I shall be able to find the right approach.

For, while as a painter I feel that I have in my possession the means of moving others in the direction in which I myself am driven, I doubt whether I can give the same sure lead by the use of words alone.

But I comfort myself with the thought that my words do not address themselves to you in isolation, but will complement and bring into focus the impressions, perhaps still a little hazy, which you have already received from my pictures.

If I should, in some measure, succeed in giving this lead, I should be content and should feel that I had found the justification which I had required.

FURTHER, in order to avoid the reproach "Don't talk, painter, paint," I shall confine myself largely to throwing some light on those elements of the creative process which, during the growth of a work of art, take place in the subconscious. To my mind, the real justification for the use of words by a painter would be to shift the emphasis by stimulating a new angle of approach; to relieve the formal element of some of the conscious emphasis which is given and place more stress on content.

This is the kind of readjustment which I should find pleasure in making and which might easily tempt me to embark on a dialectical analysis.

But this would mean that I should be following too closely my own inclinations and forgetting the fact that most of you are much more familiar with content than with form. I shall, therefore, not be able to avoid saying something about form.

I shall try to give you a glimpse of the painter's workshop, and I think we shall eventually arrive at some mutual understanding.

For there is bound to be some common ground between layman and artist where a mutual approach is possible and whence the artist no longer appears as a being totally apart.

But, as a being, who like you, has been brought, unasked, into this world of variety, and where, like you, he must find his way for better or for worse.

A being who differs from you only in that he is able to master life by the use of his own specific gifts; a being perhaps happier than the man who has no means of creative expression and no chance of release through the creation of form.

This modest advantage should be readily granted the artist. He has difficulties enough in other respects.

MAY I use a simile, the simile of the tree? The artist has studied this world of variety and has, we may suppose, unobtrusively found his way in it. His sense of direction has brought order into the passing stream of image and experience. This sense of direction in nature and life, this branching and spreading array, I shall compare with the root of the tree.

From the root the sap flows to the artist, flows through him, flows to his eye.

Thus he stands as the trunk of the tree.

Battered and stirred by the strength of the flow, he molds his vision into his work.

As, in full view of the world, the crown of the tree unfolds and spreads in time and in space, so with his work.

Nobody would affirm that the tree grows its crown in the image of its root. Between above and below can be no mirrored reflection. It is obvious that different functions expanding in different elements must produce vital divergences.

But it is just the artist who at times is denied those departures from nature which his art demands. He has even been charged with incompetence and deliberate distortion.

And yet, standing at his appointed place, the trunk of the tree, he does nothing other than gather and pass on what comes to him from the depths. He neither serves nor rules—he transmits.

His position is humble. And the beauty at the crown is not his own. He is merely a channel.

BEFORE starting to discuss the two realms which I have compared with the crown and the root, I must make a few further reservations.

It is not easy to arrive at a conception of a whole which is constructed from parts belonging to different dimensions. And not only nature, but also art, her transformed image, is such a whole.

It is difficult enough, oneself, to survey this whole, whether nature or art, but still more difficult to help another to such a comprehensive view.

This is due to the consecutive nature of the only methods available to us for conveying a clear three-dimensional concept of an image in space, and results from deficiencies of a temporal nature in the spoken word.

For, with such a medium of expression, we lack the means of discussing, in its constituent parts, an image which possesses simultaneously a number of dimensions.

But, in spite of all these difficulties, we must deal with the constituent parts in great detail.

However, with each part, irrespective of the amount of study which it may itself require, we must not lose sight of the fact that it is only a part of the whole. Otherwise our courage may fail us when we find ourselves faced with a new part leading in a completely different direction, into new dimensions, perhaps into a remoteness where the recollection of previously explored dimensions may easily fade.

To each dimension, as, with the flight of time, it disappears from view, we should say: now you are becoming the Past. But possibly later at a critical—perhaps fortunate—moment we may meet again on a new dimension, and once again you may become the Present.

And, if, as the number of dimensions grows, we find increasing difficulty in visualizing all the different parts of the structure at the same time, we must exercise great patience.

What the so-called spatial arts have long succeeded in expressing, what even the time-bound art of music has gloriously achieved in the harmonies of polyphony, this phenomenon of many simultaneous dimensions which helps drama to its climax, does not, unfortunately, occur in the world of verbal didactic expression.

Contact with the dimensions must, of necessity, take place externally to this form of expression; and subsequently.

And yet, perhaps I shall be able to make myself so completely understood that, as a result, you will be in a better position with any given picture, to experience easily and quickly the phenomenon of simultaneous contact with these many dimensions.

As a humble mediator—not to be identified with the crown of the tree—I may well succeed in imparting to you a power of rich, brilliant vision.

And now to the point—the dimensions of the picture.

I HAVE already spoken of the relationship between the root and the crown, between nature and art, and have explained it by a comparison with the difference between the two elements of earth and air, and with the correspondingly differing functions of below and above.

The creation of a work of art—the growth of the crown of the tree—must of necessity, as a result of entering into the specific dimensions of pictorial art, be accompanied by distortion of the natural form. For, therein is nature reborn.

What, then, are these specific dimensions?

First, there are the more or less limited, formal factors, such as line, tone value, and color.

Of these, line is the most limited, being solely a matter of simple Measure. Its properties are length (long or short), angles (obtuse or acute), length of radius and focal distance. All are quantities subject to measurement.

Measure is the characteristic of this element. Where the possibility of measurement is in doubt, line cannot have been handled with absolute purity.

Of a quite different nature is tone value, or, as it is also called, chiaroscuro—the many degrees of shading between black and white. This second element can be characterized by Weight. One stage may be more or less rich in white energy, another more or less weighted toward the black. The various stages can be weighed against one another. Further, the blacks can be related to a white norm (on a white background) and the whites to a black norm (on a blackboard). Or both together can be referred to a medium grey norm.

Thirdly, color, which clearly has quite different characteristics. For it can be neither weighed nor measured. Neither with scales nor with ruler can any difference be detected between two surfaces, one a pure yellow and the other a pure red, of similar area and similar brilliance. And yet, an essential difference remains, which we, in words, label yellow and red.

In the same way, salt and sugar can be compared, in their saltiness and sweetness.

Hence, color may be defined as Quality.

We now have three formal means at our disposal—Measure, Weight, and Quality, which in spite of fundamental differences, have a definite interrelationship.

The form of this relationship will be shown by the following short analysis.

Color is primarily Quality. Secondly, it is also Weight, for it has not only color value but also brilliance. Thirdly, it is Measure, for besides Quality and Weight, it has its limits, its area, and its extent, all of which may be measured.

Tone value is primarily Weight, but in its extent and its boundaries, it is also Measure.

Line, however, is solely Measure.

Thus, we have found three quantities which all intersect in the region of pure color, two only in the region of pure contrast, and only one extends to the region of pure line.

These three quantities impart character, each according to its individual contribution—three interlocked compartments. The largest compartment contains three quantities, the medium two, and the smallest only one.

(Seen from this angle the saying of Liebermann may perhaps be best understood "The art of drawing is the art of omission.")

This shows a remarkable intermixture of our quantities and it is only logical that the same high order should be shown in the clarity with which they are used. It is possible to produce quite enough combinations as it is.

Vagueness in one's work is therefore only permissible when there is a real inner need. A need which could explain the use of colored or very pale lines, or the application of further vagueness such as the shades of grey ranging from yellow to blue.

The symbol of pure line is the linear scale with its wide variations of length.

The symbol of pure contrast is the weight scale with its different degrees between white and black.

What symbol is now suitable for pure color? In what unit can its properties best be expressed?

IN THE completed color circle, which is the form best suited for expressing the data necessary to define the relationship between the colors.

Its clear center, the divisibility of its circumference into six arcs, the picture of the three diameters drawn through these six intersections; in this way the outstanding points are shown in their place against the general backcloth of color-relationships.

These relationships are firstly diametrical and, just as there are three diameters, so are there three diametrical relations worthy of mention, namely Red Green Yellow Purple and Blue Orange (i.e. the principal complementary color-pairs).

Along the circumference the main or primary colors alternate with the most important mixed or secondary colors in such a manner that the mixed colors (three in number) lie between their primary components, i.e. green between yellow and blue, purple between red and blue, and orange between yellow and red.

The complementary color pairs connected by the diameters mutually destroy each other since their mixture along the diameter results in grey. That this is true for all three is shown by the fact that all three diameters possess a common point of intersection and of bisection, the grey center of the color circle.

Further, a triangle can be drawn through the points of the three primary colors, yellow, red, and blue. The corners of this triangle are the primary colors themselves and the sides between each represent the mixture of the two primary colors lying at their extremes. Thus the green side lies opposite the red corner, the purple side opposite the yellow corner, and the orange side opposite the blue corner. There are now three primary and three main secondary colors or six main adjacent colors, or three color pairs.

Leaving this subject of formal elements I now come to the first construction using the three categories of elements which have just been enumerated.

This is the climax of our conscious creative effort.
This is the essence of our craft.
This is critical.

From this point, given mastery of the medium, the structure can be assured foundations of such strength that it is able to reach out into dimensions far removed from conscious endeavor.

This phase of formation has the same critical importance in the negative sense. It is the point where one can miss the greatest and most important aspects of content and thus fail, although possibly possessing the most exquisite talent. For one may simply lose one's bearings on the formal plane. Speaking from my own experience, it depends on the mood of the artist at the time which of the many elements are brought out of their general order, out of their appointed array, to be raised together to a new order and form an image which is normally called the subject.

This choice of formal elements and the form of their mutual relationship is, within narrow limits, analogous to the idea of motif and theme in musical thought.

With the gradual growth of such an image before the eyes an association of ideas gradually insinuates itself which may tempt one to a material interpretation. For any image of complex structure can, with

some effort of imagination, be compared with familiar pictures from nature.

These associative properties of the structure, once exposed and labelled, no longer correspond wholly to the direct will of the artist (at least not to his most intensive will) and just these associative properties have been the source of passionate misunderstandings between artist and layman.

While the artist is still exerting all his efforts to group the formal elements purely and logically so that each in its place is right and none clashes with the other, a layman, watching from behind, pronounces the devastating words "But that isn't a bit like uncle."

The artist, if his nerve is disciplined, thinks to himself, "To hell with uncle! I must get on with my building. . . . This new brick is a little too heavy and to my mind puts too much weight on the left; I must add a good-sized counterweight on the right to restore the equilibrium."

And he adds this side and that until finally the scales show a balance.

And he is relieved if, in the end, the shaking which he has perforce had to give his original pure structure of good elements, has only gone so far as to provide that opposition which exists as contrast in a living picture.

But sooner or later, the association of ideas may of itself occur to him, without the intervention of a layman. Nothing need then prevent him from accepting it, provided that it introduces itself under its proper title.

Acceptance of this material association may suggest additions which, once the subject is formulated, clearly stand in essential relationship to it. If the artist is fortunate, these natural forms may fit into a slight gap in the formal composition, as though they had always belonged there.

The argument is therefore concerned less with the question of the existence of an object, than with its appearance at any given moment—with its nature.

I only hope that the layman who, in a picture, always looks for his favorite subject, will, as far as I am concerned, gradually die out and remain to me nothing but a ghost which cannot help its failings. For a man only knows his own objective passions. And admittedly it gives him great pleasure when, by chance, a familiar face of its own accord emerges from a picture.

The objects in pictures look out at us serene or severe, tense or relaxed, comforting or forbidding, suffering or smiling.

They show us all the contrasts in the psychic-physiognomical field, contrasts which may range from tragedy to comedy.

But it is far from ending there.
The figures, as I have often called these objective images, also have their own distinctive aspects, which result from the way in which the selected groups of elements have been put in motion.

If a calm and rigid aspect has been achieved, then the construction has aimed at giving either an array along wide horizontals without any elevation, or, with high elevation, prominence to visible and extended verticals.

This aspect can, while preserving its calm, lose some of its rigidity. The whole action can be transferred to an intermediate state such as water or atmosphere, where no predominant verticals exist (as in floating or hovering).

I say intermediate state as distinct from the first wholly earthbound position.

At the next stage a new aspect appears. Its character, which is one of extreme turbulence, has the effect of giving it life.

Why not?

I have admitted that, in a picture, an objective concept can be justified and have thus acquired a new dimension.

I have named the elements of form singly and in their particular context.

I have tried to explain their emergence from this context.

I have tried to explain their appearance as groups, and their combination, limited at first, but later somewhat more extensive, into images.

Into images which, in the abstract, may be called constructions, but which, seen concretely, may be named each after the association which they have prompted, such as star, vase, plant, animal, head, or man.

This, firstly, identified the dimensions of the elemental ingredients of the picture with line, tone value, and color. And then the first constructive combination of these ingredients gave us the dimension of figure or, if you prefer it, the dimension of object.

THESE dimensions are now joined by a further dimension which determines the question of content.

Certain proportions of line, the combination of certain tones from the scale of tone values, certain harmonies of color, carry with them at the time quite distinctive and outstanding modes of expression.

The linear proportions can, for example, refer to angles: movements which are angular and zigzag—as opposed to smooth and horizontal—strike resonances of expression which are similarly contrasting.

In the same way a conception of contrast can be given by two forms of linear construction, the one consisting of a firmly jointed structure and the other of lines loosely scattered.

Contrasting modes of expression in the region of tone value are given by:

The wide use of all tones from black to white, implying full-bodied strength.

Or the limited use of the upper light half or the lower dark half of the scale.

Or medium shades around the grey which imply weakness through too much or too little light.

Or timid shadows from the middle. These, again, show great contrasts in meaning.

And what tremendous possibilities for the variation of meaning are offered by the combination of colors.

Color as tone value: e.g. red in red, i.e. the entire range from a deficiency to an excess of red, either widely extended, or limited in range. Then the same in yellow (something quite different). The same in blue—what contrasts!

Or colors diametrically opposed—i.e. changes from red to green, from yellow to purple, from blue to orange.

Tremendous fragments of meaning.

Or changes of color in the direction of chords,[1] not touching the grey center, but meeting in a region of warmer or cooler grey.

What subtleties of shading compared with the former contrasts.

Or: color changes in the direction of arcs of the circle, from yellow through orange to red or from red through violet to blue, or far flung over the whole circumference.

What tremendous variations from the smallest shading to the glowing symphony of color. What perspectives in the dimension of meaning!

Or finally, journeys through the whole field of color, including the grey center, and even touching the scale from black to white.

[1. The word used by the author was "segment." This would appear to be a geometrical slip which has been corrected in the translation.—Translator's note.]

ONLY on a new dimension can one go beyond these last possibilities. We could now consider what is the proper place for the assorted colors, for each assortment clearly possesses its possibilities of combination.

And each formation, each combination will have its own particular constructive expression, each figure its face—its features.

Such forceful means of expression point quite clearly to the dimension of style. Here Romanticism arose in its crassly pathetic phase.

This form of expression tries convulsively to fly from the earth and eventually rises above it to reality. Its own power forces it up, triumphing over gravity.

If, finally, I may be allowed to pursue these forces, so hostile to earth, until they embrace the life force itself, I will emerge from the oppressively pathetic style to that Romanticism which is one with the universe.

Thus, the statics and dynamics of the mechanism of creative art coincide beautifully with the contrast between Classicism and Romanticism.

Our picture has, as has been described, progressed gradually through dimensions so numerous and of such importance, that it would be unjust to refer to it any longer as a "Construction." From now on we will give it the resounding title of "Composition."

On the subject of the dimensions, however, let us be content with this rich perspective.

I WOULD like now to examine the dimensions of the object in a new light and so try to show how it is that the artist frequently arrives at what appears to be such an arbitrary "deformation" of natural forms.

First, he does not attach such intense importance to natural form as do so many realist critics, because, for him, these final forms are not the real stuff of the process of natural creation. For he places more value on the powers which do the forming than on the final forms themselves.

He is, perhaps unintentionally, a philosopher, and if he does not, with the optimists, hold this world to be the best of all possible worlds, nor to be so bad that it is unfit to serve as a model, yet he says:

"In its present shape it is not the only possible world."

Thus he surveys with penetrating eye the finished forms which nature places before him.

The deeper he looks, the more readily he can extend his view from the present to the past, the more deeply he is impressed by the one essential image of creation itself, as Genesis, rather than by the image of nature, the finished product.

Then he permits himself the thought that the process of creation can today hardly be complete and he sees the act of world creation stretching from the past to the future. Genesis eternal!

He goes still further!

He says to himself, thinking of life around him: this world at one time looked different and, in the future, will look different again.

Then, flying off to the infinite, he thinks: it is very probable that, on other stars, creation has produced a completely different result.

Such mobility of thought on the process of natural creation is good training for creative work.

It has the power to move the artist fundamentally, and since he is himself mobile, he may be relied upon to maintain freedom of development of his own creative methods.

This being so, the artist must be forgiven if he regards the present state of outward appearances in his own particular world as accidentally fixed in time and space. And as altogether inadequate compared with his penetrating vision and intense depth of feeling.

And is it not true that even the small step of a glimpse through the microscope reveals to us images which we should deem fantastic and overimaginative if we were to see them somewhere accidentally, and lacked the sense to understand them?

Your realist, however, coming across such an illustration in a sensational magazine, would exclaim in great indignation: "Is that supposed to be nature? I call it bad drawing."

Does then the artist concern himself with microscopy? History? Paleontology?

Only for purposes of comparison, only in the exercise of his mobility of mind. And not to provide a scientific check on the truth of nature.

Only in the sense of freedom.

In the sense of a freedom, which does not lead to fixed phases of development, representing exactly what nature once was, or will be, or could be on another star (as perhaps may one day be proved).

But in the sense of a freedom which merely demands its rights, the right to develop, as great Nature herself develops.

From type to prototype.

Presumptuous is the artist who does not follow his road through to the end. But chosen are those artists who penetrate to the region of that secret place where primeval power nurtures all evolution.

There, where the powerhouse of all time and space—call it brain or heart of creation—activates every function; who is the artist who would not dwell there?

In the womb of nature, at the source of creation, where the secret key to all lies guarded.

But not all can enter. Each should follow where the pulse of his own heart leads.

So, in their time, the Impressionists—our opposites of yesterday—had every right to dwell within the matted undergrowth of everyday vision.

But our pounding heart drives us down, deep down to the source of all.

What springs from this source—whatever it may be called, dream, idea or fantasy—must be taken seriously only if it unites with the proper creative means to form a work of art.

Then those curiosities become realities—realities of art which help to lift life out of its mediocrity.

For not only do they, to some extent, add more spirit to the seen, but they also make secret visions visible.

I SAID "with the proper creative means." For at this stage is decided whether pictures or something different will be born. At this stage, also, is decided the kind of the pictures.

These unsettled times have brought chaos and confusion (or so it seems, if we are not too near to judge).

But among artists, even among the youngest of them, one urge seems to be gradually gaining ground:
The urge to the culture of these creative means, to their pure cultivation, to their pure use.

The legend of the childishness of my drawing must have originated from those linear compositions of mine in which I tried to combine a concrete image, say that of a man, with the pure representation of the linear element.

Had I wished to present the man "as he is," then I should have had to use such a bewildering confusion of line that pure elementary representation would have been out of the question. The result would have been vagueness beyond recognition.

And anyway, I do not wish to represent the man as he is, but only as he might be.

And thus I could arrive at a happy association between my vision of life [*Weltanschauung*] and pure artistic craftsmanship.

And so it is over the whole field of use of the formal means: in all things, even in colors, must all trace of vagueness be avoided.

This then is what is called the untrue coloring in modern art.

As you can see from this example of "childishness" I concern myself with work on the partial processes of art. I am also a draughtsman.

I have tried pure drawing, I have tried painting in pure tone values. In color, I have tried all partial methods to which I have been led by my sense of direction in the color circle. As a result, I have worked out methods of painting in colored tone values, in complementary colors, in multicolors and methods of total color painting.

Always combined with the more subconscious dimensions of the picture.

Then I tried all possible syntheses of two methods. Combining and again combining, but, of course, always preserving the culture of the pure element.

Sometimes I dream of a work of really great breadth, ranging through the whole region of element, object, meaning, and style.

This, I fear, will remain a dream, but it is a good thing even now to bear the possibility occasionally in mind.

Nothing can be rushed. It must grow, it should grow of itself, and if the time ever comes for that work—then so much the better!

We must go on seeking it!
We have found parts, but not the whole!
We still lack the ultimate power, for:
the people are not with us.

But we seek a people. We began over there in the Bauhaus. We began there with a community to which each one of us gave what he had. More we cannot do.

Malevich

Suprematism

"Suprematism" is the second of the two essays which together comprise *The Non-Objective World,* Malevich's major treatise published in Germany in 1927.

By 1912, Kasimir Malevich (1878–1935) had absorbed the impulses emanating from western Europe and was already an artist of distinction. In December 1915, at the "0.10" exhibition in Moscow, he launched Suprematism, his new visual language of flat geometric forms. After the October Revolution he was a leading force among Russian artists devoted to complete abstraction: Tatlin, Lissitzky, Rodchenko, Popova, Gabo, and others. A charismatic teacher in Moscow and Vitebsk, where Lissitzky became a disciple, he had a major role until the mid-1920s, when abstract art came under increasing conservative pressures. Other artists emigrated (Kandinsky, Gabo, Chagall, Exter) but Malevich remained in Russia, without making a pact with the antirevolutionary esthetic of the post-Lenin Party. He seems to have continued his art in isolation until his death in 1935, with the notable exception of the trip to Germany in 1927.

Malevich came to Berlin in 1927 for an exhibition of his paintings at the Grosse Berliner Kunstausstellung. He brought with him the manuscript of his *The Non-Objective World,* which was translated into German by A. von Riesen and published by Albert Langen, Munich, as volume eleven of the Bauhaus books. *Die Gegenstandslose Welt* was presumably written over a span of years. It speaks with Malevich's own voice, and yet suits the orientation of the *de Stijl,* Purist, and other movements of the 1920s which shared a faith in the world of modern technology in opposition to Dada and Surrealism.

I have included the second part of the treatise (the first is called "Introduction to the Theory of the Additional Element in Painting") because it is the clearest exposition of his ideas. The first part is actually an application of the principles enunciated in the second, and though ideally both should be read together, it was essential, for this anthology, to find the text that most completely exposed Malevich's esthetic principles.

The entire text was translated by Howard Dearstyne from the German (the Russian manuscript has not been uncovered) and, accompanied by many illustrations and an introduction by L. Hilbersheimer, was published by Paul Theobald and Company, Chicago, in 1959. I am grateful to Paul Theobald and Company for authorizing me to reproduce "Suprematism."

Suprematism

Under Suprematism I understand the supremacy of pure feeling in creative art.

To the Suprematist the visual phenomena of the objective world are, in themselves, meaningless; the significant thing is feeling, as such, quite apart from the environment in which it is called forth.

The so-called "materialization" of a feeling in the conscious mind really means a materialization of the *reflection* of that feeling through the medium of some realistic conception. Such a realistic conception is without value in suprematist art. . . . And not only in suprematist art but in art generally, because the enduring, true value of a work of art (to whatever school it may belong) resides solely in the feeling expressed.

Academic naturalism, the naturalism of the Impressionists, Cézanneism, Cubism, etc.—all these, in a way, are nothing more than dialectic methods which, as such, in no sense determine the true value of an art work.

An objective representation, having objectivity as its aim, is something which, as such, has nothing to do with art, and yet the use of objective forms in an art work does not preclude the possibility of its being of high artistic value.

Hence, to the Suprematist, the appropriate means of representation is always the one which gives fullest possible expression to feeling as such and which ignores the familiar appearance of objects.

Objectivity, in itself, is meaningless to him; the concepts of the conscious mind are worthless.

Feeling is the determining factor . . . and thus art arrives at non-objective representation—at Suprematism.

It reaches a "desert" in which nothing can be perceived but feeling.

Everything which determined the objective-ideal structure of life and of "art"—ideas, concepts, and images—all this the artist has cast aside in order to heed pure feeling.

The art of the past which stood, at least ostensibly, in the service of religion and the state, will take on new life in the pure (unapplied) art of *Suprematism*, which will build up a new world—the world of feeling. . . .

When, in the year 1913, in my desperate attempt to free art from the ballast of objectivity, I took refuge in the square form and exhibited a picture which consisted of nothing more than a black square on

a white field, the critics and, along with them, the public sighed, "Everything which we loved is lost. We are in a desert. . . . Before us is nothing but a black square on a white background!"

"Withering" words were sought to drive off the symbol of the "desert" so that one might behold on the "dead square" the beloved likeness of "reality" ("true objectivity" and a spiritual feeling). The square seemed incomprehensible and dangerous to the critics and the public . . . and this, of course, was to be expected.

The ascent to the heights of nonobjective art is arduous and painful . . . but it is nevertheless rewarding. The familiar recedes ever further and further into the background. . . . The contours of the objective world fade more and more and so it goes, step by step, until finally the world—"everything we loved and by which we have lived"— becomes lost to sight.

No more "likeness of reality," no idealistic images—nothing but a desert!

But this desert is filled with the spirit of nonobjective sensation which pervades everything.

Even I was gripped by a kind of timidity bordering on fear when it came to leaving "the world of will and idea," in which I had lived and worked and in the reality of which I had believed.

But a blissful sense of liberating nonobjectivity drew me forth into the "desert," where nothing is real except feeling . . . and so feeling became the substance of my life.

This was no "empty square" which I had exhibited but rather the feeling of nonobjectivity.

I realized that the "thing" and the "concept" were substituted for feeling and understood the falsity of the world of will and idea.

Is a milk bottle, then, the symbol of milk?

Suprematism is the rediscovery of pure art which, in the course of time, had become obscured by the accumulation of "things."

It appears to me that, for the critics and the public, the painting of Raphael, Rubens, Rembrandt, etc., has become nothing more than a *conglomeration* of countless "things," which conceal its true value— the feeling which gave rise to it. The virtuosity of the objective representation is the only thing admired.

If it were possible to extract from the works of the great masters the feeling expressed in them—the actual artistic value, that is—and to hide this away, the public, along with the critics and the art scholars, would never even miss it.

So it is not at all strange that my square seemed empty to the public.

If one insists on judging an art work on the basis of the virtuosity of the objective representation—the verisimilitude of the illusion— and thinks he sees in the objective representation itself a symbol of the inducing emotion, he will never partake of the gladdening content of a work of art.

The general public is still convinced today that art is bound to per-ish if it gives up the imitation of "dearly-loved reality" and so it observes with dismay how the hated element of pure feeling—abstrac-tion—makes more and more headway. . . .

Art no longer cares to serve the state and religion, it no longer wishes to illustrate the history of manners, it wants to have nothing further to do with the object, as such, and believes that it can exist, in and for itself, without "things" (that is, the "time-tested wellspring of life").

But the nature and meaning of artistic creation continue to be mis-understood, as does the nature of creative work in general, because feeling, after all, is always and everywhere the one and only source of every creation.

The emotions which are kindled in the human being are stronger than the human being himself . . . they must at all costs find an out-let—they must take on overt form—they must be communicated or put to work.

It was nothing other than a yearning for speed . . . for flight . . . which, seeking an outward shape, brought about the birth of the air-plane. For the airplane was not contrived in order to carry business letters from Berlin to Moscow, but in obedience to the irresistible drive of this yearning for speed to take on external form.

The "hungry stomach" and the intellect which serves this must always have the last word, of course, when it comes to determining the origin and purpose of *existing* values . . . but that is a subject in itself.

And the state of affairs is exactly the same in art as in creative tech-nology. . . . In painting (I mean here, naturally, the accepted "artistic" painting) one can discover behind a technically correct portrait of Mr. Miller or an ingenious representation of the flower girl at Potsdamer Platz not a trace of the true essence of art—no evidence whatever of feeling. Painting is the dictatorship of a method of representation, the purpose of which is to depict Mr. Miller, his environment and his ideas.

The black square on the white field was the first form in which nonobjective feeling came to be expressed. The square = feeling, the white field = the void beyond this feeling.

Yet the general public saw in the nonobjectivity of the representa-tion the demise of art and failed to grasp the evident fact that feeling had here assumed external form.

The suprematist square and the forms proceeding out of it can be likened to the primitive marks (symbols) of aboriginal man which rep-resented, in their combinations, *not ornament but a feeling of rhythm.*

Suprematism did not bring into being a new world of feeling but rather, an altogether new and direct form of representation of the world of feeling.

The square changes and creates new forms, the elements of which can be classified in one way or another depending upon the feeling which gave rise to them.

When we examine an antique column, we are no longer interested in the fitness of its construction to perform its technical task in the building but recognize in it the material expression of a pure feeling. We no longer see in it a structural necessity but view it as a work of art in its own right.

"Practical life," like a homeless vagabond, forces its way into every artistic form and believes itself to be the genesis and reason for existence of this form. But the vagabond doesn't tarry long in one place and once he is gone (when to make an art work serve "practical purposes" no longer seems practical) the work recovers its full value.

Antique works of art are kept in museums and carefully guarded, not to preserve them for practical use but in order that their eternal artistry may be enjoyed.

The difference between the new, nonobjective ("useless") art and the art of the past lies in the fact that the full artistic value of the latter comes to light (becomes recognized) only after life, in search of some new expedient, has forsaken it, whereas the unapplied artistic element of the new art outstrips life and shuts the door on "practical utility."

And so there the new nonobjective art stands—the expression of pure feeling, seeking no practical values, no ideas, no "promised land."

An antique temple is not beautiful because it once served as the haven of a certain social order or of the religion associated with this, but rather because its form sprang from a pure feeling for plastic relationships. The artistic feeling which was given material expression in the building of the temple is for us eternally valid and vital but as for the social order which once encompassed it—this is dead.

Life and its manifestations have hitherto been considered from two different standpoints—the material and the religious. It would seem that a consideration of life from the standpoint of art ought to become a third and equally valid point of view. But in practice, art (as a second-rate power) is relegated to the service of those who view the world and life from one or the other of the first two standpoints. This state of affairs is curiously inconsistent with the fact that art always and under all circumstances plays the decisive role in the creative life and that art values alone are absolute and endure forever. With the most primitive of means (charcoal, hog bristles, modeling sticks, catgut, and steel strings) the artist creates something which the most ingenious and efficient technology will never be able to create.

The adherents of "utility" think they have the right to regard art as the apotheosis of life (the utilitarian life, that is).

In the midst of this apotheosis stands "Mr. Miller"—or rather, the portrait of Mr. Miller (that is, a copy of a "copy" of life). The mask of life hides the true countenance of art. Art is not to us what it could be.

And moreover, the efficiently mechanized world could truly serve a purpose if only it would see to it that we (every one of us) gained the greatest possible amount of "free time" to enable us to meet the only obligation to nature which mankind has taken upon itself—namely to create art.

Those who promote the construction of useful things, things which serve a purpose, and who combat art or seek to enslave it, should bear in mind the fact that there is no such thing as a constructed object which is useful. Has the experience of centuries not demonstrated that "useful" things don't long remain useful?

Every object which we see in the museums clearly supports the fact that not one single, solitary thing is really useful, that is, convenient, for otherwise it would not be in a museum! And if it once seemed useful this is only because nothing more useful was then known. . . .

Do we have the slightest reason to assume that the things which appear useful and convenient to us today will not be obsolete tomorrow . . . ? And shouldn't it give us pause that the oldest works of art are as impressive today in their beauty and spontaneity as they were many thousands of years ago?

The Suprematists have deliberately given up objective representation of their surroundings in order to reach the summit of the true "unmasked" art and from this vantage point to view life through the prism of pure artistic feeling.

Nothing in the objective world is as "secure and unshakeable" as it appears to our conscious minds. We should accept nothing as predetermined—as constituted for eternity. Every "firmly established," familiar thing can be shifted about and brought under a new and, primarily, unfamiliar order. Why then should it not be possible to bring about an artistic order?

The various complementary and conflicting feelings—or rather, images and ideas—which, as reflections of these feelings, take shape in our imaginations, struggle incessantly with each other: the awareness of God against that of the Devil; the sensation of hunger versus a feeling for the beautiful.

The awareness of God strives to vanquish the awareness of the Devil—and the flesh at the same time. It tries to "make credible" the evanescence of earthly goods and the everlasting glory of God.

And art, too, is condemned, except when it serves the worship of God—the Church. . . .

—Out of the awareness of God arose religion—and out of religion the Church.

—Out of the sensation of hunger developed concepts of utility—and out of these concepts trade and industry.

Both the Church and industry tried to monopolize those artistic abilities which, being creative, are constantly finding expression, in order to provide effective bait for their products (for the ideal-material as well as for the purely material). In this way, as the saying goes, "the pill of utility is sugar-coated."

The aggregated reflections of feelings in the individual's consciousness—feelings of the most varied kinds—determine his "view of life." Since the feelings affecting him change, the most remarkable alterations in this "view of life" can be observed; the atheist becomes pious, the God-fearing, godless, etc. . . . The human being can be likened, in a way, to a radio receiver which picks up and converts a whole series of different waves of feeling, the sum-total of which determines the above-mentioned view of life.

Judgments concerning the values of life therefore fluctuate widely. Only art values defy the shifting drift of opinion, so that, for example, pictures of God or the saints, insofar as the artistic feeling incorporated in them is apparent, can be placed by atheists in their collections without compunction (and, in fact, actually are collected by them). Thus do we have, again and again, the opportunity of convincing ourselves that the guidance of our conscious minds—"creation" with a purpose—always calls into being relative values (which is to say, valueless "values") and that nothing but the expression of the pure feeling of the subconscious or superconscious (nothing, that is, other than artistic creation) can give tangible form to absolute values. Actual utility (in the higher sense of the term) could therefore be achieved only if the subconscious or superconscious were accorded the privilege of directing creation.

Our life is a theater piece, in which nonobjective feeling is portrayed by objective imagery.

A bishop is nothing but an actor who seeks with words and gestures, on an appropriately "dressed" stage, to convey a religious feeling, or rather the reflection of a feeling in religious form. The office clerk, the blacksmith, the soldier, the accountant, the general . . . these are all characters out of one stage play or another, portrayed by various people, who become so carried away that they confuse the play and their parts in it with life itself. We almost never get to see the *actual human face* and if we ask someone who he is, he answers, "an engineer," "a farmer," etc., or, in other words, he gives the title of the role played by him in one or another affective drama.

The title of the role is also set down next to his full name, and certified in his passport, thus removing any doubt concerning the surprising fact that the owner of the passport is the engineer Ivan and not the painter Kasimir.

In the last analysis, what each individual knows about himself is

precious little, because the "actual human face" cannot be discerned behind the mask, which is mistaken for the "actual face."

The philosophy of Suprematism has every reason to view both the mask and the "actual face" with skepticism, since it disputes the reality of human faces (human forms) altogether.

Artists have always been partial to the use of the human face in their representations, for they have seen in it (the versatile, mobile, expressive mimic) the best vehicle with which to convey their feelings. The Suprematists have nevertheless abandoned the representation of the human face (and of natural objects in general) and have found new symbols with which to render direct feelings (rather than externalized reflections of feelings), for *the Suprematist does not observe and does not touch—he feels.*

We have seen how art, at the turn of the century, divested itself of the ballast of religious and political ideas which had been imposed upon it and came into its own—attained, that is, the form suited to its intrinsic nature and became, along with the two already mentioned, a third independent and equally valid "point of view." The public is still, indeed, as much convinced as ever that the artist creates superfluous, impractical things. It never considers that these superfluous things endure and retain their vitality for thousands of years, whereas necessary, practical things survive only briefly.

It does not dawn on the public that it fails to recognize the real, true value of things. This is also the reason for the chronic failure of everything utilitarian. A true, absolute order in human society could only be achieved if mankind were willing to base this order on lasting values. Obviously, then, the artistic factor would have to be accepted in every respect as the decisive one. As long as this is not the case, the uncertainty of a "provisional order" will obtain, instead of the longed-for tranquillity of an absolute order, because the provisional order is gauged by current utilitarian understanding and this measuring-stick is variable in the highest degree.

In the light of this, all art works which, at present, are a part of "practical life" or to which practical life has laid claim, are in some sense devaluated. Only when they are freed from the encumbrance of practical utility (that is, when they are placed in museums) will their truly artistic, absolute value be recognized.

The sensations of sitting, standing, or running are, first and foremost, plastic sensations and they are responsible for the development of corresponding "objects of use" and largely determine their form.

A chair, bed, and table are not matters of utility but rather, the forms taken by plastic sensations, so the generally held view that all objects of daily use result from practical considerations is based upon false premises.

We have ample opportunity to become convinced that we are never in a position for recognizing any real utility in things and that we shall never succeed in constructing a really practical object. We can evidently only *feel* the essence of absolute utility but, since a feeling is always nonobjective, any attempt to grasp the utility of the objective is Utopian. The endeavor to confine feeling within concepts of the conscious mind or, indeed, to replace it with conscious concepts and to give it concrete, utilitarian form, has resulted in the development of all those useless, "practical things" which become ridiculous in no time at all.

It cannot be stressed too often that absolute, true values arise only from artistic, subconscious, or superconscious creation.

The new art of Suprematism, which has produced new forms and form relationships by giving external expression to pictorial feeling, will become a new architecture: it will transfer these forms from the surface of canvas to space.

The suprematist element, whether in painting or in architecture, is free of every tendency which is social or otherwise materialistic.

Every social idea, however great and important it may be, stems from the sensation of hunger; every art work, regardless of how small and insignificant it may seem, originates in pictorial or plastic feeling. It is high time for us to realize that the problems of art lie far apart from those of the stomach or the intellect.

Now that art, thanks to Suprematism, has come into its own—that is, attained its pure, unapplied form—and has recognized the infallibility of nonobjective feeling, it is attempting to set up a genuine world order, a new philosophy of life. It recognizes the nonobjectivity of the world and is no longer concerned with providing illustrations of the history of manners.

Nonobjective feeling has, in fact, always been the only possible source of art, so that in this respect Suprematism is contributing nothing new but nevertheless the art of the past, because of its use of objective subject matter, harbored unintentionally a whole series of feelings which were alien to it.

But a tree remains a tree even when an owl builds a nest in a hollow of it.

Suprematism has opened up new possibilities to creative art, since *by virtue of the abandonment of so-called "practical considerations," a plastic feeling rendered on canvas can be carried over into space.* The artist (the painter) is no longer bound to the canvas (the picture plane) and can transfer his compositions from canvas to space.

Ernst

Beyond Painting

"Beyond Painting," published in 1937 at the height of Surrealism, is a quixotic and thoroughly Surrealist piece of autobiography in which Max Ernst interleafs many dozens of titles of his works as elements of his prose, thereby obscuring the boundaries between life and art. In the guise of startling dream images he outlines his career, concentrating upon his unique creations, including his Dada collages of borrowed and transformed images that indeed foretold later Surrealist painting, and his *frottages*, his rubbings of diverse textures that in 1925 launched a rich mixture of techniques in drawings, prints, and paintings. In the process he refers warmly to most of his fellow Surrealists, and quotes liberally in praise of himself from the movement's founder, André Breton, and from Aragon. References to Leonardo, Piero di Cosimo, Rimbaud, Picasso, and others establish his ancestry and that of the movement as a whole.

Ernst (1891–1976) was a self-taught artist on the fringes of the German vanguard by 1912. After service in World War I, he joined Johannes Baargeld and Hans Arp in 1919 to form the short-lived Cologne branch of the explosive Dada movement. With Paul Eluard's help he emigrated in 1922 to Paris, where his collages, prints, and paintings introduced a new kind of fantastic reality that owed a debt to Giorgio De Chirico but was informed by his own serious study of psychology and philosophy. Although he eventually broke with Breton in 1938, Ernst was a central figure in Paris-based Surrealism. His work appeared in books by Eluard (*Répétitions,* 1922), Tristan Tzara, René Crevel, Kafka, and many others. Equally influential were his own frottage and collage collections, *Histoire naturelle* (1926), *La Femme 100 Têtes* (1929), and *Une Semaine de bonté* (1934). Ernst's liaisons with notable women contributed to his notoriety: Leonora Carrington, Peggy Guggenheim, and Dorothea Tanning, whom he married in 1946. He had moved to the United States in 1941 and settled with Tanning in Sedona, Arizona, in 1946. He returned to France in 1953 and until his death actively continued working in painting, collage, printmaking, sculpture, film making, book illustration, and writing.

"Beyond Painting," which Ernst signed "Paris, October 1936," was first published as "*Au-delà de la peinture*" in volume 11 of *Cahiers d'art,* 1936, pp. 149–82. Its first integral translation into English was made by Dorothea Tanning in a collection of Ernst's writings, *Beyond Painting,* one of the series "Documents of Modern Art" edited by Robert Motherwell for Wittenborn, Schultz (New York, 1948), pp. 3–19. I am thankful to Wittenborn Art Books for permission to publish it here. Another translation was made by Lucy R. Lippard for her *Surrealists on Art* (Englewood Cliffs, N.J., 1970).

Beyond Painting

I. History of a Natural History

"... it is like the tinkling of the bell, which makes one hear that which one imagines." —Leonardo da Vinci (*Treatise on Painting*)

From 5 to 7 years

I see before me a panel, very rudely painted with wide black lines on a red ground, representing false mahogany and calling forth associations of organic forms (menacing eye, long nose, great head of a bird with thick black hair, etc.).

In front of the panel, a glossy black man is making gestures, slow, comical and, according to my memories of a very obscure epoch, joyously obscene. This rogue of a fellow wears the turned-up moustaches of my father.

After having executed some leaps in slow motion, legs spread, knees drawn up, torso bent forward, he smiles and draws from the pocket of his trousers a fat crayon in a soft material which I find I cannot describe more precisely. He sets to work: panting violently he hurriedly traces the black lines on the panel of false mahogany. He quickly imparts to it new forms, forms which are at once surprising and abject. He accentuates the resemblance to ferocious or viscous animals to such a point that he extracts from it living creatures that fill me with horror and anguish. Content with his art, the fellow tosses his creations in the air, then gathers them in a kind of vase which he paints, intentionally, on the inside. He whirls the contents of the vase by stirring it, faster and faster, with his fat crayon. The vase itself, in whirling, becomes a top. The crayon becomes a whip. Now I realize that this strange painter is my father. He wields the whip with all his force and accompanies his movements with terrible gasps of breath, comparable to the snorts of an enormous and enraged steam-engine. With fiendish passion he causes the top to whirl and leap around my bed, that abominable top which contains all the horrors that my father is capable of evoking in an amiable panel of false mahogany by means of his frightful soft crayon.

One day, at the age of puberty, in examining the question of how my father had conducted himself in the night of my conception, there rose in me, as if in response to this question of filial respect, precise and irrefutable, the memory of that vision of half sleep that I had forgotten. For a long time afterward I was unable to disengage myself from a quite unfavorable impression of my father's conduct on the

occasion of my conception, an impression perhaps unreasonable and unjust, but carefully thought over. . . .

At the age of puberty

The well-known game of purely optical representations which obsesses us in half-sleep quickly becomes a procession of normally clad men and women which departs from a distant horizon toward my bed. Before arriving, the participants separate: the women pass to the right, the men to the left. Curious, I lean toward the right so that not one face shall escape me. Moreover, I am struck by the extreme youth of all these women; and later by the fact that the persons in question are always the same, only the head changing a little, the identity never. In scrutinizing them carefully, face by face, I realize my error: among these women many are of a "certain age," some really old and only two or three very young, perhaps 18 years of age, the age expedient to my puberty.

I am too occupied by the women to give any attention to those passing on the men's side. But *I know without seeing* that I shall now commit the contrary error: All these gentlemen begin by frightening me with their precocious senility and their remarkable ugliness, but upon close examination only my father, among all these, bears the traits of an old man.

January 1925

I see myself lying in my bed and, standing at my feet, a tall slender woman dressed in a very red gown. The gown is transparent, the woman also. I am ravished by the surprising elegance of her bone structure. I am tempted to pay her a compliment.

The 10th of August, 1925

Botticelli did not like landscape painting. He felt that it was "a kind of short and mediocre investigation." He says with contempt that "by throwing a sponge soaked with different colors against a wall one makes a spot in which may be seen a beautiful landscape." That statement brought him a severe admonition from his colleague, Leonardo da Vinci:

He [Botticelli] is right; in such a daub one may certainly find bizarre inventions. I mean to say that he who is disposed to gaze attentively at this spot may discern therein some human heads, various animals, a battle, some rocks, the sea, clouds, groves, and a thousand other things—it is like the tinkling of the bell which makes one hear what one imagines. But though this stain serves to suggest some ideas it does not teach one how to finish any part of the painting. And the above-mentioned painter makes very bad landscapes. To be universal and to please varying tastes it is

necessary that in the same composition may be found some very dark passages and others of a gently lighted penumbra. It is not to be despised, in my opinion, if, after gazing fixedly at the spot on the wall, the coals in the grate, the clouds, the flowing stream, if one remembers some of their aspects; and if you look at them carefully you will discover some quite admirable inventions. Of these the genius of the painter may take full advantage, to compose battles of animals and of men, of landscapes or monsters, of devils and other fantastic things which bring you honor. In these confused things genius becomes aware of new inventions, but it is necessary to know well (how to draw) all the parts that one ignores, such as the parts of animals and the aspects of landscape, rocks and vegetation. (from *Treatise on Painting*)

On the tenth of August, 1925, an insupportable visual obsession caused me to discover the technical means which have brought a clear realization of this lesson of Leonardo. Beginning with a memory of childhood (related above) in the course of which a panel of false mahogany, situated in front of my bed, had played the role of optical *provocateur* of a vision of half-sleep, and finding myself one rainy evening in a seaside inn, I was struck by the obsession that showed to my excited gaze the floor-boards upon which a thousand scrubbings had deepened the grooves. I decided then to investigate the symbolism of this obsession and, in order to aid my meditative and hallucinatory faculties, I made from the boards a series of drawings by placing on them, at random, sheets of paper which I undertook to rub with black lead. In gazing attentively at the drawings thus obtained, "the dark passages and those of a gently lighted penumbra," I was surprised by the sudden intensification of my visionary capacities and by the hallucinatory succession of contradictory images superimposed, one upon the other, with the persistence and rapidity characteristic of amorous memories.

My curiosity awakened and astonished, I began to experiment indifferently and to question, utilizing the same means, all sorts of materials to be found in my visual field: leaves and their veins, the ragged edges of a bit of linen, the brushstrokes of a "modern" painting, the unwound thread from a spool, etc. There my eyes discovered human heads, animals, a battle that ended with a kiss (*the bride of the wind*), rocks, *the sea and the rain, earthquakes,* the *sphinx in her stable,* the *little tables around the earth,* the *palette of Caesar, false positions,* a *shawl of frost flowers,* the *pampas.*

Blows of whips and threads of lava, fields of honor, inundations and seismic plants, fans, the plunge of the chestnut tree.

The *lightning flashes under fourteen years of age, the vaccinated bread, the conjugal diamonds, the cuckoo, origin of the pendulum, the feast of death, the wheel of light.*

A system of solar money.

The habits of leaves, the fascinating cypress.
Eve, the only one who remains to us.

Under the title *Natural History* I have brought together the first results obtained by the procedure of *frottage* (rubbing), from *The Sea and the Rain* to *Eve, the Only One Who Remains to Us.* (Published in 1926, under the direction of Jeanne Bucher.)

I insist on the fact that the drawings thus obtained lost more and more, through a series of suggestions and transmutations that offered themselves spontaneously—in the manner of that which passes for hypnagogic visions—the character of the material interrogated (the wood, for example) and took on the aspect of images of an unhoped-for precision, probably of a sort which revealed the first cause of the obsession, or produced a simulacrum of that cause.

From 1925 to the present

The procedure of *frottage,* resting thus upon nothing more than the intensification of the irritability of the mind's faculties by appropriate technical means, excluding all conscious mental guidance (of reason, taste, morals), reducing to the extreme the active part of that one whom we have called, up to now, the "author" of the work, this procedure is revealed by the following to be the real equivalent of that which is already known by the term *automatic writing.* It is as a spectator that the author assists, indifferent or passionate, at the birth of his work and watches the phases of its development. Even as the role of the poet, since the celebrated *lettre de voyant* of Rimbaud, consists in writing according to the dictates of that which articulates itself in him, so the role of the painter is to pick out and *project that which sees itself in him.*[1] In finding myself more and more engrossed in this activity (passivity) which later came to be called "critical paranoia,"[2] and in adapting to the technical means of painting (for example: the scraping of pigments upon a ground prepared in colors and placed on an uneven surface) the procedure of *frottage* which seemed applicable at first only to drawing, and in striving more and more to restrain my own active participation in the unfolding of the picture and, finally, by widening in this way the active part of the mind's hallucinatory faculties I came to assist *as spectator* at the birth of all my works, from the tenth of August, 1925,[3] memorable day of the discovery of

1. Vasari relates that Piero di Cosimo sometimes sat plunged in contemplation of a wall upon which certain sick persons had formed the habit of spitting. Out of these stains he formed equestrian battles, fantastic towns and the most magnificent landscapes. He did the same with the clouds of the sky.

2. This rather pretty term (and one which will probably have some success because of its paradoxical content) seems to me to be subject to precaution inasmuch as the notion of paranoia is employed there in a sense which doesn't correspond to its medical meaning. I prefer, on the other hand, the proposition of Rimbaud: "The poet becomes a *seer,* by a long, immense and conscious disorder of all the senses."

3. With the exception of *The Virgin Spanking the Infant Jesus* (1926), picture-manifesto, painted after an idea of André Breton.

frottage. A man of "ordinary constitution" (I employ here the words of Rimbaud), I have done everything to render my soul monstrous.[4] Blind swimmer, I have made myself see. *I have seen.* And I was surprised and enamoured of what I *saw,* wishing to identify myself with it.

In a country the color of a *pigeon's breast* I acclaimed the flight of *1,000,000 doves.* I saw them invade the *forests,* black with desires, and the *walls* and *seas* without end.

I saw an *ivy leaf float upon the ocean* and I felt a *very gentle earth-quake.* I saw a *pale, white dove, flower of the desert. She refused to understand. Along the length of a cloud* a superb man and woman danced the *Carmagnole of love.* The Dove *closed herself in her wings* and swallowed the key forever.

A string lying on my table made me see a number of *young men trampling upon their mother,* while several *young girls* amused themselves with *beautiful poses.*

Some exceedingly beautiful women cross a river, crying. A man, walking on the water, takes a young girl by the hand and jostles another. Some persons of a rather reassuring aspect—in fact, *they had lain too long in the forest*—made their *savage gestures* only *to be charming.* Someone said: *"The immobile father."*

It was then that I saw myself, *showing my father's head to a young girl.* The earth quaked but slightly.

I decided to erect a *monument to the birds.*

It was *the beautiful season.* It was the time of *serpents, earth worms, plume-flowers, scale-flowers, tubular flowers.* It was the time when *the forest flew away and the flowers struggled under the water.* The time of the *circumflex Medusa.*

In 1930, after having composed with violence and method my story, *The Hundred-Headed Woman* (Woman Without a Head),[5] I was visited nearly every day by the *Superior of the birds* named *Loplop,* my private phantom, attached to my person. He presented me with a *heart in a cage,* the *sea in a cage, two petals, three leaves, a flower and a young girl.* Also, *the man of the black eggs and the man with the red cape.* On a beautiful autumn afternoon he told me that one day *he had invited a Lacedemonian to come and listen to a man who imitated the nightingale quite perfectly. The Lacedemonian replied: "I have often heard the nightingale herself."* One evening he told me some jokes which didn't make me laugh: *"Joke: it would be better not to reward a beautiful deed at all than to reward it badly.* A soldier had

lost both arms in a battle. His colonel offered him a five-dollar bill. The soldier responded: "No doubt you think, sir, that I have lost only a pair of gloves."

I had already said "Bonjour" to Satan in 1928. An unavowed old man was burdened at that time with a bundle of clouds on his back while a white lace flower, its neck pierced by a stone, trembled quietly as it sat upon a tambourine. Why am I not this charming flower? Why do I always change myself into an earthquake, the ace of spades, a shadow entering through the doorway?

Somber vision, that of Europe after the rain!

The 24th of December, 1933 I was visited by a young chimera in evening dress.

Eight days later I met a blind swimmer.

A little patience (15 days of waiting) and I should assist in the attirement of the bride. The bride of the wind embraced me in passing by at a swift gallop (simple effect of touch).

I saw the barbarians looking toward the west, barbarians emerging from the forest, barbarians walking toward the west. On my return to the garden of the Hesperides I followed, with a joy that was but poorly concealed, the phases of a battle between two bishops. "It was as beautiful as the chance meeting upon an operating table of a sewing machine and an umbrella." (Lautréamont)

> I caressed the lionness of Belfort.
> The antipode of the landscape.
> A beautiful Rhenish woman.
> Whole wheat landscape.
> The asparagus of the moon.
> The drakes of Mars.
> The absolute presence.

Voracious gardens devoured by a vegetation springing from the debris of trapped airplanes.

I saw myself with the head of a kite, a knife in my hand, in the attitude of *The Thinker* of Rodin. But it was actually the liberated attitude of Rimbaud's *Seer*.

I saw with my eyes the nymph Echo.

I saw with my eyes the appearances of things receding, and I felt a calm and ferocious joy. In the measure of my activity (passivity) I contributed to the general overthrow of those values which, in our time, have been considered the most established and secure.

The indicating forest

Enter, enter, have no fear of being blinded. . . .

The field of vision and of action opened up by *frottage* is not limited by the capacity of the mind's faculties of irritability. It far surpasses the limits of artistic and poetic activity. On this subject I could not better explain myself than by quoting the words of André Breton:

Leonardo's lesson, setting his students to copy in their pictures that which they saw taking shape in the spots on an old wall (each according to his own lights) is far from being understood. The whole passage from subjectivity to objectivity is implicitly resolved there, and the weight of that resolution goes far beyond, in human interest, the weight of inspiration itself. Surrealism has been most particularly concerned with that part of the lesson. Surrealism did not start from there, but rediscovered it on the way and with it, its possibilities of extension to all other domains besides painting. The new associations of images brought forth by the poet, the artist, the scientist, are comparable to it, inasmuch as their creation uses a screen of a particular structure which, concretely, can be either a decrepit wall, a cloud or anything else: a persistent and vague sound carries to the exclusion of all others, the phrase we need to hear. The most striking fact is that an activity of this kind which in order to exist necessitates the unreserved acceptance of a more or less lasting passivity, far from being limited to the sensory world, has been able to penetrate profoundly the moral world. The good luck, the happiness of the scientist or the artist in their *discovery* can only be considered as a particular case, not distinguished in its essence from ordinary human happiness. Some day, man will be able to direct himself if, like the artist, he will consent to reproduce, without changing anything, that which an appropriate screen can offer him in advance of his acts. This screen exists. Every life contains some of these homogeneous entities, of cracked or cloudy appearance, which each of us has only to consider fixedly in order to read his own near future. He should enter the whirlwind, he should retrace the stream of events which, above all others, seemed to him doubtful or obscure and by which he was harassed. There—if his interrogation is worth the effort—all the logical principles will be routed and the powers of the *objective hazard*, making a joke of all probability, will come to his aid. On this screen, everything which man wants to know is written in phosphorescent letters, in letters of *desire*.

(from *The Star-Shaped Castle*)

II. The Placing Under Whisky-Marine

Before he became spoiled Aragon wrote:

When and where did collage first appear? I believe, in spite of the attempts of several Dadaists of the first moment, that one must pay homage to Max Ernst for it, at least for that which among the forms of collage, is farthest from the principle of *papier collé*: photographic collage and collage from illustrations. Everything

outside of this discovery had the tendency to become generalized, and the German Dada publications, for example, contained collages signed by at least ten authors. However, the success of this procedure depended more upon the astonishment of *knowing the system* than upon the necessity of expressing oneself at any price. Very soon the use of collage was found to be limited to a few men and it is certain that the whole atmosphere of the collages of that time was found to be that of the thought of Max Ernst and Max Ernst only. (from *A Challenge of Painting*)

What is collage?

The simple hallucination, after Rimbaud; the placing under whisky-marine,[6] after Max Ernst. It is something like the alchemy of the visual image. THE MIRACLE OF THE TOTAL TRANSFIGURATION OF BEINGS AND OBJECTS WITH OR WITHOUT MODIFICATION OF THEIR PHYSICAL OR ANATOMICAL ASPECT.

"Poetic old-worldliness played a large part in my verbal alchemy.

"I accustomed myself to simple hallucination: I saw quite deliberately a mosque in place of a factory, a drummers' school conducted by angels, carriages on the highways of the sky, a salon at the bottom of a lake; monsters, mysteries, a vaudeville poster raising horrors before my eyes.

"Then I expressed my magic sophisms with the hallucination of words." (Rimbaud: *A Season in Hell*)

What is the mechanism of collage?

I am tempted to see in collage the exploitation of the chance meeting of two distant realities on an unfamiliar plane or, to use a shorter term, the culture of systematic displacement and its effects. In the words of André Breton:

Surreality will be the function of our will to recognize completely our own lonely displacement (and it is easily understood that if one were to displace a hand by severing it from an arm, that hand becomes more wonderful as a hand;—and in speaking of the "lonely displacement" we are not thinking only of the possibility of moving in space).

(Preface to *The Hundred-Headed Woman*)

A ready-made reality, whose naive destination has the air of having been fixed, once and for all (a canoe), finding itself in the presence of another and hardly less absurd reality (a vacuum cleaner), in a place where both of them must feel displaced (a forest), will, by this very fact, escape to its naive destination and to its identity; it will pass from

6. Whisky-Marine—like aquamarine. A distortion, humorous and very serious at the same time.

its false absolute, through a series of relative values, into a new absolute value, true and poetic: canoe and vacuum cleaner will make love. The mechanism of collage, it seems to me, is revealed by this very simple example. The complete transmutation, followed by a pure act, as that of love, will make itself known naturally *every time the conditions are rendered favorable by the given facts: the coupling of two realities, irreconcilable in appearance, upon a plane which apparently does not suit them.*

Speaking of the procedure of collage in 1920 André Breton tells us:

> But the marvelous faculty of reaching two distant realities, without leaving the field of our experience, and, at their coming together, of drawing out a spark; of putting within reach of our senses some abstract figures carrying the same intensity, the same relief as the others; and in depriving ourselves of a system of reference, of displacing ourselves in our own memory—that is what, provisionally, holds us.
>
> (Preface to the Max Ernst exhibition, May 1920)

And he adds here these prophetic words: "Who knows if, thus, we are not preparing ourselves to escape some day the principle of identity."

What is the technique of collage?

If it is the plumes that make the plumage it is not the glue that makes the gluing (ce n'est pas la colle qui fait le collage).

One day in the summer of 1929 a painter I knew asked me: "What are you doing these days? Are you working?" I replied: "Yes, I'm making gluings. I'm preparing a book that will be called *La Femme 100 Têtes.*" Then he whispered in my ear: "And what sort of glue do you use?" With that modest air that my contemporaries admire in me I was obliged to confess to him that in most of my collages there wasn't any glue at all. Also that I am not responsible for the term "collage"; that of the fifty-six titles in the catalogue of my exhibition of collages in Paris in 1920, an exhibition which, according to Aragon: ". . . is perhaps the first showing which allows one a glimpse of the resources and the thousand means of an entirely new art—in this city where Picasso has never had the opportunity of exhibiting his constructions in steel wool, cardboard, bits of cloth etc.," only twelve justified the term *collage-découpage*. They are: 1. The Hat Makes the Man. 2. The Slightly Ill Horse. 3. The Swan Is Quite Peaceable. 4. Disrobed. 5. The Song of the Flesh. 6. Aerography. 7. Massacre of the Innocents. 8. Little Piece for Eight Hands. 9. Chinese Nightingale. 10. Ingres Gasmetric. 11. Switzerland, Birthplace of Dada. 12. The Steamer and the Fish.

As for the forty-four others, Aragon placed them in saying that "the place to catch hold of the thought of Max Ernst is where with a bit of

color, some crayon, he attempts to acclimate the phantom which he is about to plunge into a strange landscape."[7]

He was right, because it was at this point that the bright bridge was flung between those two procedures which prompted the inspiration; *frottage* and *collage*. The similarity of the two is such that I can, without changing many words, use the terms employed earlier for the one, to relate how I made the discovery of the other.

One rainy day in 1919, finding myself in a village on the Rhine, I was struck by the obsession which held under my gaze the pages of an illustrated catalogue showing objects designed for anthropologic, microscopic, psychologic, mineralogic, and paleontologic demonstration. There I found brought together elements of figuration so remote that the sheer absurdity of that collection provoked a sudden intensification of the visionary faculties in me and brought forth an illusive succession of contradictory images, double, triple and multiple images, piling up on each other with the persistence and rapidity which are peculiar to love memories and visions of half-sleep.

These visions called themselves new planes, because of their meeting in a new unknown (the plane of non-agreement). It was enough at that time to embellish these catalogue pages, in painting or drawing, and thereby in gently reproducing only that which *saw itself in me,* a color, a pencil mark, a landscape foreign to the represented objects, the desert, a tempest, a geological cross-section, a floor, a single straight line signifying the horizon . . . thus I obtained a faithful fixed image of my hallucination and transformed into revealing dramas my most secret desires—from what had been before only some banal pages of advertising.

Under the title "La Mise sous Whisky-Marin" I assembled and exhibited in Paris (May 1920) the first results obtained by this procedure, from the *Phallustrade* to *The Wet Nurse of the Stars.*

What are the collages of Max Ernst of which every child worthy of the name should know the nomenclature by heart?

The phallustrade. The vernal robe of the muse. The shadow of a great dada.[8] Unheard-of menace, coming from one knows not where. Bone-mill of the peaceable hairdressers. All the transverse and longitudinal cross-sections. Sagging relief, taken from the lungs of a 47-year-old smoker. The acerbity of the mattress.

The preparation of the bone-glue. Hypertrophic trophy. Do not smile. Religious dada. Ambiguous figure.

The little tear duct that says tic-tac.

The hat makes the man.

7. Aragon. *A Challenge to Painting.*
8. Do not forget, we are in 1919.

When half grown the women are carefully poisoned—they are pre-served in bottles—the little American girl whom we bring out this year amuses herself by suckling the dogs of the sea.—the human eye is embroidered with Rupert's drops of curdled air and salted snow (Knitted relief). The canalization of gas. The galactometric forehead. The ascaride of sand. The guardian angel. Dehumanized seed. Three figures with-out sex. The stamens of Arp. Half-world of the two worlds.

The transfiguration of the chameleon on Mount Tabor is made in an elegant limousine while the angels and canaries fly away from the houses of man and while the very holy robe of Our Lord cries out de profundis three times before whipping the flesh of the exhibitionists. Somnambulist elevator.

Opulent Mimi of love. The little Venus of the Eskimos.

Gay awakening of the geyser. Young man burdened with a faggot. Guard-house drums of the celestial army. Childhood learns dada. Charity and voluptuousness.

The bed-chamber of Max Ernst.

The Chinese nightingale. The seed of the pyramids.

The dog who spits. The dog, well-coiffured in spite of the difficul-ties of the terrain, caused by an abundant snowfall. The woman with the beautiful throat . . . the song of the flesh.

Dada Degas. Dada Gauguin. The volume of the man, calculable by the accessories of the woman.

Wet-nurse of the stars.

It is now the twenty-second time that Lohengrin has abandoned his fiancee (for the first time) . . . and the earth has stretched her bark over four violins. We shall never meet again . . . we shall never give battle to the angels. . . . The swan is so peaceful . . . he rows furiously to reach Leda.

The orthochromatic Ferris-wheel. *Erectio sine qua non.* Ask your doctor. Here, everything is floating. . . .

Little machine built by minimax dadamax in person, serving to salt without fear the female sucking-cups at the beginning of the critical age.

Above the clouds walks the midnight. Above the midnight the invis-ible bird of day looks down. A little higher than the bird the air moves, and the walls and the roofs float.

Landscape in old iron: error of those who prefer navigating on the grass to a bust of a woman.

What is a Phallustrade?

It is an alchemic product, composed of the following elements: the autostrade, the balustrade and a certain quantity of phallus. A phal-lustrade is a verbal collage. One might define collage as an alchemy resulting from the unexpected meeting of two or more heterogeneous

elements, those elements provoked either by a will which—from a love of clairvoyance—is directed toward systematical confusion and disorder of all the senses (Rimbaud), or by hazard, or by a will favorable to hazard.[9] Hazard, as Hume defined it, is: *the equivalent of ignorance in which we find ourselves in relation to the real causes of events*, a definition which is increasingly corroborated by the development of calculations regarding probabilities, and by the importance which this discipline holds in modern sciences and practical life: microphysics, astrophysics, biology, agronomy, demography, etc.[10]

Hazard is also—and this very difficult aspect of hazard has been neglected by the seekers of the "laws of chance"—*the master of humor* and consequently, in an epoch which is far from rosy (the epoch in which we live), in which a beautiful act consists in losing one's two arms in combat with his fellow men, the master of the humor-that-isn't-rosy, the *black humor*.

A phallustrade is a typical product of black humor. A sagging relief, taken from the lung of a 47-year-old smoker, is another. It has been said that the predominant note in my collages of the Dada period is this humor. But this is not always so and in certain of these collages humor doesn't appear at all. (The Somnambulist Elevator, The Massacre of the Innocents, Above the Clouds. . . .) It seems to me one can say that collage is a hypersensitive and rigorously true instrument, like a seismograph, capable of registering the exact quantity of possibilities for human happiness in each epoch. The quantity of black humor contained in each authentic collage is found there in the inverse proportion of the possibilities for happiness (objective and subjective).

This invalidates the opinion of those who wish to see, in the pretended absence of all humor in surrealist painting, the essential difference between Surrealist and Dadaist works: can they believe that our epoch is any rosier than the years 1917–1921?

9. In the hope of increasing the fortuity of the elements entering the composition of a drawing and thus augment the suddenness of associations, the Surrealists had recourse to a procedure which they called "Exquisite Corpse," and which consists in making a drawing of a person by several people. The paper is folded and each collaborator draws his part, without knowing what form the drawing has so far taken.
The considerable part played by hazard is limited here only by a kind of mental contagion. To judge by the results, we find the procedure able to produce strong, pure Surrealist images. As Breton says: "For me, the strongest surrealist image is that which represents the highest degree of arbitrariness, that which one has the hardest time to translate into a practical language, whether it conceals an enormous amount of apparent contradiction, or one of its terms is curiously hidden, or, in announcing itself sensational, it comes untied feebly (so that it closes suddenly the angle of its compass), or it justifies itself in a formally derisive manner, or it is hallucinatory, or it very naturally lends the mask of the concrete to the abstract or vice-versa, or it involves the negation of some elementary physical quality, or it provokes laughter. (*Surrealist Manifesto*)
10. Arp, in certain of his works, is guided by the "laws of hazard."

What is the most noble conquest of collage?
The irrational. The magisterial eruption of the irrational in all
domains of art, of poetry, of science, in the private life of individuals,
in the public life of peoples. He who speaks of collage speaks of the
irrational. Collage has crept slyly into our common objects. We have
acclaimed its appearance in the Surrealist films (I am thinking of *The
Golden Age* of Buñuel and Dalí: the cow in the bed, the bishop and the
giraffe flung through the window, the chariot crossing the salon of the
governor, the Minister of the Interior glued to the ceiling after his sui-
cide, etc.). In assembling collages one after another, without choice, we
have been surprised by the clarity of the irrational action that resulted:
The Hundred-Headed Woman (*Woman Without a Head*), the *Dream
of a Little Girl Who Wished to Enter Carmel*, the *Week of Kindness*.
Do not forget this other conquest of collage: *surrealist painting*, in at
least one of its multiple aspects, that which, between 1921 and 1924,
I was the only one to develop[11] and in which, later, while I advanced
alone, feeling my way, into the yet unexplored forests of *frottage*,
others continued their researches (Magritte, for example, whose pic-
tures are collages entirely painted by hand, and Dalí).

When the thoughts of two or more authors were systematically
fused into a single work (otherwise called collaboration) this fusion
could be considered as akin to collage. I quote as examples two texts
resulting from the collaboration of my good friend Paul Eluard and
myself; the first taken from *Misfortunes of the Immortals* (1922), the
second from an unfinished book which proposed to find new tech-
niques in the practice of love, *Et Suivant Votre Cas* (1923).

Shattered fans
The crocodiles of today are no longer crocodiles. Where are the
good old adventurers who caught you in the nostrils of minuscule
bicycles and pretty ear-drops of ice? Following the speed of the finger,
the racers at the four cardinal points paid each other compliments.
What a pleasure it was then to lean with graceful abandon upon those
agreeable rivers salted with pigeons and pepper!
There are no more real birds. In the evening the taut cords on the
way home did not trip anyone, but at each false obstacle smiles cut a
little deeper into the eyes of the acrobats. The dust smelled of the
thunderbolt. Formerly, the good old fish wore beautiful red shoes on
their fins.
There are no more real water-bicycles, nor microscopy, nor bacteri-
ology. On my word, the crocodiles of today are no longer crocodiles.

11. Chirico, to whom I pay homage in passing, had already taken another road, as
we know. Everyone knows the other extremely important aspects of Surrealist painting,
of which the most authentic representatives are Arp, Tanguy, Miró, Man Ray, Picasso,
and Giacometti, and which began with the *papier collés* of Braque and Picasso.

Series of Young Women

The woman lying on a flat surface, a table for example, is covered by a cover folded in half.

One presents the object to her by placing it above her head and within the radius of her vision. Lower the object slowly, so that the woman follows it with her gaze, then raises her head, and bends her neck, the chin coming in contact with the breast.

Remain thus a moment, then return gently to the starting position. It is preferable that the object be shiny and of a lively color.

Seat the woman on the table, letting her arrange her arms and legs as she likes.

Attract her attention with the object placed above her head, move it, lower it toward the right, continue the movement downward then bring it up again toward the left. Always hold the object far enough away that the woman cannot grasp it. Abandon it to her only to reward her for her efforts.

III. Instantaneous Identity

If one is to believe the description of Max Ernst contained in his identity papers he would be only 45 years old at the moment of writing these lines. He would have an oval face, blue eyes and pale hair. His height would not be over average—or under, either. As for any particular marks the identity papers accord him none. Consequently he could, if pursued by the police, easily plunge into the crowd and disappear forever. The women, however, find his face young and framed with silky white hair which "makes him look distinguished." They credit him with charm, a great deal of "reality" and seduction, a perfect physique and agreeable manners (the danger of pollution, according to his own confession, has become such an old habit with him that he is proudly pleased with it as a sign of urbanity) but a difficult character, hopelessly complex, obstinate and with an impenetrable mind ("he is a nest of contradictions," they say) transparent and full of enigma at the same time.

It is hard for them to reconcile the gentleness and moderation of his expressions with the calm violence which is the essence of his thought. They readily compare him to a very light earthquake which gently displaces the furniture yet is in no hurry to change the position of things. What they find particularly disagreeable, even insupportable, is their almost total lack of success in discovering his IDENTITY in the flagrant contradictions (apparent) which exist between his spontaneous comportment and the dictates of his conscious thought. Regarding "nature" for example, one may discern in him two attitudes, in appearance irreconcilable: that of the god Pan and the man Papou who possesses all the mysteries and realizes the playful pleasure in his union with her ("He marries nature, he pursues the nymph Echo,"

they say) and that of a conscious and organized Prometheus, thief of
fire who, guided by thought, persecutes her with an implacable hatred
and grossly injures her. "This monster is pleased only by the antipodes
of the landscape," they repeat. And a teasing little girl adds: "He is a
brain and a vegetable at the same time."

Nevertheless, these two attitudes (contradictory in appearance but
in reality simply in a state of conflict) that he displays in nearly every
domain are convulsively fused into one each time he comes face to
face with a fact (such as a tree, a stone, an eye, etc.) and this union is
brought about in the same way as that other: when one brings two
distant realities together on an apparently antipathetic plane (that
which in simple language is called "collage") an exchange of energy
transpires, provoked by this very meeting. This exchange, which
might be a broad flowing stream or a shattering stroke of lightning
and thunder, I am tempted to consider the equivalent of that which,
in classical philosophy, is called *identity*. I conclude, in transposing the
thought of André Breton, that IDENTITY WILL BE CONVULSIVE OR WILL
NOT EXIST.

The Constructive Idea in Art

With J. L. Martin and Ben Nicholson, Naum Gabo edited the collection *Circle* in 1937, one of the most fertile gatherings of essays in the twentieth century. Among its contributors were Moholy-Nagy, Massine, Gropius, and Mondrian (whose essay is included in the present anthology). Gabo's "The Constructive Idea in Art" was deservedly the first article in the book.

In 1909, Gabo (1890–1977) had been sent to Munich by his father, a Russian businessman, to study medicine. He was more attracted to mathematics, physics, and chemistry, and also became enamored of the arts, a natural result in the Munich of Kandinsky, Klee, and De Chirico. Visits in 1913 and 1914 to his brother Antoine Pevsner, then working in Paris, helped consummate his turning to art. After spending the war years in Oslo, Gabo returned to Moscow and with his brother joined in the movement called Constructivism. Together they wrote the "Realistic Manifesto" of 1920. By 1922 internecine arguments among vanguard artists so discouraged Gabo that he left for western Europe. He worked in Germany, France, and England, then came to the United States in 1946.

The *Circle* essay speaks not only for Gabo and Constructivism, but is one of the most sensible statements of the relationships between modern abstract art and science. In the epigrammatic "Science teaches, Art asserts; Science persuades, Art acts," Gabo points to the independence of art which too often is assimilated with the "scientific attitude," yet he does it from the standpoint of respect and deep love for the sciences.

Naum Gabo kindly extended permission to reproduce his essay here, as did Faber and Faber, London, who published *Circle* in 1937. Among Gabo's important writings are the A. W. Mellon lectures, *Of divers arts* (New York, 1962).

The Constructive Idea in Art

Our century appears in history under the sign of revolution and dis-integration. The revolutions have spared nothing in the edifice of cul-ture which had been built up by the past ages. They had already begun at the end of the last century and proceeded in ours with unusual speed until there was no stable point left in either the material or the ideal structure of our life. The war was only a natural consequence of a disintegration which started long ago in the depths of the previous civilization. It is innocent to hope that this process of disintegration will stop at the time and in the place where we want it to. Historical processes of this kind generally go their own way. They are more like floods, which do not depend on the strokes of the oarsmen floating on the waters. But, however long and however deep this process may go in its material destruction, it cannot deprive us any more of our opti-mism about the final outcome, since we see that in the realm of ideas we are now entering on the period of reconstruction.

We can find efficient support for our optimism in those two domains of our culture where the revolution has been the most thor-ough, namely, in Science and in Art. The critical analysis in natural science with which the last century ended had gone so far that at times the scientists felt themselves to be in a state of suspension, having lost most of the fundamental bases on which they had depended for so many centuries. Scientific thought suddenly found itself confronted with conclusions which had before seemed impossible, in fact the word "impossibility" disappeared from the lexicon of scientific lan-guage. This brought the scientists of our century to the urgent task of filling up this emptiness. This task now occupies the main place in all contemporary scientific works. It consists in the construction of a new stable model for our apprehension of the universe.

However dangerous it may be to make far-reaching analogies between Art and Science, we nevertheless cannot close our eyes to the fact that at those moments in the history of culture when the creative human genius had to make a decision, the forms in which this genius manifested itself in Art and in Science were analogous. One is inclined to think that this manifestation in the history of Art lies on a lower level than it does in the history of Science, or at least on a level which is accessible to wider social control. The terminology of Science alone plunges a layman into a state of fear, humility, and admiration. The inner world of Science is closed to an outsider by a curtain of enigmas. He has been educated to accept the holy mysticism of these enigmas

142

since the beginning of culture. He does not even try to intrude in this world in order to know what happens there, being convinced that it must be something very important since he sees the results in obvious technical achievements. The average man knows, for instance, that there is electricity and that there is radio and he uses them every day. He knows the names of Marconi and Edison, but it is doubtful whether he has ever heard anything about the scientific work of Hertz, and there is no doubt that he has never heard anything about the electromagnetic waves theory of Maxwell or his mathematical formulae.

Not so is the attitude of the average man to Art. Access to the realm of Art is open to every man. He judges about Art with the unconstrained ease of an employer and owner. He does not meditate about those processes which brought the artist or the group of artists to make one special kind of Art and not another, or if occasionally he does he never relinquishes his right to judge and decide, to accept or reject; in a word, he takes up an attitude which he would never allow himself to take with Science. He is convinced that on his judgments depend the value and the existence of the work of art. He does not suspect that through the mere fact of its existence a work of art has already performed the function for which it has been made and has affected his concept of the world regardless of whether he wants it to or not. The creative processes in the domain of Art are as sovereign as the creative processes in Science. Even for many theorists of Art the fact remains unperceived that the same spiritual state propels artistic and scientific activity at the same time and in the same direction.

At first sight it seems unlikely that an analogy can be drawn between a scientific work of, say, Copernicus and a picture by Raphael, and yet it is not difficult to discover the tie between them. In fact Copernicus's scientific theory of the world is coincident with Raphael's concept in Art. Raphael would never have dared to take the naturalistic image of his famous Florentine pastry-cook as a model for the "Holy Marie" if he had not belonged to the generation which was already prepared to abandon the geocentrical theory of the universe. In the artistic concept of Raphael there is no longer any trace of the mythological religious mysticism of the previous century as there is no longer any trace of this mysticism in Copernicus's book, *The Revolution of the Celestial Orbits*. In the work of both, the earth is no longer the cosmic center and man is no longer the crown of creation and the only hero of the cosmic drama; both are parts of a larger universe and their existence does not any more appear as the mystical and dematerialized phenomenon of the mediaeval age. At that time one and the same spirit governed the artistic studios of Florence and held sway under the arches of the Neapolitan Academy for the Empirical Study of Nature led by Telesio. This tie between Science and Art has never ceased to exist throughout the history of

human culture, and we can discern it in whatever section of history we look. This fact explains many phenomena in the spiritual processes of our own century that brought our own generation to the Constructive idea in Art.

The immediate source from which the Constructive idea derives is Cubism, although it had almost the character of a repulsion rather than an attraction. The Cubistic school was the summit of a revolutionary process in Art which was already started by the Impressionists at the end of the last century. One may estimate the value of particular Cubistic works as one likes, but it is incontestable that the influence of the Cubistic ideology on the spirits of the artists at the beginning of this century has no parallel in the history of Art for violence and intrepidity. The revolution which this school produced in the minds of artists is only comparable to that which happened at approximately the same time in the world of physics. Many falsely assume that the birth of Cubistic ideology was caused by the fashion for Negro art which was prevalent at that time; but in reality Cubism was a purely European phenomenon and its substance has nothing in common with the demonism of primitive tribes. The Cubistic ideology has a highly differentiated character and its manifestation could only be possible in the atmosphere of a refined culture. In fact it wants an especially sharpened and cultivated capacity for analytic thought to undertake the task of revaluation of old values in Art and to perform it with violence as the Cubistic school did. All previous schools in Art have been in comparison merely reformers; Cubism was a revolution. It was directed against the fundamental basis of Art. All that was before holy and intangible for an artistic mind, namely, the formal unity of the external world, was suddenly laid down on their canvases, torn in pieces and dissected as if it were a mere anatomical specimen. The borderline which separated the external world from the artist and distinguished it in forms of objects disappeared; the objects themselves disintegrated into their component parts and a picture ceased to be an image of the visible forms of an object as a unit, a world in itself, but appeared as a mere picture analysis of the inner mechanism of its cells. The medium between the inner world of the artist and the external world had lost its extension, and between the inner world of the perceptions of the artist and the outer world of existing things there was no longer any substantial medium left which could be measured either by distance or by mind. The contours of the external world which served before as the only guides to an orientation in it were erased; even the necessity for orientation lost its importance and was replaced by other problems, those of exploration and analysis. The creative act of the Cubists was entirely at variance with any which we have observed before. Instead of taking the object as a separate world and passing it through his perceptions producing a third object, namely, the picture, which is the product of the first two,

the Cubist transfers the entire inner world of his perceptions with all its component parts (logic, emotion, and will) into the interior of the object penetrating through its whole structure, stretching its substance to such an extent that the outside integument explodes and the object itself appears destroyed and unrecognizable. That is why a Cubist painting seems like a heap of shards from a vessel exploded from within. The Cubist has no special interest in those forms which differentiate one object from another.

Although the Cubists still regarded the external world as the point of departure for their Art, they did not see and did not want to see any difference between, say, a violin, a tree, a human body, etc. All those objects were for them only one extended matter with a unique structure and only this structure was of importance for their analytic task. It is understandable that in such an artistic concept of the world the details must possess unexpected dimensions and the parts acquire the value of entities, and in the inner relations between them the disproportion grows to such an extent that all inherited ideas about harmony are destroyed. When we look through a Cubistic painting to its concept of the world the same thing happens to us as when we enter the interior of a building which we know only from a distance—it is surprising, unrecognizable, and strange. The same thing happens which occurred in the world of physics when the new Relativity Theory destroyed the borderlines between Matter and Energy, between Space and Time, between the mystery of the world in the atom and the consistent miracle of our galaxy.

I do not mean to say by this that these scientific theories have affected the ideology of the Cubists, one must rather presume that none of those artists had so much as heard of or studied those theories. It is much more probable that they would not have apprehended them even if they had heard about them, and in the end it is entirely superfluous. The state of ideas in this time has brought both creative disciplines to adequate results, each in its own field, so that the edifice of Art as well as the edifice of Science was undermined and corroded by a spirit of fearless analysis which ended in a revolutionary explosion. Yet the destruction produced in the world of Art was more violent and more thorough.

Our own generation found in the world of Art after the work of the Cubists only a conglomeration of ruins. The Cubistic analysis had left for us nothing of the old traditions on which we could base even the flimsiest foundation. We have been compelled to start from the beginning. We had a dilemma to resolve, whether to go further on the way of destruction or to search for new bases for the foundation of a new Art. Our choice was not so difficult to make. The logic of life and the natural artistic instinct prompted us with its solution.

The logic of life does not tolerate permanent revolutions. They are possible on paper but in real life a revolution is only a means, a tool

but never an aim. It allows the destruction of obstacles which hinder a new construction, but destruction for destruction's sake is contrary to life. Every analysis is useful and even necessary, but when this analysis does not care about the results, when it excludes the task of finding a synthesis, it turns to its opposite, and instead of clarifying a problem it only renders it more obscure. Life permits to our desire for knowledge and exploration the most daring and courageous excursions, but only to the explorers who, enticed far away into unknown territories, have not forgotten to notice the way by which they came and the aim for which they started. In Art more than anywhere else in the creative discipline, daring expeditions are allowed. The most dizzying experiments are permissible, but even in Art the logic of life arrests the experiments as soon as they have reached the point when the death of the experimental objects becomes imminent. There were moments in the history of Cubism when the artists were pushed to these bursting points; sufficient to recall the sermons of Picabia, 1914–16, predicting the wreck of Art, and the manifestos of the Dadaists who already celebrated the funeral of Art with chorus and demonstrations. Realizing how near to complete annihilation the Cubist experiments had brought Art, many Cubists themselves have tried to find a way out, but the lack of consequence has merely made them afraid and has driven them back to Ingres (Picasso, 1919–23) and to the Gobelins of the sixteenth century (Braque, etc.). This was not an outlet but a retreat. Our generation did not need to follow them since it has found a new concept of the world represented by the Constructive idea.

The Constructive idea is not a programmatic one. It is not a technical scheme for an artistic manner, nor a rebellious demonstration of an artistic sect; it is a general concept of the world, or better, a spiritual state of a generation, an ideology caused by life, bound up with it and directed to influence its course. It is not concerned with only one discipline in Art (painting, sculpture, or architecture); it does not even remain solely in the sphere of Art. This idea can be discerned in all domains of the new culture now in construction. This idea has not come with finished and dry formulas, it does not establish immutable laws or schemes, it grows organically along with the growth of our century. It is as young as our century and as old as the human desire to create.

The basis of the Constructive idea in Art lies in an entirely new approach to the nature of Art and its functions in life. In it lies a complete reconstruction of the means in the different domains of Art, in the relations between them, in their methods, and in their aims. It embraces those two fundamental elements on which Art is built up, namely, the Content and the Form. These two elements are, from the Constructive point of view, one and the same thing. It does not separate Content from Form—on the contrary, it does not see as possible

their separated and independent existence. The thought that Form could have one designation and Content another cannot be incorporated in the concept of the Constructive idea. In a work of art they have to live and act as a unit, proceed in the same direction and produce the same effect. I say "have to" because never before in Art have they acted in such a way in spite of the obvious necessity of this condition. It has always been so in Art that either one or the other predominated, conditioning and predetermining the other.

This was because in all our previous Art concepts of the world a work of art could not have been conceived without the representation of the external aspect of the world. Whichever way the artist presented the outside world, either as it is or as seen through his personal perceptions, the external aspect remained as the point of departure and the kernel of its content. Even in those cases where the artist tried to concentrate his attention only on the inner world of his perceptions and emotions, he could not imagine the picture of this inner world without the images of the outer one. The most that he could dare in such cases was the more or less individual distortions of the external images of Nature; that is, he altered only the scale of the relations between the two worlds, always keeping to the main system of its content, but did not attack the fact of their independence; and this indestructible content in a work of art always predicted the forms which Art has followed down to our own time.

The apparently ideal companionship between Form and Content in the old Art was indeed an unequal division of rights and was based on the obedience of the Form to the Content. This obedience is explained by the fact that all formalistic movements in the history of Art, whenever they appeared, never went so far as to presume the possibility of an independent existence of a work apart from the naturalistic content, nor to suspect that there might be a concept of the world which could reveal a Content in a Form.

This was the main obstacle to the rejuvenation of Art, and it was at this point that the Constructive idea laid the cornerstone of its foundation. It has revealed a universal law that the elements of a visual art, such as lines, colors, shapes, possess their own forces of expression independent of any association with the external aspects of the world; that their life and their action are self-conditioned psychological phenomena rooted in human nature; that those elements are not chosen by convention for any utilitarian or other reason as words and figures are, they are not merely abstract signs, but they are immediately and organically bound up with human emotions. The revelation of this fundamental law has opened up a vast new field in art giving the possibility of expression to those human impulses and emotions which have been neglected. Heretofore these elements have been abused by being used to express all sorts of associative images which might have been expressed otherwise, for instance, in literature and poetry.

But this point was only one link in the ideological chain of the constructive concept, being bound up with the new conception of Art as a whole and of its functions in life. The Constructive idea sees and values Art only as a creative act. By a creative act it means every material or spiritual work which is destined to stimulate or perfect the substance of material or spiritual life. Thus the creative genius of Mankind obtains the most important and singular place. In the light of the Constructive idea the creative mind of Man has the last and decisive word in the definite construction of the whole of our culture. To be sure, the creative genius of Man is only a part of Nature, but from this part alone derives all the energy necessary to construct his spiritual and material edifice. Being a result of Nature it has every right to be considered as a further cause of its growth. Obedient to Nature, it intends to become its master; attentive to the laws of Nature it intends to make its own laws, following the forms of Nature it re-forms them. We do not need to look for the origin of this activity, it is enough for us to state it and to feel its reality continually acting on us. Life without creative effort is unthinkable, and the whole course of human culture is one continuous effort of the creative will of Man. Without the presence and the control of the creative genius, Science by itself would never emerge from the state of wonder and contemplation from which it is derived and would never have achieved substantial results. Without the creative desire Science would go astray in its own schemes, losing its aim in its reasoning. No criterion could be established in any spiritual discipline without this creative will. No way could be chosen, no direction indicated without its decision. There are no truths beyond its truths. How many of them life hides in itself, how different they are and how inimical. Science is not able to resolve them. One scientist says, "The truth is here"; another says, "It is there"; while a third says, "It is neither here nor there, but somewhere else." Every one of them has his own proof and his own reason for saying so, but the creative genius does not wait for the end of their discussion. Knowing what it wants, it makes a choice and decides for them.

The creative genius knows that truths are possible everywhere, but only those truths matter to it which correspond to its aims and which lie in the direction of its course. The way of a creative mind is always positive, it always asserts; it does not know the doubts which are so characteristic of the scientific mind. In this case it acts as Art.

The Constructive idea does not see that the function of Art is to represent the world. It does not impose on Art the function of Science. Art and Science are two different streams which rise from the same creative source and flow into the same ocean of the common culture, but the currents of these two streams flow in different beds. Science teaches, Art asserts; Science persuades, Art acts; Science explores and apprehends, informs and proves. It does not undertake anything

without first being in accord with the laws of Nature. Science cannot deal otherwise because its task is knowledge. Knowledge is bound up with things which are; and things which are, are heterogeneous, changeable, and contradictory. Therefore the way to the ultimate truth is so long and difficult for Science.

The force of Science lies in its authoritative reason. The force of Art lies in its immediate influence on human psychology and in its active contagiousness. Being a creation of Man it re-creates Man. Art has no need of philosophical arguments, it does not follow the signposts of philosophical systems; Art, like life, dictates systems to philosophy. It is not concerned with the meditation about what is and how it came to be. That is a task for Knowledge. Knowledge is born of the desire to know, Art derives from the necessity to communicate and to announce. The stimulus of Science is the deficiency of our knowledge. The stimulus of Art is the abundance of our emotions and our latent desires. Science is the vehicle of facts—it is indifferent, or at best tolerant, to the ideas which lie behind facts. Art is the vehicle of ideas and its attitude to facts is strictly partial. Science looks and observes, Art sees and foresees. Every great scientist has experienced a moment when the artist in him saved the scientist. "We are poets," said Pythagoras, and in the sense that a mathematician is a creator he was right.

In the light of the Constructive idea the purely philosophical wondering about real and unreal is idle. Even more idle is the intention to divide the real into super-real and sub-real, into conscious reality and subconscious reality. The Constructive idea knows only one reality. Nothing is unreal in Art. Whatever is touched by Art becomes reality, and we do not need to undertake remote and distant navigations in the subconscious in order to reveal a world which lies in our immediate vicinity. We feel its pulse continually beating in our wrists. In the same way we shall probably never have to undertake a voyage in interstellar space in order to feel the breath of the galactic orbits. This breath is fanning our heads within the four walls of our own rooms.

There is and there can be only one reality—existence. For the Constructive idea it is more important to know and to use the main fact that Art possesses in its own domain the means to influence the course of this existence, enriching its content and stimulating its energy.

This does not mean that this idea constantly compels Art to an immediate construction of material values in life; it is sufficient when Art prepares a state of mind which will be able only to construct, coordinate and perfect instead of to destroy, disintegrate and deteriorate. Material values will be the inevitable result of such a state. For the same reason the Constructive idea does not expect from Art the performance of critical functions even when they are directed against the negative sides of life. What is the use of showing us what is bad without revealing what is good? The Constructive idea prefers that

Art perform positive works which lead us toward the best. The measure of this perfection will not be so difficult to define when we realize that it does not lie outside us but is bound up in our desire and in our will to it. The creative human genius, which never errs and never mistakes, defines this measure. Since the beginning of Time man has been occupied with nothing else but the perfecting of his world.

To find the means for the accomplishment of this task the artist need not search in the external world of Nature; he is able to express his impulses in the language of those absolute forms which are in the substantial possession of his Art. This is the task which we constructive artists have set ourselves, which we are doing, and which we hope will be continued by the future generation.

Mondrian

Plastic Art and Pure Plastic Art

"Plastic Art and Pure Plastic Art" is the most influential of several essays by Mondrian, and one of the few by any artist which constructs a complete, integral aesthetic system.

In 1917 Piet Mondrian (1872–1944) had been one of the principal founders of the Dutch movement *de Stijl,* but he left to Van Doesburg the role of principal propagandist. He returned to Paris after the war (he had earlier lived there, from 1911 to 1914), and in 1920 published his first major essay, "*Le Néo-Plasticisme.*" Here and in subsequent writings he worked out many of the elements of the 1937 essay. In Paris until 1938, then in London for two years, Mondrian moved to New York City when the war broke out, and died there in 1944. The war years in New York were among his most productive as an artist-essayist, three essays being published in 1942 alone.

"Plastic Art and Pure Plastic Art" is a brilliant essay because, like Mondrian's paintings, it makes no compromises. Since it is an extreme, it will at first prove difficult, especially because Mondrian redefines such words as "subjectivity" and "objectivity," but the alert reader will soon be caught up in a remarkable challenge to traditional concepts of what is "real" and what is art.

The essay originally appeared in *Circle,* edited by Naum Gabo, J. L. Martin, and Ben Nicholson (London, 1937). The text here, with only a few words changed later by Mondrian, comes from *Plastic Art and Pure Plastic Art and Other Essays,* one of the series "Documents of Modern Art," edited by Robert Motherwell for Wittenborn, Schultz (New York, 1945). The late Harry Holtzman kindly permitted me to republish the essay. Its definitive form is found in Holtzman and Martin S. James, eds., *The New Art—The New Life: The Collected Writings of Piet Mondrian* (Boston, 1986), pp. 288–300.

Plastic Art and
Pure Plastic Art

Part I

Although Art is fundamentally everywhere and always the same, nevertheless two main human inclinations, diametrically opposed to each other, appear in its many and varied expressions. One aims at the *direct creation of universal beauty,* the other at the *esthetic expression of oneself,* in other words, of that which one thinks and experiences. The first aims at representing reality objectively, the second subjectively. Thus we see in every work of figurative art the desire, objectively to represent beauty, solely through form and color, in mutually balanced relations, and, at the same time, an attempt to express that which these forms, colors, and relations arouse in us. This latter attempt must of necessity result in an individual expression which veils the pure representation of beauty. Nevertheless, both the two opposing elements (universal-individual) are indispensable if the work is to arouse emotion. Art had to find the right solution. In spite of the dual nature of the creative inclinations, figurative art has produced a harmony through a certain coordination between objective and subjective expression. For the spectator, however, who demands a pure representation of beauty, the individual expression is too predominant. For the artist the search for a unified expression through the balance of two opposites has been, and always will be, a continual struggle.

Throughout the history of culture, art has demonstrated that universal beauty does not arise from the particular character of the form, but from the dynamic rhythm of its inherent relationships, or—in a composition—from the mutual relations of forms. Art has shown that it is a question of determining the relations. It has revealed that the forms exist only for the creation of relationships; that forms create relations and that relations create forms. In this duality of forms and their relations neither takes precedence.

The only problem in art is to achieve a balance between the subjective and the objective. But it is of the utmost importance that this problem should be solved, in the realm of plastic art—technically, as it were—and not in the realm of thought. The work of art must be "produced," "constructed." One must create as objective as possible a representation of forms and relations. Such work can never be

empty because the opposition of its constructive elements and its exe-
cution arouse emotion.

If some have failed to take into account the inherent character of
the form and have forgotten that this—untransformed—predomi-
nates, others have overlooked the fact that an individual expression
does not become a universal expression through figurative represen-
tation, which is based on our conception of feeling, be it classical,
romantic, religious, surrealist. Art has shown that universal expres-
sion can only be created by *a real equation of the universal and the
individual.*

Gradually art is purifying its plastic means and thus bringing out
the relationships between them. Thus, in our day two main tendencies
appear: the one maintains the figuration, the other eliminates it.
While the former employs more or less complicated and particular
forms, the latter uses simple and neutral forms, or, ultimately, the free
line and the pure color. It is evident that the latter (nonfigurative art)
can more easily and thoroughly free itself from the domination of the
subjective than can the figurative tendency; particular forms and col-
ors (figurative art) are more easily exploited than neutral forms. It is,
however, necessary to point out, that the definitions "figurative" and
"nonfigurative" are only approximate and relative. For every form,
even every line, represents a figure; no form is absolutely neutral.
Clearly, everything must be relative, but, since we need words to make
our concepts understandable, we must keep to these terms.

Among the different forms we may consider those as being neutral
which have neither the complexity nor the particularities possessed by
the natural forms or abstract forms in general. We may call those neu-
tral which do not evoke individual feelings or ideas. Geometrical
forms being so profound an abstraction of form may be regarded as
neutral; and on account of their tension and the purity of their out-
lines they may even be preferred to other neutral forms.

If, as a conception, non-figurative art has been created by the mu-
tual interaction of the human duality, this art has been *realized* by the
mutual interaction of *constructive elements and their inherent rela-
tions.* This process consists in mutual purification; purified construc-
tive elements set up pure relationships, and these in their turn demand
pure constructive elements. Figurative art of today is the outcome of
figurative art of the past, and nonfigurative art is the outcome of the
figurative art of today. Thus the unity of art is maintained.

If nonfigurative art is born of figurative art, it is obvious that the
two factors of human duality have not only changed, but have also
approached one another toward a mutual balance, toward unity. One
can rightly speak of an *evolution in plastic art.* It is of the greatest
importance to note this fact, for it reveals the true way of art; the only
path along which we can advance. Moreover, the evolution of the
plastic arts shows that the dualism which has manifested itself in art

is only relative and temporal. Both science and art are discovering and making us aware of the fact that *time is a process of intensification,* an evolution from the individual toward the universal, of the subjective toward the objective; toward the essence of things and of ourselves.

A careful observation of art since its origin shows that artistic expression seen from the outside is *not a process of prolongment but of intensifying one and the same thing,* universal beauty; and that seen from the inside *it is a growth.* Extension results in a continual repetition of nature; it is not human and art cannot follow it. So many of these repetitions which parade as "art" clearly cannot arouse emotions.

Through intensification one creates successively on more profound planes; extension remains always on the same plane. Intensification, be it noted, is diametrically opposed to extension; they are at right angles to each other as are length and depth. This fact shows clearly the temporal opposition of nonfigurative and figurative art.

But if throughout its history art has meant a *continuous and gradual change in the expression of one and the same thing,* the opposition of the two trends—in our time so clear-cut—is actually an unreal one. It is illogical that the two principal tendencies in art, figurative and non-figurative (objective and subjective) should be so hostile. Since art is in essence universal, its expression cannot rest on a subjective view. Our human capacities do not allow of a perfectly objective view, but that does not imply that the plastic expression of art is based on subjective conception. Our subjectivity realizes but does not create the work.

If the two human inclinations already mentioned are apparent in a work of art, they have both collaborated in its realization, but it is evident that the work will clearly show which of the two has predominated. In general, owing to the complexity of forms and the vague expression of relations, the two creative inclinations will appear in the work in a confused manner. Although in general there remains much confusion, today the two inclinations appear more clearly defined as two tendencies: *figurative and nonfigurative art.* So-called nonfigurative art often also creates a particular representation; figurative art, on the other hand, often neutralizes its forms to a considerable extent. The fact that art which is really nonfigurative is rare does not detract from its value; evolution is always the work of pioneers, and their followers are always small in number. This following is not a clique; it is the result of all the existing social forces; it is composed of all those who through innate or acquired capacity are ready to represent the existing degree of human evolution. At a time when so much attention is paid to the collective, to the "mass," it is necessary to note that evolution, ultimately, is never the expression of the mass. The mass remains behind yet urges the pioneers to creation. For the

pioneers, the social contact is indispensable, but not in order that they may know that what they are doing is necessary and useful, nor in order that "collective approval may help them to persevere and nourish them with living ideas." This contact is necessary only in an indirect way; it acts especially as an obstacle which increases their determination. The pioneers create through their reaction to external stimuli. They are guided not by the mass but by that which they see and feel. They discover consciously or unconsciously the fundamental laws hidden in reality, and aim at realizing them. In this way they further human development. They know that humanity is not served by making art comprehensible to everybody; to try this is to attempt the impossible. One serves mankind by enlightening it. Those who do not see will rebel, they will try to understand and will end up by "seeing." In art the search for a content which is collectively understandable is false; the content will always be individual. Religion, too, has been debased by that search.

Art is not made for anybody and is, at the same time, for everybody. It is a mistake to try to go too fast. The complexity of art is due to the fact that different degrees of its evolution are present at one and the same time. The present carries with it the past and the future. But we need not try to foresee the future; we need only take our place in the development of human culture, a development which has made non-figurative art supreme. It has always been only one struggle, of only one real art: to create universal beauty. This points the way for both present and future. We need only continue and develop what already exists. The essential thing is that the *fixed laws of the plastic arts must be realized*. These have shown themselves clearly in nonfigurative art.

Today one is tired of the dogmas of the past, and of truths once accepted but successively jettisoned. One realizes more and more the relativity of everything, and therefore one tends to reject the idea of fixed laws, of a single truth. This is very understandable but does not lead to profound vision. For there are "made" laws, "discovered" laws, but also laws—a truth for all time. These are more or less hidden in the reality which surrounds us and do not change. Not only science, but art also, shows us that reality, at first incomprehensible, gradually reveals itself, by the mutual relations that are inherent in things. Pure science and pure art, disinterested and free, can lead the advance in the recognition of the laws which are based on these relationships. A great scholar has recently said that pure science achieves practical results for humanity. Similarly, one can say that pure art, even though it appear abstract, can be of direct utility for life.

Art shows us that there are also constant truths concerning forms. Every form, every line has its own expression. This objective expression can be modified by our subjective view but it is no less true for that. Round is always round and square is always square. Simple though these facts are, they often appear to be forgotten in art. Many try to

achieve one and the same end by different means. In plastic art this is
an impossibility. In plastic art it is necessary to choose constructive
means which are of one piece with that which one wants to express.
Art makes us realize that there are *fixed laws which govern and point
to the use of the constructive elements, of the composition and of the
inherent interrelationships between them.* These laws may be regarded
as subsidiary laws to the *fundamental* law of equivalence which creates
dynamic equilibrium and reveals the true content of reality.

Part II

We live in a difficult but interesting epoch. After a secular culture,
a turning point has arrived; this shows itself in all the branches of
human activity. Limiting ourselves here to science and art, we notice
that, just as in medicine some have discovered the natural laws relat-
ing to physical life, in art some have discovered the artistic laws relat-
ing to plastics. In spite of all opposition, these facts have become
movements. But confusion still reigns in them. Through science we are
becoming more and more conscious of the fact that our physical state
depends in great measure on what we eat, on the manner in which our
food is arranged and on the physical exercise which we take. Through
art we are becoming more and more conscious of the fact that the
work depends in large measure on the constructive elements which we
use and on the construction which we create. We will gradually real-
ize that we have not hitherto paid sufficient attention to constructive
physical elements in their relation to the human body, nor to the con-
structive plastic elements in their relation to art. That which we eat
has deteriorated through a refinement of natural produce. To say this,
appears to invoke a return to a primitive natural state and to be in
opposition to the exigencies of pure plastic art, which degenerates pre-
cisely through figurative trappings. But a return to pure natural nour-
ishment does not mean a return to the state of primitive man; it means
on the contrary that cultured man obeys the laws of nature discovered
and applied by science.

Similarly in nonfigurative art, to recognize and apply natural laws
is not evidence of a retrograde step; the pure abstract expression of
these laws proves that the exponent of nonfigurative art associates
himself with the most advanced progress and the most cultured
minds, that he is an exponent of denaturalized nature, of civilization.

In life, sometimes the spirit has been overemphasized at the expense
of the body, sometimes one has been preoccupied with the body and
neglected the spirit; similarly in art, content and form have alternately
been overemphasized or neglected because *their inseparable unity* has
not been clearly realized.

To create this unity in art *balance of the one and the other must be
created.*

It is an achievement of our time to have approached such balance in a field in which disequilibrium still reigns.

Disequilibrium means conflict, disorder. Conflict is also a part of life and of art, but it is not the whole of life or universal beauty. Real life is the *mutual interaction of two oppositions of the same value but of a different aspect and nature.* Its plastic expression is universal beauty.

In spite of world disorder, instinct and intuition are carrying humanity to a real equilibrium, but how much misery has been and is still being caused by primitive animal instinct. How many errors have been and are being committed through vague and confused intuition? Art certainly shows this clearly. But art shows also that in the course of progress, intuition becomes more and more conscious and instinct more and more purified. Art and life illuminate each other more and more; they reveal more and more their laws according to which a real and living balance is created.

Intuition enlightens and so links up with pure thought. They together become an intelligence which is not simply of the brain, which does not calculate, but which feels and thinks. Which is creative both in art and in life. From this intelligence there must arise non-figurative art in which instinct no longer plays a dominating part. Those who do not understand this intelligence regard nonfigurative art as a purely intellectual product.

Although all dogma, all preconceived ideas, must be harmful to art, the artist can nevertheless be guided and helped in his intuitive researches by reasoning apart from his work. If such reasoning can be useful to the artist and can accelerate his progress, it is indispensable that such reasoning should accompany the observations of the critics who talk about art and who wish to guide mankind. Such reasoning, however, cannot be individual, which it usually is; it cannot arise out of a body of knowledge outside plastic art. If one is not an artist oneself one must at least know the *laws and culture of plastic art.* If the public is to be well informed and if mankind is to progress it is essential that the confusion which is everywhere present should be removed. For enlightenment, a clear demonstration of the *succession of artistic tendencies is necessary.* Hitherto, a study of the different styles of plastic art in their progressive succession has been difficult since the expression of the essence of art has been veiled. In our time, which is reproached for not having a style of its own, the content of art has become clear and the different tendencies reveal more clearly the progressive succession of artistic expression. Nonfigurative art brings to an end the ancient culture of art; at present, therefore, one can review and judge more surely *the whole culture of art.* We are now at the turning-point of this culture; *the culture of particular form is approaching its end. The culture of determined relations has begun.*

It is not enough to explain the value of a work of art in itself; it is above all necessary to show *the place which a work occupies on the scale of the evolution of plastic art.* Thus in speaking of art, it is not permissible to say "this is how I see it" or "this is my idea." True art like true life takes a *single road.*

The laws which in the culture of art have become more and more determinate are the *great hidden laws of nature which art establishes in its own fashion.* It is necessary to stress the fact that these laws are more or less hidden behind the superficial aspect of nature. Abstract art is therefore opposed to a natural representation of things. But it *is not opposed to nature* as is generally thought. It is opposed to the raw primitive animal nature of man, but it is one with true human nature. It is opposed to the conventional laws created during the culture of the particular form but it is one with the laws of the culture of pure relationships.

First and foremost there is the fundamental law of *dynamic equilibrium* which is opposed to the static equilibrium necessitated by the particular form.

The important task then of all art is to destroy the static equilibrium by establishing a dynamic one. Nonfigurative art demands an attempt of what is a consequence of this task, the *destruction* of particular form and the *construction* of a rhythm of mutual relations, of mutual forms or free lines. We must bear in mind, however, a distinction between these two forms of equilibrium in order to avoid confusion; for when we speak of equilibrium pure and simple we may be for, and at the same time against, a balance in the work of art. It is of the greatest importance to note the destructive-constructive quality of dynamic equilibrium. Then we shall understand that the equilibrium of which we speak in nonfigurative art is not without movement of action but is on the contrary a continual movement. We then understand also the significance of the name "constructive art."

The fundamental law of dynamic equilibrium gives rise to a number of other laws which relate to the constructive elements and their relations. These laws determine the manner in which dynamic equilibrium is achieved. The relations of *position* and those of *dimension* both have their own laws. Since the relation of the rectangular position is constant, it will be applied whenever the work demands the expression of stability; to destroy this stability there is a law that relations of a changeable dimension-expression must be substituted. The fact that all the relations of position except the rectangular one lack that stability, also creates a law which we must take into account if something is to be established in a determinate manner. Too often right and oblique angles are arbitrarily employed. All art expresses the rectangular relationship even though this may not be in a determinate manner; first by the height and width of the work and its constructive forms, then by the mutual relations of these forms. Through the

clarity and simplicity of neutral forms, nonfigurative art has made the rectangular relation more and more determinate until, finally, it has established it through free lines which intersect and appear to form rectangles.

As regards the relations of dimension, they must be varied in order to avoid repetition. Although, as compared with the stable expression of the rectangular relationship, they belong to individual expression, it is precisely they that are most appropriate for the destruction of the static equilibrium of all form. By offering him a freedom of choice the relations of dimension *present the artist with one of the most difficult problems.* And the closer he approaches the ultimate consequence of his art the more difficult is his task.

Since the constructive elements and their mutual relations form an inseparable unity, the laws of the relations govern equally the constructive elements. These, however, have also their own laws. It is obvious that one cannot achieve the same expression through different forms. But it is often forgotten that varied forms or lines *achieve—in form—altogether different degrees in the evolution of plastic art.* Beginning with natural forms and ending with the most abstract forms, *their expression becomes more profound.* Gradually form and line gain in tension. For this reason the straight line is a stronger and more profound expression than the curve.

In pure plastic art the significance of different forms and lines is very important; it is precisely this fact which makes it pure.

In order that art may be really abstract, in other words, that it should not represent relations with the natural aspect of things, the law of the *denaturalization of matter* is of fundamental importance. In painting, the primary color that is as pure as possible realizes this abstraction of natural color. But color is, in the present state of technique, also the best means for denaturalizing matter in the realm of abstract constructions in three dimensions; technical means are as a rule insufficient.

All art has achieved a certain measure of abstraction. This abstraction has become more and more accentuated until in pure plastic art not only a transformation of form but also of matter—be it through technical means or through color—a more or less neutral expression is attained.

According to our laws, it is a great mistake to believe that one is practicing nonfigurative art by merely achieving neutral forms or free lines and determinate relations. For in composing these forms one runs the risk of a figurative creation, that is to say one or more particular forms.

Nonfigurative art is created by establishing *a dynamic rhythm of determinate mutual relations* which *excludes the formation of any particular form.* We note thus, that to destroy particular form is only to do more consistently what all art has done.

The dynamic rhythm which is essential in all art is also the essential element of a nonfigurative work. In figurative art this rhythm is veiled. Yet we all pay homage to clarity.

The fact that people generally prefer figurative art (which creates and finds its continuation in abstract art) can be explained by the dominating force of the individual inclination in human nature. *From this inclination arises all the opposition to art which is purely abstract.*

In this connection we note first the *naturalistic conception* and the *descriptive or literary orientation:* both a real danger to purely abstract art. From a purely plastic point of view, until nonfigurative art, artistic expression has been naturalistic or descriptive. To have emotion aroused by pure plastic expression one must abstract from figuration and so become "neutral." But with the exception of some artistic expressions (such as Byzantine art)[1] there has not been the desire to employ neutral plastic means, which would have been much more logical than to become neutral oneself in contemplating a work of art. Let us note, however, that the spirit of the past was different from the spirit of our own day, and that it is only tradition which has carried the past into our own time. In past times when one lived in contact with nature and when man himself was more natural than he is today, abstraction from figuration in thought was easy; it was done unconsciously. But in our more or less denaturalized period, such abstraction becomes an effort.

However that may be, the fact that figuration is a factor which is unduly taken into account, and whose abstraction in the mind is only relative, proves that today even great artists regard figuration as indispensable. At the same time these artists are already abstracting from figuration to a much greater extent than has been done before. More and more, not only the uselessness of figuration, but also obstacles which it creates, will become obvious. In this search for clarity, nonfigurative art develops.

There is, however, one tendency which cannot forgo figuration without losing its descriptive character. That is Surrealism. Since the predominance of individual thought is opposed to pure plastics it is also opposed to nonfigurative art. Born of a literary movement, its descriptive character demands figuration. However purified or deformed it may be, figuration veils pure plastics. There are, it is true, Surrealist works whose plastic expression is very strong and of a kind that if the work is observed at a distance, i.e., if the figurative representation is abstracted from, they arouse emotion by form, color, and their relations alone. But if the purpose was nothing but plastic expression, why then use figurative representation? Clearly, there must have been the intention to express something outside the realm of pure plastics. This of course is often the case even in abstract art.

1. As regards these works we must note that, lacking a dynamic rhythm, they remain, in spite of the profound expression of forms, more or less ornamental.

There, too, there is sometimes added to the abstract forms something particular, even without the use of figuration; through the color or through the execution, a particular idea or sentiment is expressed. There it is generally not the literary inclination but the naturalistic inclination which has been at work. It must be obvious that if one evokes in the spectator the sensation of, say, the sunlight or moonlight, of joy or sadness, or any other determinate sensation, one has not succeeded in establishing universal beauty, one is not purely abstract.

As for Surrealism, we must recognize that it deepens feeling and thought, but since this deepening is limited by individualism it cannot reach the foundation, the universal. So long as it remains in the realm of dreams, which are only a rearrangement of the events of life, it cannot touch true reality. Through a different composition of the events of life, it may remove their ordinary course but it cannot purify them. Even the intention of freeing life from its conventions and from everything which is harmful to the true life can be found in Surrealist literature. Nonfigurative art is fully in agreement with this intention but it achieves its purpose; it frees its plastic means and its art from all particularity. The names, however, of these tendencies, are only indications of their conceptions; it is the realization which matters. With the exception of nonfigurative art, there seems to have been a lack of realization of the fact that it is possible to express oneself profoundly and humanely by plastics alone, that is, by employing a neutral plastic means without the risk of falling into decoration or ornament. Yet all the world knows that even a single line can arouse emotion. But although one sees—and this is the artist's fault—few nonfigurative works which live by virtue of their dynamic rhythm and their execution, figurative art is no better in this respect. In general, people have not realized that one can express our very essence through neutral constructive elements; that is to say, we can express the essence of art. The essence of art of course is not often sought. As a rule, individualist human nature is so predominant, that the expression of the essence of art through a rhythm of lines, colors, and relationships appears insufficient. Recently, even a great artist has declared that "complete indifference to the subject leads to an incomplete form of art."

But everybody agrees that art is only a problem of plastics. What good then is a subject? It is to be understood that one would need a subject to expound something named "Spiritual riches, human sentiments and thoughts." Obviously, all this is individual and needs particular forms. But at the root of these sentiments and thoughts there is one thought and one sentiment: these do not easily define themselves and have no need of analogous forms in which to express themselves. It is here that neutral plastic means are demanded.

For pure art then, the subject can never be an additional value, it is the line, the color, and their relations which must "bring into play the

whole sensual and intellectual register of the inner life . . . ," not the subject. Both in abstract art and in naturalistic art color expresses itself "in accordance with the form by which it is determined," and in all art it is the artist's task to make forms and colors living and capable of arousing emotion. If he makes art into an "algebraic equation" that is no argument against the art, it only proves that he is not an artist.

If all art has demonstrated that to establish the force, tension and movement of the forms, and the intensity of the colors of reality, it is necessary that these should be purified and transformed; if all art has purified and transformed and is still purifying and transforming these forms of reality and their mutual relations, if all art is thus a continually deepening process: why then stop halfway? If all art aims at expressing universal beauty, why establish an individualist expression? Why then not continue the sublime work of the Cubists? That would not be a continuation of the same tendency, but on the contrary, *a complete break-away from it and all that has existed before it.* That would only be going along the same road that we have already travelled.

Since Cubist art is still fundamentally naturalistic, the break which pure plastic art has caused consists in becoming abstract instead of naturalistic in essence. While in Cubism, from a naturalistic foundation, there sprang forcibly the use of plastic means, still half object, half abstract, the abstract basis of pure plastic art must result in the use of purely abstract plastic means.

In removing completely from the work all objects, "the world is not separated from the spirit," but is on the contrary *put into a balanced opposition* with the spirit, since the one and the other are purified. This creates a perfect unity between the two opposites. There are, however, many who imagine that they are too fond of life, particular reality, to be able to suppress figuration, and for that reason they still use in their work the object or figurative fragments which indicate its character. Nevertheless, one is well aware of the fact that in art one cannot hope to represent in the image things as they are, nor even as they manifest themselves in all their living brilliance. The Impressionists, Divisionists, and Pointillists have already recognized that. There are some today who, recognizing the weakness and limitation of the image, attempt to create a work of art through the objects themselves, often by composing them in a more or less transformed manner. This clearly cannot lead to an expression of their content nor of their true character. One can more or less remove the conventional appearance of things (Surrealism), but they continue nevertheless to show their particular character and to arouse in us individual emotions. To love things in reality is to love them profoundly; it is to see them as a microcosmos in the macrocosmos. *Only in this way can one achieve a universal expression of reality.* Precisely on account of its profound love for things, nonfigurative art does not aim at rendering them in their particular appearance.

Precisely by its existence nonfigurative art shows that "art" *continues always on its true road*. It shows that *"art" is not the expression of the appearance of reality such as we see it, nor of the life which we live,* but that *it is the expression of true reality and true life* . . . *indefinable but realizable in plastics*.

Thus we must carefully distinguish between two kinds of reality; one which has an individual and one which has a universal appearance. In art the former is the expression of space determined by particular things or forms, the latter establishes expansion and limitation—the creative factors of space—through neutral forms, free lines, and pure colors. While universal reality arises from determinate relations, particular reality shows only veiled relations. The latter must obviously be confused in just that respect in which universal reality is bound to be clear. The one is free, the other is tied to individual life, be it personal or collective. Subjective reality and relatively objective reality: this is the contrast. Pure abstract art aims at creating the latter, figurative art the former.

It is astonishing, therefore, that one should reproach pure abstract art with not being "real," and that one should envisage it as "arising from particular ideas."

In spite of the existence of nonfigurative art, one is talking about art today as if nothing determinate in relation to the new art existed. Many neglect the real nonfigurative art, and looking only at the fumbling attempts and at the empty nonfigurative works which today are appearing everywhere, ask themselves whether the time has not arrived "to integrate form and content" or "to unify thought and form." But one should not blame nonfigurative art for that which is only due to the ignorance of its very content. If the form is without content, without universal thought, it is the fault of the artist. Ignoring that fact, one imagines that figuration, subject, particular form, could add to the work that which the plastic itself is lacking. As regards the "content" of the work, we must note that our "attitude with regard to things, our organized individuality with its impulses, its actions, its reactions when in contact with reality, the lights and shades of our spirit," etc., certainly do modify the nonfigurative work, but they do not constitute its content. We repeat that its content cannot be described, and that it is only through pure plastics and through the execution of the work that it can be made apparent. Through this indeterminable content, the nonfigurative work is "fully human." Execution and technique play an important part in the aim of establishing a more or less objective vision which the essence of the nonfigurative work demands. The less obvious the artist's hand the more objective will the work be. This fact leads to a preference for a more or less mechanical execution or to the employment of materials produced by industry. Hitherto, of course, these materials have been imperfect from the point of view of art. If these materials and their

colors were more perfect and if a technique existed by which the artist could easily cut them up in order to compose his work as he conceives it, an art more real and more objective in relation to life than painting would arise. All these reflections evoke questions which have already been asked many years ago, mainly: is art still necessary and useful for humanity? Is it not even harmful to its progress? Certainly the art of the past is superfluous to the new spirit and harmful to its progress: just because of its beauty it holds many people back from the new conception. The new art is, however, still very necessary to life. In a clear manner it establishes the laws according to which a real balance is reached. Moreover, it must create among us a profoundly human and rich beauty realized not only by the best qualities of the new architecture, but also by all that the constructive art in painting and sculpture makes possible.

But although the new art is necessary, the mass is conservative. Hence these cinemas, these radios, these bad pictures which overwhelm the few works which are really of our era.

It is a great pity that those who are concerned with the social life in general do not realize the utility of pure abstract art. Wrongly influenced by the art of the past, the true essence of which escapes them, and of which they only see that which is superfluous, they make no effort to know pure abstract art. Through another conception of the word "abstract," they have a certain horror of it. They are vehemently opposed to abstract art because they regard it as something ideal and unreal. In general they use art as propaganda for collective or personal ideas, thus as literature. They are both in favor of the progress of the mass and against the progress of the elite, thus against the logical march of human evolution. Is it really to be believed that the evolution of the mass and that of the elite are incompatible? The elite rises from the mass; is it not therefore its highest expression?

To return to the execution of the work of art, let us note that it must contribute to a revelation of the subjective and objective factors in mutual balance. Guided by intuition, it is possible to attain this end. The execution is of the greatest importance in the work of art; it is through this, in large part, that intuition manifests itself and creates the essence of the work.

It is therefore a mistake to suppose that a nonfigurative work comes out of the unconscious, which is a collection of individual and prenatal memories. We repeat that it comes from pure intuition, which is at the basis of the subjective-objective dualism.

It is, however, wrong to think that the nonfigurative artist finds impressions and emotions received from the outside useless, and regards it even as necessary to fight against them. On the contrary, all that the nonfigurative artist receives from the outside is not only useful but indispensable, because it arouses in him the desire to create that which he only vaguely feels and which he could *never represent*

in a true manner without the contact with visible reality and with the life which surrounds him. It is precisely from this visible reality that he draws the objectivity which he needs in opposition to his personal subjectivity. It is precisely from this visible reality that he draws his means of expression: and, as regards the surrounding life, it is precisely this which has made his art nonfigurative.

That which distinguishes him from the figurative artist is the fact that in his creations he frees himself from individual sentiments and from particular impressions which he receives from outside, and that he breaks loose from the domination of the individual inclination within him.

It is therefore equally wrong to think that the nonfigurative artist creates through "the pure intention of his mechanical process," that he makes "calculated abstractions," and that he wishes to "suppress sentiment not only in himself but also in the spectator." It is a mistake to think that he retires completely into his system. That which is regarded as a system is nothing but constant obedience to the laws of pure plastics, to necessity, which art demands from him. It is thus clear that he has not become a mechanic, but that the progress of science, of technique, of machinery, of life as a whole, has only made him into a living machine, capable of realizing in a pure manner the essence of art. In this way, he is in his creation sufficiently neutral, that nothing of himself or outside of him can prevent him from establishing that which is universal. Certainly his art is art for art's sake . . . for the sake of the art *which is form and content at one and the same time.*

If all real art is "the sum total of emotions aroused by purely pictorial means" his art is the sum of the emotions aroused by plastic means.

It would be illogical to suppose that nonfigurative art will remain stationary, for this art contains *a culture* of the use of new plastic means and their determinate relations. Because the field is new there is all the more to be done. What is certain is that no escape is possible for the nonfigurative artist; he *must stay within his field and march toward the consequence of his art.*

This consequence brings us, in a future perhaps remote, toward the end of *art as a thing separated from our surrounding environment, which is the actual plastic reality.* But this end is at the same time a new beginning. Art will not only continue but will realize itself more and more. By the unification of architecture, sculpture, and painting, a new plastic reality will be created. Painting and sculpture will not manifest themselves as separate objects, nor as "mural art" which destroys architecture itself, nor as "applied" art, but *being purely constructive* will aid the creation of a surrounding not merely utilitarian or rational but also pure and complete in its beauty.

Beckmann

On My Painting

Max Beckmann (1884–1950), the great independent among German Expressionists, did not attempt to explain his art, nor art in general. *On My Painting* is a beautiful extension in words of the haunting world of his paintings, one of the rare instances in which an artist has succeeded in putting into words the sense not just of his paintings, but of their genesis. It is probably more accurate to call it a prose poem, rather than an essay.

"On My Painting" was a lecture given by Beckmann at the New Burlington Galleries, London, in 1938. It was published in 1941 by the late Curt Valentin, in New York, and I am indebted to Ralph F. Colin, executor of the Valentin estate, for permission to use it here. The late Matilda Beckmann, working from the original German manuscript, provided me with a number of corrections, especially in the "song" toward the end of the text. With the greatest goodwill and patience, she checked and rechecked the revisions, and I am eternally grateful to her. The original German typescript is now in the Museum of Modern Art, New York. The present essay, translated with Matilda Beckmann's aid, is reprinted in Barbara Copeland Buenger, ed., *Self-Portrait in Words: Collected Writings and Statements 1903–1950/Max Beckmann* (Chicago, 1997), pp. 298–307.

On My Painting

Before I begin to give you an explanation, an explanation which it is nearly impossible to give, I would like to emphasize that I have never been politically active in any way. I have only tried to realize my conception of the world as intensely as possible.

Painting is a very difficult thing. It absorbs the whole man, body and soul—thus I have passed blindly many things which belong to real and political life.

I assume, though, that there are two worlds: the world of spiritual life and the world of political reality. Both are manifestations of life which may sometimes coincide but are very different in principle. I must leave it to you to decide which is the more important.

What I want to show in my work is the idea which hides itself behind so-called reality. I am seeking for the bridge which leads from the visible to the invisible, like the famous cabalist who once said: "If you wish to get hold of the invisible you must penetrate as deeply as possible into the visible."

My aim is always to get hold of the magic of reality and to transfer this reality into painting—to make the invisible visible through reality. It may sound paradoxical, but it is, in fact, reality which forms the mystery of our existence.

What helps me most in this task is the penetration of space. Height, width, and depth are the three phenomena which I must transfer into one plane to form the abstract surface of the picture, and thus to protect myself from the infinity of space. My figures come and go, suggested by fortune or misfortune. I try to fix them divested of their apparent accidental quality.

One of my problems is to find the Self, which has only one form and is immortal—to find it in animals and men, in the heaven and in the hell which together form the world in which we live.

Space, and space, again, is the infinite deity which surrounds us and in which we are ourselves contained.

That is what I try to express through painting, a function different from poetry and music but, for me, predestined necessity.

When spiritual, metaphysical, material, or immaterial events come into my life, I can only fix them by way of painting. It is not the subject which matters but the translation of the subject into the abstraction of the surface by means of painting. Therefore I hardly need to abstract things, for each object is unreal enough already, so unreal that I can only make it real by means of painting.

Often, very often, I am alone. My studio in Amsterdam, an enormous old tobacco storeroom, is again filled in my imagination with figures from the old days and from the new, like an ocean moved by storm and sun and always present in my thoughts.

Then shapes become beings and seem comprehensible to me in the great void and uncertainty of the space which I call God.

Sometimes I am helped by the constructive rhythm of the Cabala, when my thoughts wander over Oannes Dagon to the last days of drowned continents. Of the same substance are the streets with their men, women, and children; great ladies and whores; servant girls and duchesses. I seem to meet them, like doubly significant dreams, in Samothrace and Piccadilly and Wall Street. They are Eros and the longing for oblivion.

All these things come to me in black and white like virtue and crime. Yes, black and white are the two elements which concern me. It is my fortune, or misfortune, that I can see neither all in black nor all in white. One vision alone would be much simpler and clearer, but then it would not exist. It is the dream of many to see only the white and truly beautiful, or the black, ugly and destructive. But I cannot help realizing both, for only in the two, only in black and in white, can I see God as a unity creating again and again a great and eternally changing terrestrial drama.

Thus without wanting it, I have advanced from principle to form, to transcendental ideas, a field which is not at all mine, but in spite of this I am not ashamed.

In my opinion all important things in art since Ur of the Chaldees, since Tel Halaf and Crete, have always originated from the deepest feeling about the mystery of Being. Self-realization is the urge of all objective spirits. It is this Self for which I am searching in my life and in my art.

Art is creative for the sake of realization, not for amusement; for transfiguration, not for the sake of play. It is the quest of our Self that drives us along the eternal and never-ending journey we must all make.

My form of expression is painting; there are, of course, other means to this end such as literature, philosophy, or music; but as a painter, cursed or blessed with a terrible and vital sensuousness, I must look for wisdom with my eyes. I repeat, with my eyes, for nothing could be more ridiculous or irrelevant than a "philosophical conception" painted purely intellectually without the terrible fury of the senses grasping each visible form of beauty and ugliness. If from those forms which I have found in the visible, literary subjects result—such as portraits, landscapes, or recognizable compositions—they have all originated from the senses, in this case from the eyes, and each intellectual subject has been transformed again into form, color, and space.

Everything intellectual and transcendent is joined together in painting by the uninterrupted labor of the eyes. Each shade of a flower, a face, a tree, a fruit, a sea, a mountain, is noted eagerly by the

intensity of the senses to which is added, in a way of which I am not conscious, the work of my mind, and in the end the strength or weakness of *my soul*. It is this genuine, eternally unchanging center of strength which makes mind and sense capable of expressing personal things. It is the strength of the soul which forces the mind to constant exercise to widen its conception of space.

Something of this is perhaps contained in my pictures.

Life is difficult, as perhaps everyone knows by now. It is to escape from these difficulties that I practice the pleasant profession of a painter. I admit that there are more lucrative ways of escaping the so-called difficulties of life, but I allow myself my own particular luxury, painting.

It is, of course, a luxury to create art and, on top of this, to insist on expressing one's own artistic opinion. Nothing is more luxurious than this. It is a game and a good game, at least for me; one of the few games which make life, difficult and depressing as it is sometimes, a little more interesting.

Love in an animal sense is an illness, but a necessity which one has to overcome. Politics is an odd game, not without danger I have been told, but certainly sometimes amusing. To eat and to drink are habits not to be despised but often connected with unfortunate consequences. To sail around the earth in 91 hours must be very strenuous, like racing in cars or splitting the atoms. But the most exhausting thing of all—is boredom.

So let me take part in your boredom and in your dreams while you take part in mine which may be yours as well.

To begin with, there has been enough talk about art. After all, it must always be unsatisfactory to try to express one's deeds in words. Still we shall go on and on, talking and painting and making music, boring ourselves, exciting ourselves, making war and peace as long as our strength of imagination lasts. Imagination is perhaps the most decisive characteristic of mankind. My dream is the imagination of space—to change the optical impression of the world of objects by a transcendental arithmetic progression of the inner being. That is the precept. In principle any alteration of the object is allowed which has a sufficiently strong creative power behind it. Whether such alteration causes excitement or boredom in the spectator is for you to decide.

The uniform application of a principle of form is what rules me in the imaginative alteration of an object. One thing is sure—we have to transform the three-dimensional world of objects into the two-dimensional world of the canvas.

If the canvas is only filled with a two-dimensional conception of space, we shall have applied art, or ornament. Certainly this may give us pleasure, though I myself find it boring as it does not give me enough visual sensation. To transform height, width, and depth into two dimensions is for me an experience full of magic in which I glimpse for a moment that fourth dimension which my whole being is seeking.

I have always on principle been against the artist speaking about himself or his work. Today neither vanity nor ambition causes me to talk about matters which generally are not to be expressed even to one-self. But the world is in such a catastrophic state, and art is so bewildered, that I, who have lived the last thirty years almost as a hermit, am forced to leave my snail's shell to express these few ideas which, with much labor, I have come to understand in the course of the years.

The greatest danger which threatens mankind is collectivism. Everywhere attempts are being made to lower the happiness and the way of living of mankind to the level of termites. I am against these attempts with all the strength of my being.

The individual representation of the object, treated sympathetically or antipathetically, is highly necessary and is an enrichment to the world of form. The elimination of the human relationship in artistic representation causes the vacuum which makes all of us suffer in various degrees—an individual alteration of the details of the object represented is necessary in order to display on the canvas the whole physical reality.

Human sympathy and understanding must be reinstated. There are many ways and means to achieve this. Light serves me to a considerable extent on the one hand to divide the surface of the canvas, on the other to penetrate the object deeply.

As we still do not know what this Self really is, this Self in which you and I in our various ways are expressed, we must peer deeper and deeper into its discovery. For the Self is the great veiled mystery of the world. Hume and Herbert Spencer studied its various conceptions but were not able in the end to discover the truth. I believe in it and in its eternal, immutable form. Its path is, in some strange and peculiar manner, our path. And for this reason I am immersed in the phenomenon of the Individual, the so-called whole Individual, and I try in every way to explain and present it. What are you? What am I? Those are the questions that constantly persecute and torment me and perhaps also play some part in my art.

Color, as the strange and magnificent expression of the inscrutable spectrum of Eternity, is beautiful and important to me as a painter; I use it to enrich the canvas and to probe more deeply into the object. Color also decided, to a certain extent, my spiritual outlook, but it is subordinated to light and, above all, to the treatment of form. Too much emphasis on color at the expense of form and space would make a double manifestation of itself on the canvas, and this would verge on craft work. Pure colors and broken tones must be used together, because they are the complements of each other.

These, however, are all theories, and words are too insignificant to define the problems of art. My first unformed impression, and what I would like to achieve, I can perhaps only realize when I am impelled as in a vision.

One of my figures, perhaps one from the "Temptation," sang this strange song to me one night—

Fill up again your pumpkins with alcohol, and hand up the largest of them to me. . . . Solemn, I will light the giant candles for you. Now in the night. In the deep black night.

We are playing hide-and-seek, we are playing hide-and-seek across a thousand seas. We gods, we gods when the skies are red at dawn, at midday, and in the blackest night.

You cannot see us, no you cannot see us but you are ourselves. . . . Therefore we laugh so gaily when the skies are red at dawn, at midday, and in the blackest night.

Stars are our eyes and the nebulae our beards. . . . We have people's souls for our hearts. We hide ourselves and you cannot see us, which is just what we want when the skies are red at dawn, at midday, and in the blackest night.

Our torches stretch away without end . . . silver, glowing red, purple, violet, green-blue, and black. We bear them in our dance over the seas and the mountains, across the boredom of life.

We sleep and stars circle in the gloomy dream. We wake and the suns assemble for the dance across bankers and fools, whores and duchesses.

Thus the figure from my "Temptation" sang to me for a long time, trying to escape from the square on the hypotenuse in order to achieve a particular constellation of the Hebrides, to the Red Giants and the Central Sun.

And then I awoke and yet continued to dream . . . painting constantly appeared to me as the one and only possible achievement. I thought of my grand old friend Henri Rousseau, that Homer in the porter's lodge whose prehistoric dreams have sometimes brought me near the gods. I saluted him in my dream. Near him I saw William Blake, noble emanation of English genius. He waved friendly greetings to me like a super-terrestrial patriarch. "Have confidence in objects," he said, "do not let yourself be intimidated by the horror of the world. Everything is ordered and correct and must fulfill its destiny in order to attain perfection. Seek this path and you will attain from your own Self ever deeper perception of the eternal beauty of creation; you will attain increasing release from all that which now seems to you sad or terrible."

I awoke and found myself in Holland in the midst of a boundless world turmoil. But my belief in the final release and absolution of all things, whether they please or torment, was newly strengthened. Peacefully I laid my head among the pillows . . . to sleep, and dream, again.

Moore

On Sculpture and Primitive Art

Henry Moore (1898–1986) was a genial host to the inquiring visitor, whom he addressed with an almost pedagogical politeness and concern. One would assume that, accordingly, he would often write about his sculpture. The opposite is true, and these three little essays are among his rare writings; two of them, significantly, were lectures. "It is a mistake for a sculptor or a painter to speak or write very often about his job," he announces in "Notes on Sculpture," but he admits that an artist can give his reader "clues." It was perhaps by keeping his mind on such clues that he succeeded in writing so directly, and in distilling so much in a few pages.

"The Sculptor's Aims" was first published in *Unit One*, 1934, edited by Herbert Read (London, Cassell and Company). "Notes on Sculpture" appeared first in *The Listener*, XVIII, 449 (August 18, 1937); "Primitive Art" was another *Listener* article, XXV, 641 (April 24, 1941). All three have been republished together frequently. I am grateful to Henry Moore for authorizing the inclusion of his essays in this anthology, when I was preparing the first edition.

The Sculptor's Aims

Each sculptor through his past experience, through observation of natural laws, through criticism of his own work and other sculpture, through his character and psychological make-up, and according to his stage of development, finds that certain qualities in sculpture become of fundamental importance to him. For me these qualities are:

Truth to material. Every material has its own individual qualities. It is only when the sculptor works direct, when there is an active relationship with his material, that the material can take its part in the shaping of an idea. Stone, for example, is hard and concentrated and should not be falsified to look like soft flesh—it should not be forced beyond its constructive build to a point of weakness. It should keep its hard tense stoniness.

Full three-dimensional realization. Complete sculptural expression is form in its full spatial reality.

Only to make relief shapes on the surface of the block is to forgo the full power of expression of sculpture. When the sculptor understands his material, has a knowledge of its possibilities and its constructive build, it is possible to keep within its limitations and yet turn an inert block into a composition which has a full form existence, with masses of varied size and section conceived in their air-surrounded entirety, stressing and straining, thrusting and opposing each other in spatial relationship—being static, in the sense that the center of gravity lies within the base (and does not seem to be falling over or moving off its base)—and yet having an alert dynamic tension between its parts.

Sculpture fully in the round has no two points of view alike. The desire for form completely realized is connected with asymmetry. For a symmetrical mass being the same from both sides cannot have more than half the number of different points of view possessed by a non-symmetrical mass.

Asymmetry is connected also with the desire for the organic (which I have) rather than the geometric.

Organic forms, though they may be symmetrical in their main disposition, in their reaction to environment, growth, and gravity, lose their perfect symmetry.

Observation of natural objects. The observation of nature is part of an artist's life, it enlarges his form-knowledge, keeps him fresh and from working only by formula, and feeds inspiration.

The human figure is what interests me most deeply, but I have found principles of form and rhythm from the study of natural objects such as pebbles, rocks, bones, trees, plants, etc.

Pebbles and rocks show nature's way of working stone. Smooth, sea-worn pebbles show the wearing away, rubbed treatment of stone and principles of asymmetry.

Rocks show the hacked, hewn treatment of stone, and have a jagged nervous block rhythm.

Bones have marvelous structural strength and hard tenseness of form, subtle transition of one shape into the next, and great variety in section.

Trees (tree trunks) show principles of growth and strength of joints, with easy passing of one section into the next. They give the ideal for wood sculpture, upward twisting movement.

Shells show nature's hard but hollow form (metal sculpture) and have a wonderful completeness of single shape.

There is in nature a limitless variety of shapes and rhythms (and the telescope and microscope have enlarged the field) from which the sculptor can enlarge his form-knowledge experience.

But beside formal qualities there are qualities of vision and expression:

Vision and expression. My aim in work is to combine as intensely as possible the abstract principles of sculpture along with the realization of my idea.

All art is an abstraction to some degree (in sculpture the material alone forces one away from pure representation and toward abstraction).

Abstract qualities of design are essential to the value of a work, but to me of equal importance is the psychological, human element. If both abstract and human elements are welded together in a work, it must have a fuller, deeper meaning.

Vitality and power of expression. For me a work must first have a vitality of its own. I do not mean a reflection of the vitality of life, of movement, physical action, frisking, dancing figures, and so on, but that a work can have in it a pent-up energy, an intense life of its own, independent of the object it may represent. When a work has this powerful vitality we do not connect the word Beauty with it.

Beauty, in the later Greek or Renaissance sense, is not the aim in my sculpture.

Between beauty of expression and power of expression there is a difference of function. The first aims at pleasing the senses, the second has a spiritual vitality which for me is more moving and goes deeper than the senses.

Because a work does not aim at reproducing natural appearances it is not, therefore, an escape from life—but may be a penetration into reality, not a sedative or drug, not just the exercise of good taste, the provision of pleasant shapes and colors in a pleasing combination, not a decoration to life, but an expression of the significance of life, a stimulation to greater effort in living.

Notes on Sculpture

It is a mistake for a sculptor or a painter to speak or write very often about his job. It releases tension needed for his work. By trying to express his aims with rounded-off logical exactness, he can easily become a theorist whose actual work is only a caged-in exposition of conceptions evolved in terms of logic and words.

But though the nonlogical, instinctive, subconscious part of the mind must play its part in his work, he also has a conscious mind which is not inactive. The artist works with a concentration of his whole personality, and the conscious part of it resolves conflicts, organizes memories, and prevents him from trying to walk in two directions at the same time.

It is likely, then, that a sculptor can give, from his own conscious experience, *clues* which will help others in their approach to sculpture, and this article tries to do this, and no more. It is not a general survey of sculpture, or of my own development, but a few notes on some of the problems that have concerned me from time to time.

Appreciation of sculpture depends upon the ability to respond to form in three dimensions. That is perhaps why sculpture has been described as the most difficult of all arts; certainly it is more difficult than the arts which involve appreciation of flat forms, shape in only two dimensions. Many more people are "form-blind" than color-blind. The child learning to see, first distinguishes only two-dimensional shape; it cannot judge distances, depths. Later, for its personal safety and practical needs, it has to develop (partly by means of touch) the ability to judge roughly three-dimensional distances. But having satisfied the requirements of practical necessity, most people go no farther. Though they may attain considerable accuracy in the perception of flat form, they do not make the further intellectual and emotional effort needed to comprehend form in its full spatial existence.

This is what the sculptor must do. He must strive continually to think of, and use, form in its full spatial completeness. He gets the solid shape, as it were, inside his head—he thinks of it, whatever its size, as if he were holding it completely enclosed in the hollow of his hand. He mentally visualizes a complex form *from all round itself*; he knows while he looks at one side what the other side is like; he identifies himself with its center of gravity, its mass, its weight; he realizes its volume, as the space that the shape displaces in the air.

And the sensitive observer of sculpture must also learn to feel shape simply as shape, not as description or reminiscence. He must, for

example, perceive an egg as a simple single solid shape, quite apart from its significance as food, or from the literary idea that it will become a bird. And so with solids such as a shell, a nut, a plum, a pear, a tadpole, a mushroom, a mountain peak, a kidney, a carrot, a tree-trunk, a bird, a bud, a lark, a lady-bird, a bulrush, a bone. From these he can go on to appreciate more complex forms or combinations of several forms.

Since the Gothic, European sculpture had become overgrown with moss, weeds—all sorts of surface excrescences which completely concealed shape. It has been Brancusi's special mission to get rid of this overgrowth, and to make us once more shape-conscious. To do this he has had to concentrate on very simple direct shapes, to keep his sculpture, as it were, one-cylindered, to refine and polish a single shape to a degree almost too precious. Brancusi's work, apart from its individual value, has been of historical importance in the development of contemporary sculpture. But it may now be no longer necessary to close down and restrict sculpture to the single (static) form unit. We can now begin to open out. To relate and combine together several forms of varied sizes, sections, and directions into one organic whole.

Although it is the human figure which interests me most deeply, I have always paid great attention to natural forms, such as bones, shells, and pebbles, etc. Sometimes for several years running I have been to the same part of the seashore—but each year a new shape of pebble has caught my eye, which the year before, though it was there in hundreds, I never saw. Out of the millions of pebbles passed in walking along the shore, I choose out to see with excitement only those which fit in with my existing form-interest at the time. A different thing happens if I sit down and examine a handful one by one. I may then extend my form-experience more, by giving my mind time to become conditioned to a new shape.

There are universal shapes to which everybody is subconsciously conditioned and to which they can respond if their conscious control does not shut them off.

Pebbles show nature's way of working stone. Some of the pebbles I pick up have holes right through them.

When first working direct in a hard and brittle material like stone, the lack of experience and great respect for the material, the fear of ill-treating it, too often result in relief surface carving, with no sculptural power.

But with more experience the completed work in stone can be kept within the limitations of its material, that is, not be weakened beyond its natural constructive build, and yet be turned from an inert mass into a composition which has a full form-existence, with masses of varied sizes and sections working together in spatial relationship.

A piece of stone can have a hole through it and not be weakened—

if the hole is of a studied size, shape, and direction. On the principle
of the arch, it can remain just as strong.

The first hole made through a piece of stone is a revelation.

The hole connects one side to the other, making it immediately
more three-dimensional.

A hole can itself have as much shape-meaning as a solid mass.

Sculpture in air is possible, where the stone contains only the hole,
which is the intended and considered form.

The mystery of the hole—the mysterious fascination of caves in hill-
sides and cliffs.

There is a right physical size for every idea.

Pieces of good stone have stood about my studio for long periods,
because though I've had ideas which would fit their proportions and
materials perfectly, their size was wrong.

There is a size to scale not to do with its actual physical size, its
measurement in feet and inches—but connected with vision.

A carving might be several times over life size and yet be petty and
small in feeling—and a small carving only a few inches in height can
give the feeling of huge size and monumental grandeur, because the
vision behind it is big. Example, Michelangelo's drawings or a
Masaccio madonna—and the Albert Memorial.

Yet actual physical size has an emotional meaning. We relate every-
thing to our own size, and our emotional response to size is controlled
by the fact that men on the average are between five and six feet high.

An exact model, to one-tenth scale, of Stonehenge, where the stones
would be less than us, would lose all its impressiveness.

Sculpture is more affected by actual size considerations than paint-
ing. A painting is isolated by a frame from its surroundings (unless it
serves just a decorative purpose) and so retains more easily its own
imaginary scale.

If practical considerations allowed me, cost of material, of trans-
port, etc., I should like to work on large carvings more often than I
do. The average in-between size does not disconnect an idea enough
from prosaic everyday life. The very small or the very big takes on an
added size emotion.

Recently I have been working in the country, where, carving in the
open air, I find sculpture more natural than in a London studio, but it
needs bigger dimensions. A large piece of stone or wood placed almost
anywhere at random in a field, orchard, or garden, immediately looks
right and inspiring.

My drawings are done mainly as a help toward making sculpture—
as a means of generating ideas for sculpture, tapping oneself for the
initial idea; and as a way of sorting out ideas and developing them.

Also, sculpture compared with drawing is a slow means of expres-
sion, and I find drawing a useful outlet for ideas which there is not
time enough to realize as sculpture. And I use drawing as a method of

study and observation of natural forms (drawings from life, drawings of bones, shells, etc.).

And I sometimes draw just for its own enjoyment.

Experience though has taught me that the difference there is between drawing and sculpture should not be forgotten. A sculptural idea which may be satisfactory as a drawing always needs some alteration when translated into sculpture.

At one time, whenever I made drawings for sculpture I tried to give them as much the illusion of real sculpture as I could—that is, I drew by the method of illusion, of light falling on a solid object. But I now find that carrying a drawing so far that it becomes a substitute for the sculpture either weakens the desire to do the sculpture, or is likely to make the sculpture only a dead realization of the drawing.

I now leave a wider latitude in the interpretation of the drawings I make for sculpture, and draw often in line and flat tones without the light and shade illusion of three dimensions; but this does not mean that the vision behind the drawing is only two-dimensional.

The violent quarrel between the abstractionists and the Surrealists seems to me quite unnecessary. All good art has contained both abstract and Surrealist elements, just as it has contained both classical and romantic elements—order and surprise, intellect and imagination, conscious and unconscious. Both sides of the artist's personality must play their part. And I think the first inception of a painting or a sculpture may begin from either end. As far as my own experience is concerned, I sometimes begin a drawing with no preconceived problem to solve, with only the desire to use pencil on paper, and make lines, tones, and shapes with no conscious aim; but as my mind takes in what is so produced, a point arrives where some idea becomes conscious and crystallizes, and then a control and ordering begin to take place.

Or sometimes I start with a set subject; or to solve, in a block of stone of known dimensions, a sculptural problem I've given myself, and then consciously attempt to build an ordered relationship of forms, which shall express my idea. But if the work is to be more than just a sculptural exercise, unexplainable jumps in the process of thought occur; and the imagination plays its part.

It might seem from what I have said of shape and form that I regard them as ends in themselves. Far from it. I am very much aware that associational, psychological factors play a large part in sculpture. The meaning and significance of form itself probably depends on the countless associations of man's history. For example, rounded forms convey an idea of fruitfulness, maturity, probably because the earth, women's breasts, and most fruits are rounded, and these shapes are important because they have this background in our habits of perception. I think the humanist organic element will always be for me of

fundamental importance in sculpture, giving sculpture its vitality.
Each particular carving I make takes on in my mind a human, or occa-
sionally animal, character and personality, and this personality con-
trols its design and formal qualities, and makes me satisfied or dissat-
isfied with the work as it develops.

My own aim and direction seems to be consistent with these beliefs,
though it does not depend upon them. My sculpture is becoming less
representational, less an outward visual copy, and so what some
people would call more abstract; but only because I believe that in this
way I can present the human psychological content of my work with
the greatest directness and intensity.

Primitive Art

The term *Primitive Art* is generally used to include the products of a great variety of races and periods in history, many different social and religious systems. In its widest sense it seems to cover most of those cultures which are outside European and the great Oriental civilizations. This is the sense in which I shall use it here, though I do not much like the application of the word "primitive" to art, since, through its associations, it suggests to many people an idea of crudeness and incompetence, ignorant gropings rather than finished achievements. Primitive art means far more than that; it makes a straightforward statement, its primary concern is with the elemental, and its simplicity comes from direct and strong feelings, which is a very different thing from that fashionable simplicity-for-its-own-sake which is emptiness. Like beauty, true simplicity is an unselfconscious virtue; it comes by the way and can never be an end in itself.

The most striking quality common to all primitive art is its intense vitality. It is something made by people with a direct and immediate response to life. Sculpture and painting for them was not an activity of calculation or academism, but a channel for expressing powerful beliefs, hopes, and fears. It is art before it got smothered in trimmings and surface decorations, before inspiration had flagged into technical tricks and intellectual conceits. But apart from its own enduring value, a knowledge of it conditions a fuller and truer appreciation of the later developments of the so-called great periods, and shows art to be a universal continuous activity with no separation between past and present.

All art has its roots in the "primitive," or else it becomes decadent, which explains why the "great" periods, Pericles' Greece and the Renaissance for example, flower and follow quickly on primitive periods, and then slowly fade out. The fundamental sculptural principles of the Archaic Greeks were near enough to Phidias's day to carry through into his carvings a true quality, although his conscious aim was so naturalistic; and the tradition of early Italian art was sufficiently in the blood of Masaccio for him to strive for realism and yet retain a primitive grandeur and simplicity. The steadily growing appreciation of primitive art among artists and the public today is therefore a very hopeful and important sign.

Excepting some collections of primitive art in France, Italy, and Spain, my own knowledge of it has come entirely from continual visits to the British Museum during the past twenty years. Now that the Museum has been closed [during World War II], one realizes all the more clearly what one has temporarily lost—the richness and comprehensiveness of its collection of past art, particularly of primitive

sculpture, and perhaps by taking a memory-journey through a few of the Museum's galleries I can explain what I believe to be the great significance of primitive periods.

At first my visits were mainly and naturally to the Egyptian galleries, for the monumental impressiveness of Egyptian sculpture was nearest to the familiar Greek and Renaissance ideals one had been born to. After a time, however, the appeal of these galleries lessened; excepting the earlier dynasties. I felt that much of Egyptian sculpture was too stylized and hieratic, with a tendency in its later periods to academic obviousness and a rather stupid love of the colossal.

The galleries running alongside the Egyptian contained the Assyrian reliefs—journalistic commentaries and records of royal lion hunts and battles, but beyond was the Archaic Greek room with its life-size female figures, seated in easy, still naturalness, grand and full like Handel's music; and then near them, downstairs in the badly lit basement, were the magnificent Etruscan Sarcophagus figures—which, when the Museum reopens, should certainly be better shown.

At the end of the upstairs Egyptian galleries were the Sumerian sculptures, some with a contained bull-like grandeur and held-in energy, very different from the liveliness of much of the early Greek and Etruscan art in the terracotta and vase rooms. In the prehistoric and Stone Age room an iron staircase led to gallery wall-cases where there were originals and casts of Paleolithic sculptures made 20,000 years ago—a lovely tender carving of a girl's head, no bigger than one's thumbnail, and beside it female figures of very human but not copyist realism with a full richness of form, in great contrast with the more symbolic two-dimensional and inventive designs of Neolithic art.

And eventually to the Ethnographical room, which contained an inexhaustible wealth and variety of sculptural achievement (Negro, Oceanic Islands, and North and South America), but overcrowded and jumbled together like junk in a marine store, so that after hundreds of visits I would still find carvings I had not discovered there before. Negro art formed one of the largest sections of the room. Except for the Benin bronzes it was mostly woodcarving. One of the first principles of art so clearly seen in primitive work is truth to material; the artist shows an instinctive understanding of his material, its right use and possibilities. Wood has a stringy fibrous consistency and can be carved into thin forms without breaking, and the Negro sculptor was able to free arms from the body, to have a space between the legs, and to give his figures long necks when he wished. This completer realization of the component parts of the figure gives to Negro carving a more three-dimensional quality than many primitive periods where stone is the main material used. For the Negro, as for other primitive peoples, sex and religion were the two main interacting springs of life. Much Negro carving, like modern Negro spirituals but without their sentimentality, has pathos, a static patience and

resignation to unknown mysterious powers; it is religious and, in movement, upward and vertical like the tree it was made from, but in its heavy bent legs is rooted in the earth.

Of works from the Americas, Mexican art was exceptionally well represented in the Museum. Mexican sculpture, as soon as I found it, seemed to me true and right, perhaps because I at once hit on similarities in it with some eleventh-century carvings I had seen as a boy on Yorkshire churches. Its "stoniness," by which I mean its truth to material, its tremendous power without loss of sensitiveness, its astonishing variety and fertility of form-invention, and its approach to a full three-dimensional conception of form, make it unsurpassed in my opinion by any other period of stone sculpture.

The many islands of the Oceanic groups all produced their schools of sculpture with big differences in form-vision. New Guinea carvings, with drawn out spider-like extensions and bird-beak elongations, made a direct contrast with the featureless heads and plain surfaces of the Nukuoro carvings; or the stolid stone figures of the Marquesas Islands against the emasculated ribbed wooden figures of Easter Island. Comparing Oceanic art generally with Negro art, it has a livelier thin flicker, but much of it is more two-dimensional and concerned with pattern making. Yet the carvings of New Ireland have, besides their vicious kind of vitality, a unique spatial sense, a bird-in-a-cage form.

But underlying these individual characteristics, these featural peculiarities in the primitive schools, a common world-language of form is apparent in them all; through the working of instinctive sculptural sensibility, the same shapes and form relationships are used to express similar ideas at widely different places and periods in history, so that the same form-vision may be seen in a Negro and a Viking carving, a Cycladic stone figure and a Nukuoro wooden statuette. And on further familiarity with the British Museum's whole collection it eventually became clear to me that the realistic ideal of physical beauty in art which sprang from fifth-century Greece was only a digression from the main world tradition of sculpture, whilst, for instance, our own equally European Romanesque and Early Gothic are in the main line.

Primitive art is a mine of information for the historian and the anthropologist, but to understand and appreciate it, it is more important to look at it than to learn the history of primitive peoples, their religions and social customs. Some such knowledge may be useful and help us to look more sympathetically, and the interesting tidbits of information on the labels attached to the carving in the Museum can serve a useful purpose by giving the mind a needful rest from the concentration of intense looking. But all that is really needed is response to the carvings themselves, which have a constant life of their own, independent of whenever and however they came to be made, and they remain as full of sculptural meaning today to those open and sensitive enough to perceive it as on the day they were finished.

For Further Reading

A brief selection favoring English-language publications
that deal with the artists' writings.

Gleizes and Metzinger

William Camfield and Daniel Robbins. *Albert Gleizes and the Section d'Or* (ex. cat.). New York, 1964.

Daniel Robbins. *Albert Gleizes 1881–1953* (ex. cat.). Paris, 1964–65.

Joann Moser and Daniel Robbins. *Jean Metzinger in Retrospect* (ex. cat.). Iowa City, 1985.

Michel Massenet. *Albert Gleizes 1881–1953*. Paris, 1998.

Kandinsky

Hans Konrad Roethel and Jean K. Benjamin. *Kandinsky*. Oxford, 1979.

Rose-Carol Washton Long. *Kandinsky, The Development of an Abstract Style*. New York, 1980.

Peg Weiss. *Kandinsky in Munich, the Formative Years*. Princeton, N.J., 1979.

Boccioni

Marianne W. Martin. *Futurist Art and Theory 1909–1915*. Oxford, 1968.

Ester Coen. *Umberto Boccioni* (ex. cat.). New York, 1988.

Le Corbusier and Ozenfant

Susan Ball. *Ozenfant and Purism: The Evolution of a Style 1915–1930*. Ann Arbor, Mich., 1981.

Kenneth E. Silver. *Esprit de Corps: The Art of the Parisian Avant-Garde and the First World War, 1914–1925*. Princeton, N.J., 1989.

Schwitters

Rex William Last. *German Dadaist Literature: Kurt Schwitters, Hugo Ball, Hans Arp*. New York, 1973.

Dorothea Dietrich. *The Collages of Kurt Schwitters: Tradition and Innovation*. New York, 1993.

Gwendolyn Webster. *Kurt Merz Schwitters: A Biographical Study*. Cardiff, Wales, 1997.

Lissitzky

Sophie Lissitzky-Küppers. *El Lissitzky: Life, Letters, Texts.* Greenwich, Conn., 1968.

Peter Nisbet. *El Lissitzky 1890–1941* (ex. cat.). Cambridge, Mass., 1987.

Henk Puts, ed. *El Lissitzky 1890–1941: Architect, Painter, Photographer, Typographer* (ex. cat.). New York, 1990.

Léger

Christopher Green. *Léger and the Avant-Garde.* New Haven and London, 1976.

Matthew Affron. "Fernand Léger and the Spectacle of Objects." Yale University Ph.D. dissertation, 1994.

Dorothy Kosinski et al. *Fernand Léger 1911–1924, The Rhythm of Modern Life* (ex. cat.). Munich and New York, 1994.

Carolyn Lanchner et al. *Fernand Léger* (ex. cat.). New York, 1998.

Klee

Christian Geelhaar. *Paul Klee and the Bauhaus.* Greenwich, Conn., 1973.

Marcel Franciscono. *Paul Klee: His Work and Thought.* Chicago, 1991.

Mark Roskill. *Klee, Kandinsky, and the Thought of Their Time: A Critical Perspective.* Urbana, Ill., 1992.

Malevich

Alison Hilton. *Kazimir Malevich.* New York, 1992.

Charlotte Douglas. *Kazimir Malevich.* New York, 1994.

John Milner. *Kazimir Malevich and the Art of Geometry.* New Haven and London, 1996.

Ernst

Robert Rainwater, ed. *Max Ernst: Beyond Surrealism, a Retrospective of the Artist's Books and Prints* (ex. cat.). New York, 1986.

Werner Spies, ed. *Max Ernst: A Retrospective* (ex. cat.). London, 1991.

Werner Spies. *Max Ernst Collages: The Invention of the Surrealist Universe.* New York, 1991.

Gabo

Herbert Read and Leslie Martin. *Gabo: Constructions, Sculpture, Paintings, Drawings, Engravings.* Cambridge, Mass., 1957.

Steven A. Nash and Jorn Merkert, eds. *Naum Gabo: Sixty Years of Constructivism* (ex. cat.). Munich and New York, 1985.

Martin Hanmer and Christina Ladder. *Constructing Modernity, The Art and Career of Naum Gabo*. New Haven, Conn., and London, 2000.

Mondrian

John Milner. *Mondrian*. New York, 1992.

Yves-Alain Bois et al. *Piet Mondrian 1872–1944* (ex. cat.). The Hague, The Netherlands, and Washington, D.C., 1995–96.

Joop Joosten and Robert P. Welsh. *Piet Mondrian: Catalogue Raisonné*. New York, 3 vols. in 2, 1998.

Beckmann

Hans Martin. *Blick auf Beckmann, Dokumente und Vortrage*. Munich, 1962.

Matthew Drutt et al. *Max Beckmann in Exile* (ex. cat.). New York, 1996.

Moore

Herbert Read, David Sylvester, and Alan Bowness. *Henry Moore: Sculpture and Drawings*. London, 3 vols., 1944–65.

Philip James, ed. *Henry Moore on Sculpture: A Collection of the Sculptor's Writings and Spoken Words*. London, 1966.

Roger Berthoud. *The Life of Henry Moore*. New York, 1987.

A CATALOG OF SELECTED
DOVER BOOKS
IN ALL FIELDS OF INTEREST

A CATALOG OF SELECTED DOVER
BOOKS IN ALL FIELDS OF INTEREST

CONCERNING THE SPIRITUAL IN ART, Wassily Kandinsky. Pioneering work by father of abstract art. Thoughts on color theory, nature of art. Analysis of earlier masters. 12 illustrations. 80pp. of text. 5⅜ x 8½. 23411-8

ANIMALS: 1,419 Copyright-Free Illustrations of Mammals, Birds, Fish, Insects, etc., Jim Harter (ed.). Clear wood engravings present, in extremely lifelike poses, over 1,000 species of animals. One of the most extensive pictorial sourcebooks of its kind. Captions. Index. 284pp. 9 x 12. 23766-4

CELTIC ART: The Methods of Construction, George Bain. Simple geometric techniques for making Celtic interlacements, spirals, Kells-type initials, animals, humans, etc. Over 500 illustrations. 160pp. 9 x 12. (Available in U.S. only.) 22923-8

AN ATLAS OF ANATOMY FOR ARTISTS, Fritz Schider. Most thorough reference work on art anatomy in the world. Hundreds of illustrations, including selections from works by Vesalius, Leonardo, Goya, Ingres, Michelangelo, others. 593 illustrations. 192pp. 7⅛ x 10¼. 20241-0

CELTIC HAND STROKE-BY-STROKE (Irish Half-Uncial from "The Book of Kells"): An Arthur Baker Calligraphy Manual, Arthur Baker. Complete guide to creating each letter of the alphabet in distinctive Celtic manner. Covers hand position, strokes, pens, inks, paper, more. Illustrated. 48pp. 8¼ x 11. 24336-2

EASY ORIGAMI, John Montroll. Charming collection of 32 projects (hat, cup, pelican, piano, swan, many more) specially designed for the novice origami hobbyist. Clearly illustrated easy-to-follow instructions insure that even beginning papercrafters will achieve successful results. 48pp. 8¼ x 11. 27298-2

THE COMPLETE BOOK OF BIRDHOUSE CONSTRUCTION FOR WOODWORKERS, Scott D. Campbell. Detailed instructions, illustrations, tables. Also data on bird habitat and instinct patterns. Bibliography. 3 tables. 63 illustrations in 15 figures. 48pp. 5¼ x 8½. 24407-5

BLOOMINGDALE'S ILLUSTRATED 1886 CATALOG: Fashions, Dry Goods and Housewares, Bloomingdale Brothers. Famed merchants' extremely rare catalog depicting about 1,700 products: clothing, housewares, firearms, dry goods, jewelry, more. Invaluable for dating, identifying vintage items. Also, copyright-free graphics for artists, designers. Co-published with Henry Ford Museum & Greenfield Village. 160pp. 8¼ x 11. 25780-0

HISTORIC COSTUME IN PICTURES, Braun & Schneider. Over 1,450 costumed figures in clearly detailed engravings–from dawn of civilization to end of 19th century. Captions. Many folk costumes. 256pp. 8⅜ x 11¾. 23150-X

CATALOG OF DOVER BOOKS

STICKLEY CRAFTSMAN FURNITURE CATALOGS, Gustav Stickley and L. & J. G. Stickley. Beautiful, functional furniture in two authentic catalogs from 1910. 594 illustrations, including 277 photos, show settles, rockers, armchairs, reclining chairs, bookcases, desks, tables. 183pp. 6½ x 9¼.
23838-5

AMERICAN LOCOMOTIVES IN HISTORIC PHOTOGRAPHS: 1858 to 1949, Ron Ziel (ed.). A rare collection of 126 meticulously detailed official photographs, called "builder portraits," of American locomotives that majestically chronicle the rise of steam locomotive power in America. Introduction. Detailed captions. xi+ 129pp. 9 x 12.
27393-8

AMERICA'S LIGHTHOUSES: An Illustrated History, Francis Ross Holland, Jr. Delightfully written, profusely illustrated fact-filled survey of over 200 American light-houses since 1716. History, anecdotes, technological advances, more. 240pp. 8 x 10⅞.
25576-X

TOWARDS A NEW ARCHITECTURE, Le Corbusier. Pioneering manifesto by founder of "International School." Technical and aesthetic theories, views of industry, eco-nomics, relation of form to function, "mass-production split" and much more. Profusely illustrated. 320pp. 6⅛ x 9¼. (Available in U.S. only.)
25023-7

HOW THE OTHER HALF LIVES, Jacob Riis. Famous journalistic record, expos-ing poverty and degradation of New York slums around 1900, by major social reformer. 100 striking and influential photographs. 233pp. 10 x 7⅞.
22012-5

FRUIT KEY AND TWIG KEY TO TREES AND SHRUBS, William M. Harlow. One of the handiest and most widely used identification aids. Fruit key covers 120 deciduous and evergreen species; twig key 160 deciduous species. Easily used. Over 300 photographs. 126pp. 5⅜ x 8½.
20511-8

COMMON BIRD SONGS, Dr. Donald J. Borror. Songs of 60 most common U.S. birds: robins, sparrows, cardinals, bluejays, finches, more–arranged in order of increasing complexity. Up to 9 variations of songs of each species.
Cassette and manual 99911-4

ORCHIDS AS HOUSE PLANTS, Rebecca Tyson Northen. Grow cattleyas and many other kinds of orchids–in a window, in a case, or under artificial light. 63 illus-trations. 148pp. 5⅜ x 8½.
23261-1

MONSTER MAZES, Dave Phillips. Masterful mazes at four levels of difficulty. Avoid deadly perils and evil creatures to find magical treasures. Solutions for all 32 exciting illustrated puzzles. 48pp. 8¼ x 11.
26005-4

MOZART'S DON GIOVANNI (DOVER OPERA LIBRETTO SERIES), Wolfgang Amadeus Mozart. Introduced and translated by Ellen H. Bleiler. Standard Italian libretto, with complete English translation. Convenient and thoroughly portable–an ideal companion for reading along with a recording or the performance itself. Introduction. List of characters. Plot summary. 121pp. 5¼ x 8½. 24944-1

TECHNICAL MANUAL AND DICTIONARY OF CLASSICAL BALLET, Gail Grant. Defines, explains, comments on steps, movements, poses and concepts. 15-page pictorial section. Basic book for student, viewer. 127pp. 5⅜ x 8½. 21843-0

CATALOG OF DOVER BOOKS

THE CLARINET AND CLARINET PLAYING, David Pino. Lively, comprehensive work features suggestions about technique, musicianship, and musical interpretation, as well as guidelines for teaching, making your own reeds, and preparing for public performance. Includes an intriguing look at clarinet history. "A godsend," *The Clarinet,* Journal of the International Clarinet Society. Appendixes. 7 illus. 320pp. 5⅜ x 8½. 40270-3

HOLLYWOOD GLAMOR PORTRAITS, John Kobal (ed.). 145 photos from 1926-49. Harlow, Gable, Bogart, Bacall; 94 stars in all. Full background on photographers, technical aspects. 160pp. 8⅜ x 11¼. 23352-9

THE ANNOTATED CASEY AT THE BAT: A Collection of Ballads about the Mighty Casey/Third, Revised Edition, Martin Gardner (ed.). Amusing sequels and parodies of one of America's best-loved poems: Casey's Revenge, Why Casey Whiffed, Casey's Sister at the Bat, others. 256pp. 5⅜ x 8½. 28598-7

THE RAVEN AND OTHER FAVORITE POEMS, Edgar Allan Poe. Over 40 of the author's most memorable poems: "The Bells," "Ulalume," "Israfel," "To Helen," "The Conqueror Worm," "Eldorado," "Annabel Lee," many more. Alphabetic lists of titles and first lines. 64pp. 5‰ x 8¼. 26685-0

PERSONAL MEMOIRS OF U. S. GRANT, Ulysses Simpson Grant. Intelligent, deeply moving firsthand account of Civil War campaigns, considered by many the finest military memoirs ever written. Includes letters, historic photographs, maps and more. 528pp. 6⅛ x 9¼. 28587-1

ANCIENT EGYPTIAN MATERIALS AND INDUSTRIES, A. Lucas and J. Harris. Fascinating, comprehensive, thoroughly documented text describes this ancient civilization's vast resources and the processes that incorporated them in daily life, including the use of animal products, building materials, cosmetics, perfumes and incense, fibers, glazed ware, glass and its manufacture, materials used in the mummification process, and much more. 544pp. 6⅛ x 9¼. (Available in U.S. only.) 40446-3

RUSSIAN STORIES/RUSSKIE RASSKAZY: A Dual-Language Book, edited by Gleb Struve. Twelve tales by such masters as Chekhov, Tolstoy, Dostoevsky, Pushkin, others. Excellent word-for-word English translations on facing pages, plus teaching and study aids, Russian/English vocabulary, biographical/critical introductions, more. 416pp. 5⅜ x 8½. 26244-8

PHILADELPHIA THEN AND NOW: 60 Sites Photographed in the Past and Present, Kenneth Finkel and Susan Oyama. Rare photographs of City Hall, Logan Square, Independence Hall, Betsy Ross House, other landmarks juxtaposed with contemporary views. Captures changing face of historic city. Introduction. Captions. 128pp. 8¼ x 11. 25790-8

AIA ARCHITECTURAL GUIDE TO NASSAU AND SUFFOLK COUNTIES, LONG ISLAND, The American Institute of Architects, Long Island Chapter, and the Society for the Preservation of Long Island Antiquities. Comprehensive, well-researched and generously illustrated volume brings to life over three centuries of Long Island's great architectural heritage. More than 240 photographs with authoritative, extensively detailed captions. 176pp. 8¼ x 11. 26946-9

NORTH AMERICAN INDIAN LIFE: Customs and Traditions of 23 Tribes, Elsie Clews Parsons (ed.). 27 fictionalized essays by noted anthropologists examine religion, customs, government, additional facets of life among the Winnebago, Crow, Zuni, Eskimo, other tribes. 480pp. 6⅛ x 9¼. 27377-6

CATALOG OF DOVER BOOKS

FRANK LLOYD WRIGHT'S DANA HOUSE, Donald Hoffmann. Pictorial essay of residential masterpiece with over 160 interior and exterior photos, plans, elevations, sketches and studies. 128pp. 9¼ x 10¾. 29120-0

THE MALE AND FEMALE FIGURE IN MOTION: 60 Classic Photographic Sequences, Eadweard Muybridge. 60 true-action photographs of men and women walking, running, climbing, bending, turning, etc., reproduced from rare 19th-century masterpiece. vi + 121pp. 9 x 12. 24745-7

1001 QUESTIONS ANSWERED ABOUT THE SEASHORE, N. J. Berrill and Jacquelyn Berrill. Queries answered about dolphins, sea snails, sponges, starfish, fishes, shore birds, many others. Covers appearance, breeding, growth, feeding, much more. 305pp. 5¼ x 8¼. 23366-9

ATTRACTING BIRDS TO YOUR YARD, William J. Weber. Easy-to-follow guide offers advice on how to attract the greatest diversity of birds: birdhouses, feeders, water and waterers, much more. 96pp. 5³⁄₁₆ x 8¼. 28927-3

MEDICINAL AND OTHER USES OF NORTH AMERICAN PLANTS: A Historical Survey with Special Reference to the Eastern Indian Tribes, Charlotte Erichsen-Brown. Chronological historical citations document 500 years of usage of plants, trees, shrubs native to eastern Canada, northeastern U.S. Also complete identifying information. 343 illustrations. 544pp. 6½ x 9¼. 25951-X

STORYBOOK MAZES, Dave Phillips. 23 stories and mazes on two-page spreads: Wizard of Oz, Treasure Island, Robin Hood, etc. Solutions. 64pp. 8¼ x 11. 23628-5

AMERICAN NEGRO SONGS: 230 Folk Songs and Spirituals, Religious and Secular, John W. Work. This authoritative study traces the African influences of songs sung and played by black Americans at work, in church, and as entertainment. The author discusses the lyric significance of such songs as "Swing Low, Sweet Chariot," "John Henry," and others and offers the words and music for 230 songs. Bibliography. Index of Song Titles. 272pp. 6½ x 9¼. 40271-1

MOVIE-STAR PORTRAITS OF THE FORTIES, John Kobal (ed.). 163 glamor, studio photos of 106 stars of the 1940s: Rita Hayworth, Ava Gardner, Marlon Brando, Clark Gable, many more. 176pp. 8⅜ x 11¼. 23546-7

BENCHLEY LOST AND FOUND, Robert Benchley. Finest humor from early 30s, about pet peeves, child psychologists, post office and others. Mostly unavailable elsewhere. 73 illustrations by Peter Arno and others. 183pp. 5⅜ x 8½. 22410-4

YEKL and THE IMPORTED BRIDEGROOM AND OTHER STORIES OF YIDDISH NEW YORK, Abraham Cahan. Film Hester Street based on *Yekl* (1896). Novel, other stories among first about Jewish immigrants on N.Y.'s East Side. 240pp. 5⅜ x 8½. 22427-9

SELECTED POEMS, Walt Whitman. Generous sampling from *Leaves of Grass*. Twenty-four poems include "I Hear America Singing," "Song of the Open Road," "I Sing the Body Electric," "When Lilacs Last in the Dooryard Bloom'd," "O Captain! My Captain!"—all reprinted from an authoritative edition. Lists of titles and first lines. 128pp. 5³⁄₁₆ x 8¼. 26878-0

CATALOG OF DOVER BOOKS

THE BEST TALES OF HOFFMANN, E. T. A. Hoffmann. 10 of Hoffmann's most important stories: "Nutcracker and the King of Mice," "The Golden Flowerpot," etc. 458pp. 5⅜ x 8½. 21793-0

FROM FETISH TO GOD IN ANCIENT EGYPT, E. A. Wallis Budge. Rich detailed survey of Egyptian conception of "God" and gods, magic, cult of animals, Osiris, more. Also, superb English translations of hymns and legends. 240 illustrations. 545pp. 5⅜ x 8½. 25803-3

FRENCH STORIES/CONTES FRANÇAIS: A Dual-Language Book, Wallace Fowlie. Ten stories by French masters, Voltaire to Camus: "Micromegas" by Voltaire; "The Atheist's Mass" by Balzac; "Minuet" by de Maupassant; "The Guest" by Camus, six more. Excellent English translations on facing pages. Also French-English vocabulary list, exercises, more. 352pp. 5⅜ x 8½. 26443-2

CHICAGO AT THE TURN OF THE CENTURY IN PHOTOGRAPHS: 122 Historic Views from the Collections of the Chicago Historical Society, Larry A. Viskochil. Rare large-format prints offer detailed views of City Hall, State Street, the Loop, Hull House, Union Station, many other landmarks, circa 1904-1913. Introduction. Captions. Maps. 144pp. 9⅜ x 12¼. 24656-6

OLD BROOKLYN IN EARLY PHOTOGRAPHS, 1865-1929, William Lee Younger. Luna Park, Gravesend race track, construction of Grand Army Plaza, moving of Hotel Brighton, etc. 157 previously unpublished photographs. 165pp. 8⅞ x 11¾.
 23587-4

THE MYTHS OF THE NORTH AMERICAN INDIANS, Lewis Spence. Rich anthology of the myths and legends of the Algonquins, Iroquois, Pawnees and Sioux, prefaced by an extensive historical and ethnological commentary. 36 illustrations. 480pp. 5⅜ x 8½. 25967-6

AN ENCYCLOPEDIA OF BATTLES: Accounts of Over 1,560 Battles from 1479 B.C. to the Present, David Eggenberger. Essential details of every major battle in recorded history from the first battle of Megiddo in 1479 B.C. to Grenada in 1984. List of Battle Maps. New Appendix covering the years 1967-1984. Index. 99 illustrations. 544pp. 6½ x 9¼. 24913-1

SAILING ALONE AROUND THE WORLD, Captain Joshua Slocum. First man to sail around the world, alone, in small boat. One of great feats of seamanship told in delightful manner. 67 illustrations. 294pp. 5⅜ x 8½. 20326-3

ANARCHISM AND OTHER ESSAYS, Emma Goldman. Powerful, penetrating, prophetic essays on direct action, role of minorities, prison reform, puritan hypocrisy, violence, etc. 271pp. 5⅜ x 8½. 22484-8

MYTHS OF THE HINDUS AND BUDDHISTS, Ananda K. Coomaraswamy and Sister Nivedita. Great stories of the epics; deeds of Krishna, Shiva, taken from puranas, Vedas, folk tales; etc. 32 illustrations. 400pp. 5⅜ x 8½. 21759-0

THE TRAUMA OF BIRTH, Otto Rank. Rank's controversial thesis that anxiety neurosis is caused by profound psychological trauma which occurs at birth. 256pp. 5⅜ x 8½. 27974-X

A THEOLOGICO-POLITICAL TREATISE, Benedict Spinoza. Also contains unfinished Political Treatise. Great classic on religious liberty, theory of government on common consent. R. Elwes translation. Total of 421pp. 5⅜ x 8½. 20249-6

CATALOG OF DOVER BOOKS

MY BONDAGE AND MY FREEDOM, Frederick Douglass. Born a slave, Douglass became outspoken force in antislavery movement. The best of Douglass' autobiographies. Graphic description of slave life. 464pp. 5⅜ x 8½. 22457-0

FOLLOWING THE EQUATOR: A Journey Around the World, Mark Twain. Fascinating humorous account of 1897 voyage to Hawaii, Australia, India, New Zealand, etc. Ironic, bemused reports on peoples, customs, climate, flora and fauna, politics, much more. 197 illustrations. 720pp. 5⅜ x 8½. 26113-1

THE PEOPLE CALLED SHAKERS, Edward D. Andrews. Definitive study of Shakers: origins, beliefs, practices, dances, social organization, furniture and crafts, etc. 33 illustrations. 351pp. 5⅜ x 8½. 21081-2

THE MYTHS OF GREECE AND ROME, H. A. Guerber. A classic of mythology, generously illustrated, long prized for its simple, graphic, accurate retelling of the principal myths of Greece and Rome, and for its commentary on their origins and significance. With 64 illustrations by Michelangelo, Raphael, Titian, Rubens, Canova, Bernini and others. 480pp. 5⅜ x 8½. 27584-1

PSYCHOLOGY OF MUSIC, Carl E. Seashore. Classic work discusses music as a medium from psychological viewpoint. Clear treatment of physical acoustics, auditory apparatus, sound perception, development of musical skills, nature of musical feeling, host of other topics. 88 figures. 408pp. 5⅜ x 8½. 21851-1

THE PHILOSOPHY OF HISTORY, Georg W. Hegel. Great classic of Western thought develops concept that history is not chance but rational process, the evolution of freedom. 457pp. 5⅜ x 8½. 20112-0

THE BOOK OF TEA, Kakuzo Okakura. Minor classic of the Orient: entertaining, charming explanation, interpretation of traditional Japanese culture in terms of tea ceremony. 94pp. 5⅜ x 8½. 20070-1

LIFE IN ANCIENT EGYPT, Adolf Erman. Fullest, most thorough, detailed older account with much not in more recent books, domestic life, religion, magic, medicine, commerce, much more. Many illustrations reproduce tomb paintings, carvings, hieroglyphs, etc. 597pp. 5⅜ x 8½. 22632-8

SUNDIALS, Their Theory and Construction, Albert Waugh. Far and away the best, most thorough coverage of ideas, mathematics concerned, types, construction, adjusting anywhere. Simple, nontechnical treatment allows even children to build several of these dials. Over 100 illustrations. 230pp. 5⅜ x 8½. 22947-5

THEORETICAL HYDRODYNAMICS, L. M. Milne-Thomson. Classic exposition of the mathematical theory of fluid motion, applicable to both hydrodynamics and aerodynamics. Over 600 exercises. 768pp. 6⅛ x 9¼. 68970-0

SONGS OF EXPERIENCE: Facsimile Reproduction with 26 Plates in Full Color, William Blake. 26 full-color plates from a rare 1826 edition. Includes "The Tyger," "London," "Holy Thursday," and other poems. Printed text of poems. 48pp. 5¼ x 7. 24636-1

OLD-TIME VIGNETTES IN FULL COLOR, Carol Belanger Grafton (ed.). Over 390 charming, often sentimental illustrations, selected from archives of Victorian graphics—pretty women posing, children playing, food, flowers, kittens and puppies, smiling cherubs, birds and butterflies, much more. All copyright-free. 48pp. 9¼ x 12¼. 27269-9

CATALOG OF DOVER BOOKS

PERSPECTIVE FOR ARTISTS, Rex Vicat Cole. Depth, perspective of sky and sea, shadows, much more, not usually covered. 391 diagrams, 81 reproductions of drawings and paintings. 279pp. 5⅜ x 8½. 22487-2

DRAWING THE LIVING FIGURE, Joseph Sheppard. Innovative approach to artistic anatomy focuses on specifics of surface anatomy, rather than muscles and bones. Over 170 drawings of live models in front, back and side views, and in widely varying poses. Accompanying diagrams. 177 illustrations. Introduction. Index. 144pp. 8⅜ x11¼. 26723-7

GOTHIC AND OLD ENGLISH ALPHABETS: 100 Complete Fonts, Dan X. Solo. Add power, elegance to posters, signs, other graphics with 100 stunning copyright-free alphabets: Blackstone, Dolbey, Germania, 97 more–including many lower-case, numerals, punctuation marks. 104pp. 8¼ x 11. 24695-7

HOW TO DO BEADWORK, Mary White. Fundamental book on craft from simple projects to five-bead chains and woven works. 106 illustrations. 142pp. 5⅜ x 8. 20697-1

THE BOOK OF WOOD CARVING, Charles Marshall Sayers. Finest book for beginners discusses fundamentals and offers 34 designs. "Absolutely first rate . . . well thought out and well executed."–E. J. Tangerman. 118pp. 7¾ x 10⅝. 23654-4

ILLUSTRATED CATALOG OF CIVIL WAR MILITARY GOODS: Union Army Weapons, Insignia, Uniform Accessories, and Other Equipment, Schuyler, Hartley, and Graham. Rare, profusely illustrated 1846 catalog includes Union Army uniform and dress regulations, arms and ammunition, coats, insignia, flags, swords, rifles, etc. 226 illustrations. 160pp. 9 x 12. 24939-5

WOMEN'S FASHIONS OF THE EARLY 1900s: An Unabridged Republication of "New York Fashions, 1909," National Cloak & Suit Co. Rare catalog of mail-order fashions documents women's and children's clothing styles shortly after the turn of the century. Captions offer full descriptions, prices. Invaluable resource for fashion, costume historians. Approximately 725 illustrations. 128pp. 8⅜ x 11¼. 27276-1

THE 1912 AND 1915 GUSTAV STICKLEY FURNITURE CATALOGS, Gustav Stickley. With over 200 detailed illustrations and descriptions, these two catalogs are essential reading and reference materials and identification guides for Stickley furniture. Captions cite materials, dimensions and prices. 112pp. 6½ x 9¼. 26676-1

EARLY AMERICAN LOCOMOTIVES, John H. White, Jr. Finest locomotive engravings from early 19th century: historical (1804–74), main-line (after 1870), special, foreign, etc. 147 plates. 142pp. 11⅜ x 8¼. 22772-3

THE TALL SHIPS OF TODAY IN PHOTOGRAPHS, Frank O. Braynard. Lavishly illustrated tribute to nearly 100 majestic contemporary sailing vessels: Amerigo Vespucci, Clearwater, Constitution, Eagle, Mayflower, Sea Cloud, Victory, many more. Authoritative captions provide statistics, background on each ship. 190 black-and-white photographs and illustrations. Introduction. 128pp. 8¾ x 11¾. 27163-3

CATALOG OF DOVER BOOKS

LITTLE BOOK OF EARLY AMERICAN CRAFTS AND TRADES, Peter Stockham (ed.). 1807 children's book explains crafts and trades: baker, hatter, cooper, potter, and many others. 23 copperplate illustrations. 140pp. 4⅝ x 6. 23336-7

VICTORIAN FASHIONS AND COSTUMES FROM HARPER'S BAZAR, 1867–1898, Stella Blum (ed.). Day costumes, evening wear, sports clothes, shoes, hats, other accessories in over 1,000 detailed engravings. 320pp. 9⅜ x 12¼. 22990-4

GUSTAV STICKLEY, THE CRAFTSMAN, Mary Ann Smith. Superb study surveys broad scope of Stickley's achievement, especially in architecture. Design philosophy, rise and fall of the Craftsman empire, descriptions and floor plans for many Craftsman houses, more. 86 black-and-white halftones. 31 line illustrations. Introduction 208pp. 6½ x 9¼. 27210-9

THE LONG ISLAND RAIL ROAD IN EARLY PHOTOGRAPHS, Ron Ziel. Over 220 rare photos, informative text document origin (1844) and development of rail service on Long Island. Vintage views of early trains, locomotives, stations, passengers, crews, much more. Captions. 8⅞ x 11¾. 26301-0

VOYAGE OF THE LIBERDADE, Joshua Slocum. Great 19th-century mariner's thrilling, first-hand account of the wreck of his ship off South America, the 35-foot boat he built from the wreckage, and its remarkable voyage home. 128pp. 5⅜ x 8½.
40022-0

TEN BOOKS ON ARCHITECTURE, Vitruvius. The most important book ever written on architecture. Early Roman aesthetics, technology, classical orders, site selection, all other aspects. Morgan translation. 331pp. 5⅜ x 8½. 20645-9

THE HUMAN FIGURE IN MOTION, Eadweard Muybridge. More than 4,500 stopped-action photos, in action series, showing undraped men, women, children jumping, lying down, throwing, sitting, wrestling, carrying, etc. 390pp. 7⅞ x 10⅝.
20204-6 Clothbd.

TREES OF THE EASTERN AND CENTRAL UNITED STATES AND CANADA, William M. Harlow. Best one-volume guide to 140 trees. Full descriptions, woodlore, range, etc. Over 600 illustrations. Handy size. 288pp. 4½ x 6⅜. 20395-6

SONGS OF WESTERN BIRDS, Dr. Donald J. Borror. Complete song and call repertoire of 60 western species, including flycatchers, juncoes, cactus wrens, many more—includes fully illustrated booklet. Cassette and manual 99913-0

GROWING AND USING HERBS AND SPICES, Milo Miloradovich. Versatile handbook provides all the information needed for cultivation and use of all the herbs and spices available in North America. 4 illustrations. Index. Glossary. 236pp. 5⅜ x 8½.
25058-X

BIG BOOK OF MAZES AND LABYRINTHS, Walter Shepherd. 50 mazes and labyrinths in all—classical, solid, ripple, and more—in one great volume. Perfect inexpensive puzzler for clever youngsters. Full solutions. 112pp. 8⅛ x 11. 22951-3

PIANO TUNING, J. Cree Fischer. Clearest, best book for beginner, amateur. Simple repairs, raising dropped notes, tuning by easy method of flattened fifths. No previous skills needed. 4 illustrations. 201pp. 5⅜ x 8½. 23267-0

HINTS TO SINGERS, Lillian Nordica. Selecting the right teacher, developing confidence, overcoming stage fright, and many other important skills receive thoughtful discussion in this indispensible guide, written by a world-famous diva of four decades' experience. 96pp. 5⅜ x 8½. 40094-8

THE COMPLETE NONSENSE OF EDWARD LEAR, Edward Lear. All nonsense limericks, zany alphabets, Owl and Pussycat, songs, nonsense botany, etc., illustrated by Lear. Total of 320pp. 5⅜ x 8½. (Available in U.S. only.) 20167-8

VICTORIAN PARLOUR POETRY: An Annotated Anthology, Michael R. Turner. 117 gems by Longfellow, Tennyson, Browning, many lesser-known poets. "The Village Blacksmith," "Curfew Must Not Ring Tonight," "Only a Baby Small," dozens more, often difficult to find elsewhere. Index of poets, titles, first lines. xxiii + 325pp. 5⅜ x 8¼. 27044-0

DUBLINERS, James Joyce. Fifteen stories offer vivid, tightly focused observations of the lives of Dublin's poorer classes. At least one, "The Dead," is considered a masterpiece. Reprinted complete and unabridged from standard edition. 160pp. 5³⁄₁₆ x 8¼. 26870-5

GREAT WEIRD TALES: 14 Stories by Lovecraft, Blackwood, Machen and Others, S. T. Joshi (ed.). 14 spellbinding tales, including "The Sin Eater," by Fiona McLeod, "The Eye Above the Mantel," by Frank Belknap Long, as well as renowned works by R. H. Barlow, Lord Dunsany, Arthur Machen, W. C. Morrow and eight other masters of the genre. 256pp. 5⅜ x 8½. (Available in U.S. only.) 40436-6

THE BOOK OF THE SACRED MAGIC OF ABRAMELIN THE MAGE, translated by S. MacGregor Mathers. Medieval manuscript of ceremonial magic. Basic document in Aleister Crowley, Golden Dawn groups. 268pp. 5⅜ x 8½. 23211-5

NEW RUSSIAN-ENGLISH AND ENGLISH-RUSSIAN DICTIONARY, M. A. O'Brien. This is a remarkably handy Russian dictionary, containing a surprising amount of information, including over 70,000 entries. 366pp. 4½ x 6⅛. 20208-9

HISTORIC HOMES OF THE AMERICAN PRESIDENTS, Second, Revised Edition, Irvin Haas. A traveler's guide to American Presidential homes, most open to the public, depicting and describing homes occupied by every American President from George Washington to George Bush. With visiting hours, admission charges, travel routes. 175 photographs. Index. 160pp. 8¼ x 11. 26751-2

NEW YORK IN THE FORTIES, Andreas Feininger. 162 brilliant photographs by the well-known photographer, formerly with *Life* magazine. Commuters, shoppers, Times Square at night, much else from city at its peak. Captions by John von Hartz. 181pp. 9¼ x 10¾. 23585-8

INDIAN SIGN LANGUAGE, William Tomkins. Over 525 signs developed by Sioux and other tribes. Written instructions and diagrams. Also 290 pictographs. 111pp. 6⅛ x 9¼. 22029-X

CATALOG OF DOVER BOOKS

ANATOMY: A Complete Guide for Artists, Joseph Sheppard. A master of figure drawing shows artists how to render human anatomy convincingly. Over 460 illustrations. 224pp. 8⅜ x 11¼. 27279-6

MEDIEVAL CALLIGRAPHY: Its History and Technique, Marc Drogin. Spirited history, comprehensive instruction manual covers 13 styles (ca. 4th century through 15th). Excellent photographs; directions for duplicating medieval techniques with modern tools. 224pp. 8⅛ x 11¼. 26142-5

DRIED FLOWERS: How to Prepare Them, Sarah Whitlock and Martha Rankin. Complete instructions on how to use silica gel, meal and borax, perlite aggregate, sand and borax, glycerine and water to create attractive permanent flower arrangements. 12 illustrations. 32pp. 5⅜ x 8½. 21802-3

EASY-TO-MAKE BIRD FEEDERS FOR WOODWORKERS, Scott D. Campbell. Detailed, simple-to-use guide for designing, constructing, caring for and using feeders. Text, illustrations for 12 classic and contemporary designs. 96pp. 5⅜ x 8½. 25847-5

SCOTTISH WONDER TALES FROM MYTH AND LEGEND, Donald A. Mackenzie. 16 lively tales tell of giants rumbling down mountainsides, of a magic wand that turns stone pillars into warriors, of gods and goddesses, evil hags, powerful forces and more. 240pp. 5⅜ x 8½. 29677-6

THE HISTORY OF UNDERCLOTHES, C. Willett Cunnington and Phyllis Cunnington. Fascinating, well-documented survey covering six centuries of English undergarments, enhanced with over 100 illustrations: 12th-century laced-up bodice, footed long drawers (1795), 19th-century bustles, 19th-century corsets for men, Victorian "bust improvers," much more. 272pp. 5⅜ x 8¼. 27124-2

ARTS AND CRAFTS FURNITURE: The Complete Brooks Catalog of 1912, Brooks Manufacturing Co. Photos and detailed descriptions of more than 150 now very collectible furniture designs from the Arts and Crafts movement depict davenports, settees, buffets, desks, tables, chairs, bedsteads, dressers and more, all built of solid, quarter-sawed oak. Invaluable for students and enthusiasts of antiques, Americana and the decorative arts. 80pp. 6½ x 9¼. 27471-3

WILBUR AND ORVILLE: A Biography of the Wright Brothers, Fred Howard. Definitive, crisply written study tells the full story of the brothers' lives and work. A vividly written biography, unparalleled in scope and color, that also captures the spirit of an extraordinary era. 560pp. 6⅛ x 9¼. 40297-5

THE ARTS OF THE SAILOR: Knotting, Splicing and Ropework, Hervey Garrett Smith. Indispensable shipboard reference covers tools, basic knots and useful hitches; handsewing and canvas work, more. Over 100 illustrations. Delightful reading for sea lovers. 256pp. 5⅜ x 8½. 26440-8

FRANK LLOYD WRIGHT'S FALLINGWATER: The House and Its History, Second, Revised Edition, Donald Hoffmann. A total revision—both in text and illustrations—of the standard document on Fallingwater, the boldest, most personal architectural statement of Wright's mature years, updated with valuable new material from the recently opened Frank Lloyd Wright Archives. "Fascinating"—*The New York Times*. 116 illustrations. 128pp. 9¼ x 10¾. 27430-6

CATALOG OF DOVER BOOKS

PHOTOGRAPHIC SKETCHBOOK OF THE CIVIL WAR, Alexander Gardner. 100 photos taken on field during the Civil War. Famous shots of Manassas Harper's Ferry, Lincoln, Richmond, slave pens, etc. 244pp. 10⅝ x 8¼. 22731-6

FIVE ACRES AND INDEPENDENCE, Maurice G. Kains. Great back-to-the-land classic explains basics of self-sufficient farming. The one book to get. 95 illustrations. 397pp. 5⅜ x 8½. 20974-1

SONGS OF EASTERN BIRDS, Dr. Donald J. Borror. Songs and calls of 60 species most common to eastern U.S.: warblers, woodpeckers, flycatchers, thrushes, larks, many more in high-quality recording. Cassette and manual 99912-2

A MODERN HERBAL, Margaret Grieve. Much the fullest, most exact, most useful compilation of herbal material. Gigantic alphabetical encyclopedia, from aconite to zedoary, gives botanical information, medical properties, folklore, economic uses, much else. Indispensable to serious reader. 161 illustrations. 888pp. 6½ x 9¼. 2-vol. set. (Available in U.S. only.) Vol. I: 22798-7
Vol. II: 22799-5

HIDDEN TREASURE MAZE BOOK, Dave Phillips. Solve 34 challenging mazes accompanied by heroic tales of adventure. Evil dragons, people-eating plants, blood-thirsty giants, many more dangerous adversaries lurk at every twist and turn. 34 mazes, stories, solutions. 48pp. 8¼ x 11. 24566-7

LETTERS OF W. A. MOZART, Wolfgang A. Mozart. Remarkable letters show bawdy wit, humor, imagination, musical insights, contemporary musical world; includes some letters from Leopold Mozart. 276pp. 5⅜ x 8½. 22859-2

BASIC PRINCIPLES OF CLASSICAL BALLET, Agrippina Vaganova. Great Russian theoretician, teacher explains methods for teaching classical ballet. 118 illustrations. 175pp. 5⅜ x 8½. 22036-2

THE JUMPING FROG, Mark Twain. Revenge edition. The original story of The Celebrated Jumping Frog of Calaveras County, a hapless French translation, and Twain's hilarious "retranslation" from the French. 12 illustrations. 66pp. 5⅜ x 8½. 22686-7

BEST REMEMBERED POEMS, Martin Gardner (ed.). The 126 poems in this superb collection of 19th- and 20th-century British and American verse range from Shelley's "To a Skylark" to the impassioned "Renascence" of Edna St. Vincent Millay and to Edward Lear's whimsical "The Owl and the Pussycat." 224pp. 5⅜ x 8½. 27165-X

COMPLETE SONNETS, William Shakespeare. Over 150 exquisite poems deal with love, friendship, the tyranny of time, beauty's evanescence, death and other themes in language of remarkable power, precision and beauty. Glossary of archaic terms. 80pp. 5³⁄₁₆ x 8¼. 26686-9

THE BATTLES THAT CHANGED HISTORY, Fletcher Pratt. Eminent historian profiles 16 crucial conflicts, ancient to modern, that changed the course of civilization. 352pp. 5⅜ x 8½. 41129-X

CATALOG OF DOVER BOOKS

THE WIT AND HUMOR OF OSCAR WILDE, Alvin Redman (ed.). More than 1,000 ripostes, paradoxes, wisecracks: Work is the curse of the drinking classes; I can resist everything except temptation; etc. 258pp. 5⅜ x 8½. 20602-5

SHAKESPEARE LEXICON AND QUOTATION DICTIONARY, Alexander Schmidt. Full definitions, locations, shades of meaning in every word in plays and poems. More than 50,000 exact quotations. 1,485pp. 6½ x 9¼. 2-vol. set.
Vol. 1: 22726-X
Vol. 2: 22727-8

SELECTED POEMS, Emily Dickinson. Over 100 best-known, best-loved poems by one of America's foremost poets, reprinted from authoritative early editions. No comparable edition at this price. Index of first lines. 64pp. 5³⁄₁₆ x 8¼. 26466-1

THE INSIDIOUS DR. FU-MANCHU, Sax Rohmer. The first of the popular mystery series introduces a pair of English detectives to their archnemesis, the diabolical Dr. Fu-Manchu. Flavorful atmosphere, fast-paced action, and colorful characters enliven this classic of the genre. 208pp. 5³⁄₁₆ x 8¼. 29898-1

THE MALLEUS MALEFICARUM OF KRAMER AND SPRENGER, translated by Montague Summers. Full text of most important witchhunter's "bible," used by both Catholics and Protestants. 278pp. 6⅜ x 10. 22802-9

SPANISH STORIES/CUENTOS ESPAÑOLES: A Dual-Language Book, Angel Flores (ed.). Unique format offers 13 great stories in Spanish by Cervantes, Borges, others. Faithful English translations on facing pages. 352pp. 5⅜ x 8½. 25399-6

GARDEN CITY, LONG ISLAND, IN EARLY PHOTOGRAPHS, 1869–1919, Mildred H. Smith. Handsome treasury of 118 vintage pictures, accompanied by carefully researched captions, document the Garden City Hotel fire (1899), the Vanderbilt Cup Race (1908), the first airmail flight departing from the Nassau Boulevard Aerodrome (1911), and much more. 96pp. 8⅞ x 11¾. 40669-5

OLD QUEENS, N.Y., IN EARLY PHOTOGRAPHS, Vincent F. Seyfried and William Asadorian. Over 160 rare photographs of Maspeth, Jamaica, Jackson Heights, and other areas. Vintage views of DeWitt Clinton mansion, 1939 World's Fair and more. Captions. 192pp. 8⅞ x 11. 26358-4

CAPTURED BY THE INDIANS: 15 Firsthand Accounts, 1750-1870, Frederick Drimmer. Astounding true historical accounts of grisly torture, bloody conflicts, relentless pursuits, miraculous escapes and more, by people who lived to tell the tale. 384pp. 5⅜ x 8½. 24901-8

THE WORLD'S GREAT SPEECHES (Fourth Enlarged Edition), Lewis Copeland, Lawrence W. Lamm, and Stephen J. McKenna. Nearly 300 speeches provide public speakers with a wealth of updated quotes and inspiration–from Pericles' funeral oration and William Jennings Bryan's "Cross of Gold Speech" to Malcolm X's powerful words on the Black Revolution and Earl of Spenser's tribute to his sister, Diana, Princess of Wales. 944pp. 5⅜ x 8⅜. 40903-1

THE BOOK OF THE SWORD, Sir Richard F. Burton. Great Victorian scholar/adventurer's eloquent, erudite history of the "queen of weapons"–from prehistory to early Roman Empire. Evolution and development of early swords, variations (sabre, broadsword, cutlass, scimitar, etc.), much more. 336pp. 6⅛ x 9¼. 25434-8

AUTOBIOGRAPHY: The Story of My Experiments with Truth, Mohandas K. Gandhi. Boyhood, legal studies, purification, the growth of the Satyagraha (nonviolent protest) movement. Critical, inspiring work of the man responsible for the freedom of India. 480pp. 5⅜ x 8½. (Available in U.S. only.) 24593-4

CELTIC MYTHS AND LEGENDS, T. W. Rolleston. Masterful retelling of Irish and Welsh stories and tales. Cuchulain, King Arthur, Deirdre, the Grail, many more. First paperback edition. 58 full-page illustrations. 512pp. 5⅜ x 8½. 26507-2

THE PRINCIPLES OF PSYCHOLOGY, William James. Famous long course complete, unabridged. Stream of thought, time perception, memory, experimental methods; great work decades ahead of its time. 94 figures. 1,391pp. 5⅜ x 8½. 2-vol. set.
Vol. I: 20381-6 Vol. II: 20382-4

THE WORLD AS WILL AND REPRESENTATION, Arthur Schopenhauer. Definitive English translation of Schopenhauer's life work, correcting more than 1,000 errors, omissions in earlier translations. Translated by E. F. J. Payne. Total of 1,269pp. 5⅜ x 8½. 2-vol. set. Vol. 1: 21761-2 Vol. 2: 21762-0

MAGIC AND MYSTERY IN TIBET, Madame Alexandra David-Neel. Experiences among lamas, magicians, sages, sorcerers, Bonpa wizards. A true psychic discovery. 32 illustrations. 321pp. 5⅜ x 8½. (Available in U.S. only.) 22682-4

THE EGYPTIAN BOOK OF THE DEAD, E. A. Wallis Budge. Complete reproduction of Ani's papyrus, finest ever found. Full hieroglyphic text, interlinear transliteration, word-for-word translation, smooth translation. 533pp. 6½ x 9¼. 21866-X

MATHEMATICS FOR THE NONMATHEMATICIAN, Morris Kline. Detailed, college-level treatment of mathematics in cultural and historical context, with numerous exercises. Recommended Reading Lists. Tables. Numerous figures. 641pp. 5⅜ x 8½. 24823-2

PROBABILISTIC METHODS IN THE THEORY OF STRUCTURES, Isaac Elishakoff. Well-written introduction covers the elements of the theory of probability from two or more random variables, the reliability of such multivariable structures, the theory of random function, Monte Carlo methods of treating problems incapable of exact solution, and more. Examples. 502pp. 5⅜ x 8½. 40691-1

THE RIME OF THE ANCIENT MARINER, Gustave Doré, S. T. Coleridge. Doré's finest work; 34 plates capture moods, subtleties of poem. Flawless full-size reproductions printed on facing pages with authoritative text of poem. "Beautiful. Simply beautiful."–Publisher's Weekly. 77pp. 9¼ x 12. 22305-1

NORTH AMERICAN INDIAN DESIGNS FOR ARTISTS AND CRAFTSPEOPLE, Eva Wilson. Over 360 authentic copyright-free designs adapted from Navajo blankets, Hopi pottery, Sioux buffalo hides, more. Geometrics, symbolic figures, plant and animal motifs, etc. 128pp. 8⅜ x 11. (Not for sale in the United Kingdom.) 25341-4

SCULPTURE: Principles and Practice, Louis Slobodkin. Step-by-step approach to clay, plaster, metals, stone; classical and modern. 253 drawings, photos. 255pp. 8¼ x 11. 22960-2

THE INFLUENCE OF SEA POWER UPON HISTORY, 1660–1783, A. T. Mahan. Influential classic of naval history and tactics still used as text in war colleges. First paperback edition. 4 maps. 24 battle plans. 640pp. 5⅜ x 8½. 25509-3

CATALOG OF DOVER BOOKS

THE STORY OF THE TITANIC AS TOLD BY ITS SURVIVORS, Jack Winocour (ed.). What it was really like. Panic, despair, shocking inefficiency, and a little hero-ism. More thrilling than any fictional account. 26 illustrations. 320pp. 5⅜ x 8½.
20610-6

FAIRY AND FOLK TALES OF THE IRISH PEASANTRY, William Butler Yeats (ed.). Treasury of 64 tales from the twilight world of Celtic myth and legend: "The Soul Cages," "The Kildare Pooka," "King O'Toole and his Goose," many more. Introduction and Notes by W. B. Yeats. 352pp. 5⅜ x 8½.
26941-8

BUDDHIST MAHAYANA TEXTS, E. B. Cowell and others (eds.). Superb, accu-rate translations of basic documents in Mahayana Buddhism, highly important in his-tory of religions. The Buddha-karita of Asvaghosha, Larger Sukhavativyuha, more. 448pp. 5⅜ x 8½.
25552-2

ONE TWO THREE . . . INFINITY: Facts and Speculations of Science, George Gamow. Great physicist's fascinating, readable overview of contemporary science: number theory, relativity, fourth dimension, entropy, genes, atomic structure, much more. 128 illustrations. Index. 352pp. 5⅜ x 8½.
25664-2

EXPERIMENTATION AND MEASUREMENT, W. J. Youden. Introductory man-ual explains laws of measurement in simple terms and offers tips for achieving accu-racy and minimizing errors. Mathematics of measurement, use of instruments, exper-imenting with machines. 1994 edition. Foreword. Preface. Introduction. Epilogue. Selected Readings. Glossary. Index. Tables and figures. 128pp. 5⅜ x 8½. 40451-X

DALÍ ON MODERN ART: The Cuckolds of Antiquated Modern Art, Salvador Dalí. Influential painter skewers modern art and its practitioners. Outrageous evaluations of Picasso, Cézanne, Turner, more. 15 renderings of paintings discussed. 44 calligraphic decorations by Dalí. 96pp. 5⅜ x 8½. (Available in U.S. only.)
29220-7

ANTIQUE PLAYING CARDS: A Pictorial History, Henry René D'Allemagne. Over 900 elaborate, decorative images from rare playing cards (14th–20th centuries): Bacchus, death, dancing dogs, hunting scenes, royal coats of arms, players cheating, much more. 96pp. 9¼ x 12¼.
29265-7

MAKING FURNITURE MASTERPIECES: 30 Projects with Measured Drawings, Franklin H. Gottshall. Step-by-step instructions, illustrations for constructing hand-some, useful pieces, among them a Sheraton desk, Chippendale chair, Spanish desk, Queen Anne table and a William and Mary dressing mirror. 224pp. 8⅛ x 11¼.
29338-6

THE FOSSIL BOOK: A Record of Prehistoric Life, Patricia V. Rich et al. Profusely illustrated definitive guide covers everything from single-celled organisms and dinosaurs to birds and mammals and the interplay between climate and man. Over 1,500 illustrations. 760pp. 7½ x 10¼.
29371-8

Paperbound unless otherwise indicated. Available at your book dealer, online at **www.doverpublications.com**, or by writing to Dept. GI, Dover Publications, Inc., 31 East 2nd Street, Mineola, NY 11501. For current price information or for free catalogues (please indicate field of interest), write to Dover Publications or log on to **www.doverpublications.com** and see every Dover book in print. Dover publishes more than 500 books each year on science, elementary and advanced mathematics, biology, music, art, literary history, social sciences, and other areas.